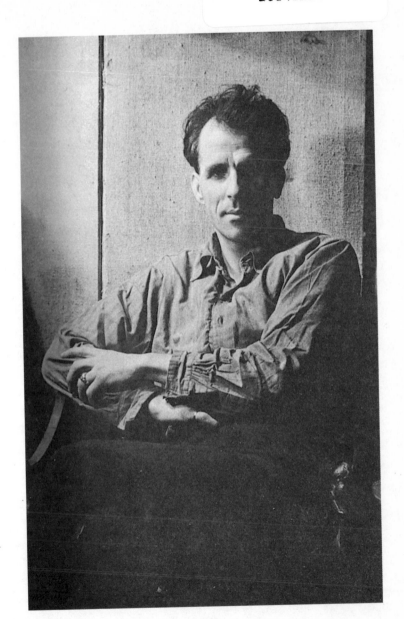

Praise for the previous edition of *Vast Alchemies*

'Peter Winnington is good not only as a biographer but as a critic on such matters as the physical rather than the purely visual qualities of Peake's imagination' – *Times Literary Supplement*

'Peter Winnington could well know more about Peake's life than anyone else – the most reliable biography so far' – Duncan Fallowell, *Independent*

'Few books uncover the creative processes as well as this one . . . Indispensable' – *Birmingham Post*

'Written with mastery of facts and with respect for its subject, *Vast Alchemies* is now the essential source for factual information about Peake's life' – *Science Fiction Studies*

'Peter Winnington has written a sensitive biography which rightly concentrates on Peake's effervescent creativity . . .' – Robert Macfarlane, *The Tablet*

One of four titles shortlisted for the 2003 Mythopoeic Society's Academic Award

Shortlisted as one of the year's best biographies by Nexus

G. PETER WINNINGTON

MERVYN PEAKE'S VAST ALCHEMIES
The Illustrated Biography

PETER OWEN PUBLISHERS
London and Chester Springs, PA, USA

PETER OWEN PUBLISHERS

73 Kenway Road, London SW5 0RE

Peter Owen books are distributed in the USA by
Dufour Editions Inc., Chester Springs, PA 19425-0007

First published in 2000 as *Vast Alchemies: The Life and Work of Mervyn Peake*
This revised edition first published in Great Britain 2009

Picture sources:
From private collections: inside front cover, 12, 16, 60, 67, 69, 70, 73, 74, 81,
82, 84, 104, 106, 107, 115, 119, 122, 140, 155, 165, 181, 187, 208, 212, 219,
225, 238, 242, 244, 246, 250, 253, 254, 264, inside back cover
Courtesy the Mervyn Peake Estate: 20, 50, 72, 78, 79, 88, 92, 116, 120,
132, 138, 162, 193, 220, 232, 263
Photographic rights: 1 © Derek Sayer 1946; 20 © the Library, University College
London; 69, 165, 242, 244 © Chris Beetles Gallery; 70 © Mike Kemp; 82, 181,
225, 246 © G. Peter Winnington; 155 © E.J.S. Parsons; 266 © R. Nicholas

ISBN 978-0-7206-1341-4

A catalogue record for this book is available from the British Library.

Printed in Great Britain by
Windsor Print Print Production Ltd, Tonbridge, Kent

Foreword to the New Edition
by Sebastian Peake

Two well-researched biographies appeared in the year 2000 covering the life and work of my late father. Although the subject was the same, the tone was very different. Both books examined in detail the incredible energy and sustained flow of ideas that emerged from the mind of a person with the ability simultaneously to write novels and plays, poems and short stories and to produce much-admired drawings, illustrations and paintings. But as one reads the two accounts of the unique artistic phenomenon that was Mervyn Peake, it is, at times, as though the biographers are writing about two different people.

I am frequently asked by my father's fans to explain his multifaceted talents. To write about someone who produced such a diverse range of artistic output presents biographers with a formidable challenge. Empathy with the mind and background of the creator of sometimes strange and disturbing worlds is essential, as is the necessity to place him firmly in a historical, familial and cultural context. Sometimes I turn to Malcolm Yorke's biography. Reading Yorke's pages, the reader is left informed, rather than moved; equipped with facts, rather than being drawn into my father's idiosyncratic and highly original world. It is, however, Peter Winnington's *Vast Alchemies* that draws me closer to the spirit and soul of the man I knew, written as it is with remarkable knowledge, erudition and sensitivity for his subject, yet not without objectivity. Both books have their merits, but it is Winnington's book that most successfully

enables the reader to appreciate the extraordinary imagination and energy that enabled Mervyn Peake, within little more than a quarter of a century, to produce such a remarkable and considerable body of work.

Sometimes polymaths such as my father are sidelined or not taken seriously, considered jacks of all trades, where other writers or artists spend a lifetime honing their particular craft. Thus the biographer of Mervyn Peake has a particularly hard task to encourage the reader to consider all aspects of his *œuvre*. Both biographers rose to the challenge as they examined an output that included fantasy novels of great originality and imagination, war art and poetry, a vast range of illustration for both adults and children, humorous and nonsense verse, portraits in oils, macabre as well as intimate short stories and a wide range of other writings, drawings and sketches.

In the original book Peter Winnington sought to present the reader with all aspects of the man, rather than merely to attempt to explain my father's genius, including both life-changing experiences and the minutiae of his daily life with his family and others with whom he came in contact, while recommending – as my father did as an art teacher – that students 'stare, stare and stare again' at their subject. In its latest incarnation *Vast Alchemies* has the advantage over the previous edition of expanding on the original text and including numerous unpublished drawings and paintings, several of which were produced on Sark during my father's two years on the island from 1933 to 1935. The reader follows my father's early life in China to his student days in London, the two halcyon years in the Channel Islands, his job as a teacher London and his development as a novelist following army call-up and his experiences as a war artist during the Second World War. Then comes the second period on Sark, the return to England at the beginning of the difficult 1950s and his decline as Parkinson's disease ensnared him in its remorseless grip.

As someone intimately associated with my father's life and work, especially since my mother's early death twenty-five years ago, I can thoroughly recommend this moving, informative and sympathetic account of a man who still retains a powerful hold over me and over many other admirers of his work.

Foreword by Michael Moorcock

IF there is an unsung hero of Mervyn Peake's life and career it has to be Oliver Caldecott, painter and publisher, who became head of the Penguin fiction list in the mid-1960s, founded Wildwood House and died prematurely. Olly and Moira Caldecott, South African exiles, had been friends of mine for several years and we shared a mutual enthusiasm for Mervyn Peake's Titus Groan sequence. We had made one or two earlier efforts to persuade its publisher to reprint it but were told there was no readership for the books. Caldecott would not give up hope.

I had been instrumental in getting a couple of Mervyn's short stories published and ran some fragments of fiction and drawings in my magazine *New Worlds*. Some of his poetry was still in print, together with one or two illustrated books, but he was thoroughly out of fashion, his reputation not helped by Kingsley Amis and others dismissing him 'as a bad fantasy writer of maverick status' and marginalizing him even further. It was almost unbearably distressing to witness this injustice. Knowing little of the brain in those days, we watched helplessly as Mervyn steadily declined into some mysterious form of dementia while the surgeons hacked at his frontal lobes and further destroyed his ability to work and reason. The frustration felt terrible. His instinctive intelligence, his kindness, even his wit flickered in his eyes but were all trapped, inexpressible. Here was an extraordinary man being destroyed from within while his genius was

rejected by the literary and art world of the day. When critics like Edwin Mullins tried to write about Peake, editors would turn the idea down. I had only a modest success. The story, even then, was that Peake had lost his mind – the strain of writing such dark books. That story was a damaging nonsense.

The last book of the set, *Titus Alone*, had contained structural weaknesses which we had all assumed were Mervyn's as his control of his work became shaky. One afternoon, however, the composer of a musical setting for *The Rhyme of the Flying Bomb*, Langdon Jones, was leafing through the manuscript books of the novel, which Mervyn's wife Maeve had asked him if he would like to see, when he realized that much of what was missing from the published book was actually in the manuscript. Checking further, he found that the book had been very badly edited by a third party and whole characters and scenes cut.

Jones began to check the handwritten manuscript against the typed pages and the final typed manuscript, slowly restoring the book to its present much-improved state. It took him over a year. He was never paid for the work. We suggested to the original publisher that they republish the book, perhaps with the new text. Not only did they not want to publish the books themselves, they were anxious to hide the fact that the last book had been so badly butchered. They became distinctly negative about the whole thing. I proposed to Maeve that we begin the process of getting back the rights. Meanwhile Mervyn became increasingly unwell.

Oliver said mysteriously that he was hoping to get a new job, which might make it easier to publish the books. And then, one morning, he phoned me to tell me, with considerable glee, that he was now the guy who was 'going to pick the Penguins'. And, of course, our first action must be to sort out the Gormenghast books and decide how to get them back into print.

Needless to say, the moment Oliver showed interest from Penguin, the original publisher began to see a new value in the books. They were still very reluctant to do a new edition of *Titus Alone*, however. Eventually the whole project was taken over by Oliver, who proposed illustrating the novels from Mervyn's own notebook drawings of his

characters. He had the authority and experience to get what he wanted. The new hardbacks were simply versions of the characteristically set Penguin texts prepared by Jones. Anthony Burgess, another Peake fan, contributed an introduction to *Titus Groan*, which he treated as a classic, and Caldecott brought the three volumes out as Penguin Modern Classics. It was the perfect way to publish the books, boldly and unapologetically, in the best possible editions Mervyn could have.

Next, with the considerable help of my ex-wife, Hilary Bailey, Maeve Peake was persuaded to write her wonderful memoir of Mervyn, *A World Away*, which Giles Gordon, another Peake fan, then at Gollancz, published with enthusiasm. BBC's *Monitor* did a rather Gothic television programme on him. Peake was back before the public at last; too late, unfortunately, to realize it.

The rest is more or less history. A history spotted with bad media features about Mervyn which insist on telling his story as a doomed one, when in fact it was a very happy story for many years, which perhaps made his tragedy all the more poignant. Bill Brandt shows him as a glowering Celt, a sort of unsodden Dylan Thomas, and his romantic good looks help to project this image. But it is worth remembering that Mervyn could be a cruel and very, very funny practical joker and his home life was about as ordinary and chaotic as the usual bohemian family's. A wonderful father, considerate husband, he was deeply loved by his family and his friends, but he was neither a saint nor a satanic presence, and what was perhaps so marvellous for me, when I first went to see him in Wallington, was realizing that so much rich talent could come from this pleasant, rather modest, witty man. I was in no doubt, though, that I had met my first authentic genius.

He and Maeve continue to be missed, but that genius is still with us; his children and grandchildren continue to reveal his inheritance, both in character and talent, and his great Gormenghast sequence remains the peak, without doubt, of a glorious and generous career.

Peake had a huge, romantic imagination, a Welsh eloquence, a sly, affectionate wit, and his technical mastery, both of narrative and line, remains unmatched. Avoiding speculation and sentimentality,

G. Peter Winnington, whose own *Peake Studies* journal has charted Peake's career for many years, gives us not just a solid introduction to the author but a considerably better understanding of the man. This book is very welcome.

Michael Moorcock
Circle Squared Ranch, Lost Pines, Texas
May 1999

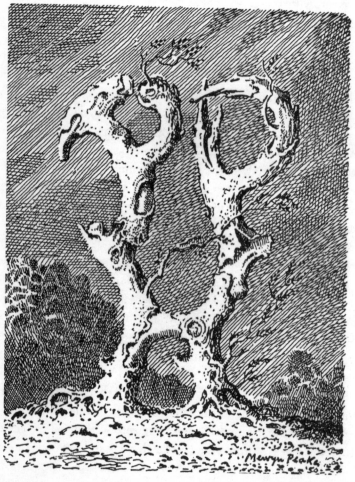

Christmas card designed for Pearn, Pollinger and Higham, 1950

Acknowledgements

G RATEFUL acknowledgement is made to Sebastian Peake and the Mervyn Peake Estate for permission to quote from Mervyn Peake's work and to reproduce his art; to C.S. Lewis Pte Ltd for permission to quote from Lewis's letter dated 20 June 1959 which is copyright C.S. Lewis Pte Ltd; to the late Graham Greene for permission to reproduce one of his letters to Mervyn Peake; to John Batchelor for permission to quote his interviews with persons now deceased; to the executors of Barbara, Countess of Moray, for permission to quote from her reminiscence of Mervyn Peake as her art teacher; to Renato Grome for permission to quote from his father's letter to Maeve Gilmore; and to Edwin Mullins for permission to quote from his reminiscence, 'How Many Miles to Babylon?', which appeared in the Mervyn Peake Review, No. 19 (Summer 1985).

My grateful thanks go to the following people for helping with information about Mervyn Peake's life and work: Pete Bellotte; Philip Best; the Very Reverend Tony Bridge; Raymond Briggs; Brigid Brophy; Louise Collis; Keith Cunningham; Eric Drake; Jenifer Frost; Kay Fuller; Stephen Furniss; Diana Gardner; Maeve Gilmore; Andrew Hall; Joan Jolly; John Lord; Patricia Mahoney; Michael Meyer; Edwin Mullins; Andrew Murray; E.J.S. Parsons; Christopher (Kit) Peake; Mr and Mrs E.L. (Lonnie) Peake; Mary Picton; Dr P.G. Smith; Lady Arabella Stuart; Maurice Temple Smith; Patricia Toplis; Margaret

Waller; and John Wood. The booksellers and Peake enthusiasts Mike Kemp and Leslie Sklaroff have generously shared bibliographical information with me.

Special thanks for the images reproduced in this book to the Mervyn Peake Estate (scanned by Alison Eldred), Chris Beetles, Pete Bellotte, Francis Byng, Jenifer Frost, Kay Fuller, Stephen Furniss, Diana Gardner, Andrew Hall, Eithne Henson, Mike Kemp, Simone Kilburn, John Newgas, E.J.S. Parsons and Audrey Thomason.

I am also grateful to the following persons and institutions for assistance with research: the Bodleian Library; Dr Philip Reed, musicologist at the Britten-Pears Library, Aldeburgh; D.M. Laverick, borough librarian at the Central Library, Bromley; John D. Hodgkinson of the Divisional Central Library, Burnley, and Mrs L. Waterhouse of Clitheroe Library, both in Lancashire; Norah Smallwood and D.J. Enright at Chatto and Windus; the Council for World Mission, who permitted me to examine the archives of the London Missionary Society; Stephanie Fearn, librarian, and David Jones, archivist, at Eltham College; the Imperial War Museum; Solange FitzGerald at the National Archives; Dr John Rhodes, curator of the Royal Engineers Museum, Chatham; the staff of the library of the School of Oriental and African Studies, London; the staff of the Research Centre at the Tate Gallery, especially Nicola Roberts; and Elizabeth Murray, who helped with my research on many subjects over many years.

Finally, I would like to thank all those persons, too numerous to list here, who have shared with me their pleasure in Mervyn Peake's work by sending articles they have written and copies of poems, drawings and paintings in their possession.

Preface

THIS is a new edition of my biography of Mervyn Peake that was published in 2000 as *Vast Alchemies*. When I wrote it Malcolm Yorke had just been appointed by the Mervyn Peake Estate to write an official biography; he was given exclusive right to reproduce and quote from Peake's work, so *Vast Alchemies* had to contain only the briefest of quotations and none of his art. Yorke's right having expired, a new edition of *Vast Alchemies* became possible. For the publisher, the amount of fresh material in it justified a new title.

Most evident of the new contents are of course are the reproductions of Mervyn Peake's paintings and drawings. They span his productive life and aim to underline the variety of styles in his portraits. Be they highly realistic or humorously fantasized (or anything in between), executed with a pencil, pen or brush, his portraits always surprise. Yet our pleasure also comes from recognizing 'another Peake'. No matter how different they may be, each contains that indefinable Peakishness that characterizes his work. Most of those reproduced here are unfamiliar (having been printed only in the *Mervyn Peake Review* or *Peake Studies*) and some are previously unpublished; only a handful have already appeared in books.

New information has led me to make many small changes in the text, providing a more precise date here and the name of a sitter there. The section on Peake's plays, in particular, is greatly expanded. More importantly, after reading the unpublished correspondence of Sir

Portrait in oils of Harriet, a daughter of Sir John Walley,
printed as a Christmas card, 1945

Kenneth Clark I have completely rewritten the account of Peake's attempts to be employed as a war artist from the moment the war was declared.

Another area of his life also gets rather different treatment in this new edition. At the end of the 1990s, Mervyn Peake's children were unaware of their father's extra-marital adventures, and I considered that my book was not the place for them to learn about them. In the event, they gave Yorke access to documents that I had not seen (and still have not) – the family cuttings book, Maeve's diary and Mervyn's letters to her – and thus they learned of Mervyn's affair with Francyn. The news broke just as *Vast Alchemies* was due to be printed. Peter Owen wanted the information to go into the book, but as it was already paginated

and indexed, the addition had to be extremely brief – sending even a single line over to the next page could invalidate index references for the rest of the chapter. Consequently some readers were puzzled by the brevity with which the topic was treated; now they will find more.

Not much more, though. As my main interest is in Mervyn Peake's work rather than his sex life, I have not made particular efforts to seek out fresh evidence or further partners. A full account of his infidelities might make colourful reading, but would it make any difference to our assessment of his work? I think not. However, if anyone wishes to share a story with me I'll be happy to record it.

Meanwhile the size of his *oeuvre* grows all the time. I learn of new drawings and paintings every month; fresh letters emerge. Nearly a third of the poems in *Collected Poems* (published in 2008) had never been printed before, revealing a larger – and richer – production than anyone had realized. We can hope that future books will show the extent of his playwriting, too.

So this edition expands on the first, building on Maeve's memoir, *A World Away*, and the books by John Batchelor, John Watney, Gordon Smith and Malcolm Yorke. To keep the reading smooth, I have placed all discussion of my sources in the notes at the end, particularly John Watney's biography. As I wrote in the Preface to the first edition, 'Given his privileged access to sources, one might have expected a better book; I have faulted it so many times on matters of fact – from the date of birth of Mervyn's brother Lonnie to the spelling of people's names – that I began to lose faith in it.' Further research has merely reduced my reliance on it. But I am as fallible as any other writer, and the mistakes that may come to light after publication will be all mine.

I am most grateful to readers who sent me comments on the first edition and look forward to receiving more. Any reader with a Peake story to tell will find in me a ready ear, and all those with Peake pictures are invited me to notify me of them, that I may record them and possibly reproduce them in *Peake Studies*.

G. Peter Winnington
July 2009

Abbreviations and editions employed

Batchelor John Batchelor, *Mervyn Peake: A Biographical and Critical Exploration*, London: Duckworth, 1974

CP *Collected Poems*, ed. R.W. Maslen, Manchester: Carcanet, 2008

G *Gormenghast*, Harmondsworth: Penguin, 1968 (the pagination is the same as the paperback editions from Vintage but not the omnibus editions)

Gilmore Maeve Gilmore, *A World Away*, London: Gollancz, 1970

MPMA *Mervyn Peake: The Man and His Art*, ed. G. Peter Winnington, London: Peter Owen, 2006

MPR *Mervyn Peake Review*

Peake Sebastian Peake, *A Child of Bliss*, Oxford: Lennard, 1989

Pocock Tom Pocock, *1945: The Dawn Came Up Like Thunder*, London: Collins, 1983

PP *Peake's Progress*, Harmondsworth: Penguin, 1981

PS *Peake Studies*

Smith Gordon Smith, *Mervyn Peake: A Memoir*, London: Gollancz, 1984

TG *Titus Groan*, Harmondsworth: Penguin, 1968 (the pagination is the same as the current paperback edition from Vintage)

Watney John Watney, *Mervyn Peake*, London: Michael Joseph, 1976

For further bibliographical details, see p. 291.

Contents

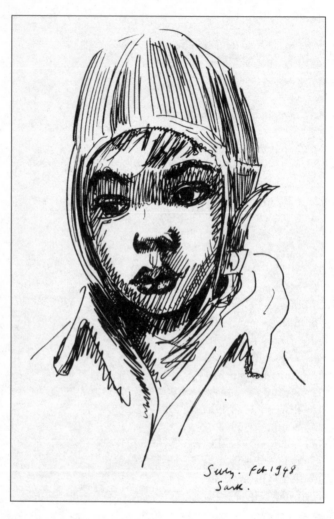

Sebastian Peake, pen and brown ink, 1948

I long to spring
Through the charged air . . .
To prance immune among vast alchemies
 – 'Coloured Money' by Mervyn Peake

PART 1

China, 1898–1922

1

Dr Peake and Bessie Powell, 1898–1911

MERVYN Peake was born in Kuling, Central China, and this fact was to have a considerable influence on his life. His parents were missionaries who met and married out there before returning to England when Mervyn was eleven years old.[1]

His father, Ernest Cromwell Peake, was born on 18 August 1874 at Ambavatory, Madagascar, to a family working for one of the oldest institutions in the missionary movement, the London Missionary Society, founded by the Congregationalists in 1807.[2] After studying in England at the School for the Sons of Missionaries at Blackheath (which was renamed Eltham College when it moved in 1912), he spent two years with a chemist, Mr Mills, in Chester, learning the art of dispensing drugs. In his spare time, he read not only novels but medical and missionary works, as well as some botany and chemistry. In this way he prepared himself both for his medical studies at Edinburgh and for missionary practice. Having obtained his Bachelor of Medicine qualification, he formally offered himself to the London Missionary Society (LMS) in October 1898, just as his elder brother George[3] had done five years before and as his younger sister Grace Caroline[4] was to do five years later. The LMS accepted him at once and asked him to cancel the arrangements he had made to complete his studies with a year as house-surgeon at Mildmay Hospital, Hackney (London). His dedication service was held on 18 December at Morningside Congregational Church, Edinburgh, and

he sailed for China on 12 January 1899. As luck would have it, his parents were making one of their rare visits to England at the time; it was to be more than fifteen years before he saw them again.[5]

He was destined for the province of Hunan in Central China, an area almost the size of England, Scotland and Wales together. When he arrived at Hankow (*Hankou* in Pinyin) in March he was warned that he might have to wait a year or two before moving further into the heart of the province, for Hunan prided itself on its opposition to foreigners. As it was, he had to spend most of his time learning Chinese, which he found very difficult; in his spare time, he helped out at Hankow hospital. At the end of June, when the heat became so oppressive that he was finding it hard to sleep at night, he was delighted to climb up from the plain and take his first holiday in the fresh air of Kuling.[6]

When European missionaries travelled up the Yangtze river at the end of the nineteenth century they suffered dreadfully from the torrid heat of the summer. In 1895 one of them, an E.S. Little, climbed up above Kiukiang (*Jiujiang*) and established a hill station, which he punningly called Kuling after the local name for the hill, *Guling* ('bull mountain'). Being situated at around 1,000 metres (3,000 feet), it was not just *cooling* but a pleasure for all the senses, with fresh streams and colourful flowers, birds and butterflies as well as stunning views of the valley far below – an ideal place for taking holidays and for recovering from sickness. Thus it became the main summer resort and meeting place for missionaries and Europeans in general from the whole of the mid-Yangtze basin.[7] Their children would spend most of the summer up there, in the charge of their amahs, while the parents stayed only two or three weeks. When Dr Peake went up in July 1899, he estimated that there were already six hundred people in the bungalows that clustered the hillsides, although it was not yet the height of the season. And Kuling continued to grow: by 1920 there were more than five hundred houses, two churches, a medical centre, a large boarding-school for American children and a smaller school for British children, branches of Hankow and Shanghai department stores, no less than fifteen public tennis courts, two bathing pools for adults and one for

children and a playground. Today, guidebooks to China send tourists up there to admire what they call 'a village lifted lock, stock and barrel out of Switzerland and grafted on to a Chinese mountaintop'.[8]

Kuling was remote, reached only by a narrow track with thousands of steps in the steeper parts, often with a precipitous drop to one side. It made a memorable journey for the missionaries, most of whom were carried up in palanquins by coolies. (Today you can ride up in a bus, an Alpine-style road having been blasted through the rocks. In *Gormenghast*, Titus is carried to his birthday masque in 'a light basketwork palanquin, or mountain-chair' [G, p. 320].) It was also nearly 200 kilometres (more than 120 miles) downriver from Hankow. When Dr Peake moved up the Hsiang river, first to Yo-Chow (*Yueyang*), 200 kilometres (125 miles) to the south of Hankow, and then Hengchow (*Hengyang*) in the heart of the Hunan province some 255 kilometres (nearly 160 miles) further south, the journey to Kuling and back by river could take six weeks. As there were no steamers above Hankow the duration of the upstream journey depended on the wind. So, during the summer of 1902 he made a six-day tour of the hills around Hengchow in the hope of finding an alternative site but without success. By way of compromise, one of the twice-yearly local committee meetings, attended by all the missionaries in the area and often lasting two to three weeks, was held up in Kuling instead of on the plain. So he continued to travel there each summer.

While Dr Peake was enjoying his first holiday up at Kuling, the life of the young woman who was to become his wife was taking a dramatic turn. Amanda Elizabeth Ann Powell (called 'Bessie' in her childhood), the eldest of three sisters, was born on 11 March 1875 in Aberdare, Glamorganshire. Her parents, Charles and Amanda (née Hardwick), were both Welsh, although they were living in London at the time when they married in 1866 (at the Baptist taber-nacle in Kensington) – and these Welsh origins, Bessie felt, were a key to her character.[9] Her father, a mason, died of pneumonia on 11 January 1881, aged only forty-five; at once her youngest sister, Florence Catherine, was sent to live with their uncle William

Powell, a surveyor, in Masons Hill, Bromley. Three years later, when William was promoted to Road Surveyor of Croydon Corporation and moved to a larger house across the road, Bessie joined her sister and her cousin, who was slightly older than she. Soon afterwards, Bessie's mother, whose health was precarious, also came to live in Bromley, but she died in August 1889 of 'pernicious anaemia', aged fifty-two years.

In Bromley Bessie was sent to private schools and then, when her uncle moved to Croydon, she attended Croydon High School between 1892 and 1894, passing her Senior Cambridge local examination in 1893.[10] For about two and a half years she had a morning job as a governess, but in May 1897 she had to give it up, for her aunt was an invalid, her uncle had fallen ill and her help was needed in the house. That September her uncle died, and a year later it became necessary for her aunt to enter a private institution. The girls' home at 2 Wellesley Grove, Croydon, was to be broken up. They had little more than the expectation (on the death of a relative) of an annuity of £15 a year each – and the desire to travel. So Bessie, who was an active member of the Christian Endeavour Society, offered herself, with Florence, to the LMS, at the same time as making arrangements to enter Mrs Menzies's Liverpool Missionary Training Institute ('Deaconess House') on 10 October 1899. The doctor who examined her expressed the hope that the climate of India would be beneficial to her – so she may have expected to go there – but her posting, two years later, was to Canton (*Guangzhou*) and not India. She sailed on 18 November 1901.

During these two years Hunan province opened up more quickly than expected: in December 1899 Dr Peake set up his first medical post in Yo-Chow at the north end of Tung-Ting (*Dongting*) Lake, accompanied by Albert Grieg (1867–1918), who was a new recruit to the LMS but already familiar with China, having been with the National Bible Society of Scotland at Hankow. However, the opening of his dispensary was delayed not only by his need to study Chinese four or five hours a day but by unrest in Hunan, followed by the Boxer Rising, which forced him to retreat to Wuchang (*Wuhan*). Something of the young doctor's spirit may be gauged

from a letter dated 17 January 1901 that he wrote to his director in London, describing the walled city with its great gates which were closed at sunset and his feelings of frustration at being thus cooped up. Longing for action, he procured a rope, which he hid under his bed, and in the cool of the evenings he surveyed the town wall for a suitable place to attach his rope and make a midnight escape. In the end he stayed put; when the fighting was over and he was able to leave in a manner more suited to his status as a missionary doctor he could not repress a sense of disappointment that nothing had happened. 'I know others have had terrible times – and it's been most sad – but somehow – well, I suppose it was just the love of adventure. Of course, I always calculated on getting off alright.'

Readers familiar with Gormenghast, which his son Mervyn was to create forty years later, will recognize the community enclosed within its great walls and the sense of adventure that sends Titus out on escapades (down a 100-foot rope by night in *Boy in Darkness*) and Steerpike, too, down the façades of the castle at the end of a rope. Mervyn clearly shared his father's taste for adventure and like his father kept it in his imagination rather than acted it out.

At Yo-Chow Dr Peake found plenty of medical work to do, and he often expressed the hope that another of his sisters, Emilie (born 27 March 1872), who had trained as a nurse, would come out to join him as his assistant. But that was not to be; she withdrew her application to the LMS, preferring to look after her brother and sister in Madagascar. Nor was it just a medical assistant that he needed. Whenever Albert Grieg left the mission Dr Peake felt his solitude acutely, for he was then the sole Englishman in that foreign city. As he confessed to his director in January 1901, he really did not like being alone like that, but there was no help for it. And things were soon to get worse: Albert Grieg married a nurse from the Hankow hospital and moved into a house of his own, leaving Dr Peake with no one to talk to. Nor could Mrs Grieg answer his need for a nurse: strict LMS rules forbidding joint incomes meant that she could help him only on a voluntary basis. His loneliness was becoming a burden.[11]

By the autumn of 1901, however, change was in the air. Other missionary groups had entered the town and the LMS was looking

to move on to Hengchow, in the heart of Hunan province. Ten days after Bessie started on her six-week voyage to Canton Dr Peake set out on a five-week journey up the Hsiang river to visit Hengchow, where their Chinese evangelist, Mr Peng, had built a mission for them, complete with chapel; everything was ready for speedy occupation. Both Grieg and Peake pressed to move there as soon as possible. The Yo-Chow mission was sold to the Reformed Church of the United States, and by April 1902 they were resident in Hengchow, which became the new headquarters of the Hunan mission.

Hengchow could certainly not provide a cure for Dr Peake's lone-liness or supply the nurse he needed. They were the sole Protestant mission in a city of between 200,000 and 300,000 inhabitants (by their own estimate). Mrs Grieg was the first foreign lady visitor and for quite some time the sole foreign lady residing there. With her help Dr Peake was ready to see his first out-patients on 28 April 1902. Soon there was work enough for a full team, never mind a single doc-tor and volunteer nurse assisted by two local boys, one of whom had the knack of fainting at the most inopportune moments. By the end of the year Dr Peake was planning a hospital and raising local funds to buy land on which to build, repeating all the while his appeals for a trained nurse. The following March the LMS granted him money for the hospital, and in June the land purchase went through at a rock-bottom price because the property was reputed to be haunted. But still no nurse was provided; worse, he was tartly informed that girls were 'not prepared to go to Hengchow as nurse assistants to a gentleman doctor'.[12] Peake appealed to London for early furlough; the strain of solitude was getting him down. He was not running away, he insisted, but his feeling of loneliness was severe and acutely painful to him. He hoped he would not get 'cranky', as some of his colleagues and predecessors had done. He posted the letter on 30 June as he left for Kuling.

In Canton Bessie was having her ups and downs too. Her initial impression that Cantonese was less difficult than she had feared proved completely false, and she went through periods of despair. Her fellow missionaries supported her, for she was much appreciated by them – and by the Chinese, too. In less than a year she found

herself taking over the duties of a colleague whose ill health had obliged her to resign. Many were the warnings she received not to outrun her strength as she familiarized herself with 'running the schools, visiting in the home and working among women.' In March 1903 her own health suddenly broke down; Drs Webb Anderson and MacLean Gibson agreed that 'owing to the state of her lungs, further residence in South China is inadvisable, and would be attended with grave danger.' On 22 March the Hong Kong district committee reported to London that, unless instructions were received to the contrary, they would dispatch Miss Powell direct to Hankey, South Africa, to join her sister Florence, who was now married to an LMS missionary, Walter Morgan.[13] The secretary lamented the impending loss to the Canton mission of 'a lady worker of no ordinary efficiency and worth, who would assuredly do well as a teacher and spiritual guide of Chinese women'. That lady worker, resting in Hong Kong, declined to be sent away. In her view there was nothing seriously wrong with her. Many others broke down in their early days and then fully recovered. Could she not do so too? Moreover she doubted that God wished her to leave Canton and she was determined to have another try. The doctors relented; she was to spend three months away from Canton; then they would examine her again. With other missionaries, she travelled along the coast and up the Yangtze river, spent a few days at Wuchang and then climbed to Kuling. There her health improved immensely; by mid-June nearly all her symptoms had disappeared. There too, in July, she met Dr Peake.

By the end of August they were engaged. Bessie saw the working of God in her life: if He had not allowed her health to break down she would never have visited Kuling; and without Kuling she would not have met Dr Peake. We might add that without her own courage and determination she would have been packed off to South Africa months before. Her fiancé felt the strain lift from his shoulders; announcing his engagement to headquarters in London, he withdrew his request for early furlough and confessed that he had been about as 'deep in the blues' as he could get.[14] Convinced that, for the sake of her health, Bessie should not spend another summer in Canton, he

sought permission for an early wedding. In his excitement he put his letter with a British stamp on it into a Chinese Imperial Post box, so he hastened to repeat his news in a second letter in case the first failed to arrive. The awaited telegram, 'December sanctioned', came in mid-November.

On 1 December 1903 Dr Peake left Hengchow for Canton (*Guangzhou*) and Hong Kong; travelling overland it took him sixteen days to make the 640-kilometre (400-mile) journey. In his unpublished memoirs (quoted by Watney, p. 42) he recalls one memorable evening when the road levelled out as it approached the foothills and suddenly, on either side, it was lined with immense statues carved out of solid blocks of stone. To his astonishment he recognized in the gloom rampant lions, elephants and wild boars placed at regular intervals, facing each other across the roadway. This must have been a Spirit Way, the paved road along which the spirit of a dead emperor reached its resting place. The Spirit Way was traditionally guarded by statues, paired on either side of the road, of generals, mandarins of the appropriate degree, followed by a prescribed series of real and mythical beasts. Sights such as this certainly inspired some of Mervyn's drawings and writing, although he may have known them only from his father's photographs.[15] There is even a specific reference to a Spirit Way in *Titus Groan*: the sculptures in the Hall of Bright Carvings are seen 'in narrowing perspective like the highway for an Emperor' (p. 19).

On the last day of 1903, exactly two years after Bessie's arrival in China and less than six months after she met Dr Peake, they were married in Hong Kong. The bride was given away by the Dr Gibson who had attended her in her illness. A month later, having sailed round the coast to Shanghai and up the Yangtze, they were back for the district committee meetings in Hankow; when these were over they proceeded to Hengchow, which they reached on 9 March. Dr Peake reopened his dispensary almost at once, seeing an average of fifty patients a day, and started on the new hospital: to keep down costs he supervised the building himself through the intermediary of Mr Peng. Mrs Peake (called Beth by her husband) found the climate of Hengchow less taxing than Canton's, but she still had a bad

cough that spring as she learned her new role as doctor's unpaid
assistant. Although Dr Peake was now married, the LMS still refused
to provide the qualified nurse that he needed for treating women
patients and training local girls.

The following year saw the birth of their first child, Ernest Leslie
(called Lonnie by his family), on 23 March.[16] He was a strong boy
and at first it seemed that all was well for his mother, too. But gynae-
cological complications set in; a lengthy operation undertaken at
Hengchow, during which she almost succumbed under the chloro-
form, failed to improve matters, and by July it was clear that she
would have to return to England to be operated on there. The
return of Dr Peake was sanctioned, too, as it was out of the question
for her to travel alone with Lonnie and, without a family or home to
return to, make arrangements for treatment in England. They arrived
in October 1905 and spent fifteen months in the home country,
partly in deputative work but mostly, for Dr Peake, in medical study.
During this time Mrs Peake gave birth to stillborn twins.

In January 1907 they embarked again for Hengchow, where they
arrived in mid-April and reopened the dispensary and hospital. There
was a great deal of work to be done: Dr Peake saw 1,500 patients that
year. Beth, now recovered, acted as matron of the hospital, and on
three afternoons a week she superintended the work in the dispen-
sary. Housing was a disappointment though; in their absence flood-
ing had rendered their house uninhabitable. As funds were not
immediately available for a new one, they lived in the hospital build-
ing. The spartan conditions may be gauged by Dr Peake's request for
£50 to glass in the veranda on the north side of the men's ward: one
patient had run off, he explained, because he could not stand the
cold (letter dated 26 July 1908). By the end of 1908 a grant had been
made and Dr Peake supervised the building of a good-sized, double-
storeyed dwelling house which was finished by the end of 1909. This
time he dispensed with the services of Mr Peng, whose honesty had
reluctantly been put into doubt, and directed the whole job him-
self. 'Not every missionary would have had the necessary skill and
knowledge to do what Dr Peake did in the way of building,' reported
his colleagues at their district meeting in January 1911, underlining

how much he had saved the society compared with the cost of Mr Grieg's house.

Installed in their own house, it seemed that at last their work in Hunan could proceed on firm foundations. Despite the social unrest that kept them away from Hengchow for many months in 1910 there was every sign that they could look forward to an expanding mission in a prosperous city. The whole area was open-ing to trade; British and Japanese steamers came up as far as Changsha, just 150 kilometres away (less than 100 miles). Coal mines were being opened, and a railway was built to run all the way through the province, from Hankow to Canton. But the two following years were to prove the most difficult in all their time in China. In January 1911 the LMS decided to pull out of Hunan altogether, sell-ing the Hengchow mission and transferring Dr Peake elsewhere. It was twenty-two months before the new owners, the American Presbyterian Mission, were ready to move in, and throughout that time Dr Peake's next station was in debate.

Meanwhile, Mrs Peake was expecting another baby. She and her husband went up to Kuling in June, and Mervyn Laurence was born there on 9 July 1911. Dr Peake stayed longer than usual, as he was asked to attend a colleague until she recovered from typhoid. Then, at the very moment when they were preparing to leave for Hengchow, revolution broke out in Wuchang: the south of China was throwing off the Manchurian dynasty that had oppressed it for so long. As the fighting spread throughout the country, foreign women and children were evacuated to Shanghai; only those in Kuling sat tight. Dr Peake went upriver to join the few doctors in Hankow who were organizing aid under the Red Cross. Here he encountered for the first time the exactions of soldiers on the civilian population. Like so many Englishmen, he protected himself from the horror of it with humour. In his memoirs (quoted by Watney, p. 15) he recalled that he and his medical colleagues were a cheerful party, despite the shells that came whistling overhead and exploded in the streets. He was getting all the adventure he could have wished for. He also worked very hard treating the wounded. It is estimated that at any one time during this period there were no less than a thousand soldiers in

mission hospitals in Hankow and quite as many civilians (*China Mission Year Book*, p. 261). Peace returned slowly; it was not until February 1912 that – against consular advice – the Peakes returned to Hengchow.[17]

This revolution produced a major change in China: the imperialist north yielded to the revolutionary south, the Empress-Dowager was overthrown and China became a republic under President Sun Yat-sen. The formal resignation of the Boy-Emperor took place early in 1912; he was then six years old, and for the next twelve years – that is, until he was eighteen – he was kept a virtual prisoner inside the walls of the 'Great Within'. There he studied under his tutors, longing to see something of the outside world. In 1924 he settled in Tientsin (*Tianjin*) as a private citizen.

Parallels between the early life of the Boy-Emperor and Titus Groan, as recounted in the first two of Mervyn's novels, are numerous and striking. *Gormenghast* begins when Titus is six, and the third volume, *Titus Alone*, takes up the story when Titus, aged eighteen, has left his ancestral home behind and ventures out into the wider world as no more than an ordinary citizen. We may wonder whether Mervyn was drawn to the story of the Boy-Emperor by parallels with his own life: the dates of the 'inner exile' correspond closely to Mervyn's childhood years in China, and the Boy-Emperor arrived in Tientsin as an ordinary citizen soon after Mervyn left that city to become just another schoolboy in England.

Even more striking are the parallels between the Groan family of Gormenghast and the descendants of Confucius, the Kong family. For more than two thousand years they lived in a mansion beside the temple at his birthplace, Qufu, in Shandong province. Second only to the Emperor in importance, 'the top family on earth' (as they were known to the Chinese) conducted all the elaborate temple ceremonies that marked the passing of the seasons and honoured the birthdays of the living and the dead. The title conferred upon them by the Emperor, 'Yansheng Duke', was passed down to one boy in each generation. The last Duke, Kong Decheng, the posthumous son of the seventy-sixth descendant of Confucius and therefore the seventy-seventh holder of the title, was born in 1920.

He was the last to live in the mansion, being forced to flee when the Japanese invaded in 1937. He spent his life of exile on Taiwan and died on 28 October 2008. Rather significantly, he and his two sisters were not brought up by their birth mother, who was only a servant, but given over to the official wife of the seventy-sixth Duke and suckled by a wet nurse, as was Titus Groan.

Like Gormenghast, the Kong mansion was enlarged by successive generations to become some 150 houses rather than a single building; it attained 560 rooms in the sixteenth century. Renovated in 1838, it was almost completely destroyed by fire in 1887 and rebuilt at once at the expense of the Emperor. Today, its 480 rooms total 12,470 square metres (over three acres) set in grounds covering more than ten times that area. The temple beside it is even larger, some 16,000 square metres (around four acres). Both are now World Heritage sites.

Here we have fragments which may point towards the story of Titus and his castle home but by no means account for it. In any case, Mervyn would know of these people and places only by repute rather than from direct experience. He never visited the Forbidden City in Peking, for instance, although his father did. The workings of the imagination are by definition mysterious, and we cannot know the precise ways in which Mervyn transmuted historical and geographical facts, fantasy and autobiography into fiction. These are but a few of the vast alchemies that give this book its title.

2
Growing Up in Tientsin, 1912–1922

IN October 1912 Dr Peake was ordered to North China to run the MacKenzie Memorial Hospital in Tientsin (*Tianjin*). It was not a pleasant move; he and Beth would gladly have stayed in Hunan, and their colleagues were keen to keep them, too. They found it all the harder to quit the station they had built themselves when the hospital at Tientsin was not an attractive proposition. During the prolonged absence of Dr Peake's predecessor, the medical standard and the very fabric of the hospital had declined deplorably. When he arrived Dr Peake had to dismiss virtually all the staff and start anew. He would have liked to do the same with the buildings, but the MacKenzie Hospital was financed by locally raised money; the LMS paid only the head doctor's salary. Taking over this post filled him with dismay, for he could see little chance of making a success of it.

They were also worried about making a 1,600-kilometre (1,000-mile) journey with little Mervyn, who was not strong, at such an unfavourable time of year; furs alone cost them a small fortune. None the less, despite a storm on the Tung-Ting Lake which immobilized them for several days, they made it first to Hankow by steamer and then, after picking up Lonnie who had been at school in Kuling, by train to Tientsin, arriving at the end of November. The cold was bitter, and at first they suffered much from the change of climate, but ultimately the dry air of Tientsin was healthier than the humidity of Hengchow. However, two weeks after their arrival Mrs

Peake caught typhus from a patient, and for many days she was at death's door. As she recovered, they looked forward to their furlough, due in March 1914, only to learn that the LMS was postponing all leave by twelve months. Such was their resilience and their faith in their work that Dr Peake could report in November 1913 that they were very happy in Tientsin and felt they were in the right place.

Thus the first home that Mervyn could remember was the hospital complex at Tientsin. As in other Treaty Ports, large areas of land adjoining the city were leased to foreign powers, which administered them under their own national laws. The MacKenzie Memorial Hospital on the Taku Road was in the French Concession, in a walled compound of its own. For the young Mervyn, that compound – 'six acres of dusty ground' – was his world, his arena, and outside it was 'China, the camels, and the sickly sweets, the mules and the beggars with alizarin wounds'. As in Gormenghast, the emphasis is on enclosure, with different people and a different culture beyond the wall. In addition to such civilized comforts as tennis courts, there was a crown-of-thorns tree (*Ziziphus spina-christi*) in the compound. Mervyn 'would climb to the top of its dangerous branches and there with a thorn on the bridge of his nose [he] would become the loftiest of all the unicorns' (*PS*, 2007; 10: 3, 3).

In addition to the hospital buildings there was a line of six grey-stone houses for the European missionaries, built in a style known locally as 'Tientsin Gothic' that was completely out of place in China; their very alignment was incongruous. In fact, to Mervyn's adult mind it looked as if the whole row had been flown in straight from Croydon (where his mother went to school and where Mervyn attended art college) and had no business to be in China at all. Although the houses were outwardly similar, each had its own feel, its own smell, so that to Mervyn they differed from one another as greatly as a dog from a frog or a pig from a cat. He lived in the fourth house down, at the tennis-court end of the compound, and thirty years later he remembered it still with great affection. However, the autobiographical notes that he made in the early 1950s (printed in *Peake's Progress*, pp. 471–87) rapidly decline into lists of single words and phrases. Of the house, he jotted down 'Under the stairs' and

'The attic', both typical sites of male infant exploration. Both are significant sites in his novels, too, Fuchsia's private domain being her attic; the counterpart for Titus are the stairs he discovers at the end of Chapter 9 of *Gormenghast* (p. 30).

However, Mervyn was not to remain in Tientsin for long: to the Peakes' surprise furlough was suddenly granted. It was too late to book steamer passages, so they took the Trans-Siberian Railway and arrived in London in May 1914. At one point during this twelve-day journey Lonnie descended alone from the train at a halt and was hauled back on again by his father just as the train was pulling out, an episode that made a deep impression on Mervyn. Lonnie, on the other hand, recalled that what had most interested Mervyn on the trip was a glass-topped case of multi-coloured stones that his mother bought him at a wayside station (*MPR*, 1978; 7: 7). This fascination with colour is reflected in *Gormenghast*, when Titus 'sees' colour for the first time, particularly in his 'glass marble . . . with its swirling spirals of rainbow colours twisted within the clear, cold white glass' (G, p. 84).

They had returned from a country recovering from revolution to a continent rushing to war. Dr Peake's first priority was to bring his medical knowledge up to date: running a hospital that treated 30,000 outpatients a year required a great deal of him. So he returned to Edinburgh and passed his MD examinations in June 1915. Then the war caught up with him and he was commissioned in the Royal Army Medical Corps. The LMS *Chronicle* printed a photograph of him looking after recruits on Salisbury Plain – as he no doubt reminded his son during the Second World War when Mervyn was posted to Salisbury Plain for a course in the use of the theodolite. Thereafter Dr Peake was briefly posted to a field hospital in Belgium where he discovered to his surprise that the matron was his sister Grace (Watney, p. 22).

For his family Dr Peake had rented a house in Clarence Road, Mottingham, near Eltham,[1] so that Lonnie could attend Eltham College as a day boy. Mervyn remained at home, too young for school, spending his time drawing and colouring sheets of paper. His talent was beginning to emerge. On this visit to England Mrs

Peake met her in-laws for the first time and Mervyn and Lonnie dis-covered their grandparents and their uncle George and his wife. All four had retired from the LMS on grounds of ill health and settled in Dorset.

It was October 1916 when they set off again for China and not without apprehension: German submarines had started sinking passenger ships, and missionaries had been lost on their way to and from their stations. So the Peakes took the safer route round the Cape, passing close to Madagascar where many of the Peake family had laboured for so many years. It took exactly two months to reach Tientsin, and coming straight from the tropics to the icy winds of North China both Lonnie and Mervyn went down at once with colds and bronchitis. That winter saw the start of a ten-year worldwide epidemic of sleeping sickness (*Encephalitis lethargica*); John Watney suggested that after lying dormant in Mervyn for forty years this disease may have caused his twelve-year decline to death. However, there is no evidence that Mervyn ever contracted sleeping sickness, and in any case the relationship that was once believed to exist between it and Parkinson's disease – which Mervyn did suffer from in his last years – has now been thoroughly disproved.[2]

The boys soon recovered, and Lonnie was sent off to a 'pretty grim' boarding-school 800 kilometres (500 miles) away by train at Chefoo (*Yantai*) on the coast (letter from Lonnie to GPW dated 9 January 1978). Mervyn and his parents settled down to the varied routine of hospital life. And more variety was soon to come. Having lived in the Yangtze basin they were no strangers to flooding, which they hardly expected to experience in the plains of the north. Yet in July 1917 heavy rain caused flooding in the neighbourhood of Tientsin; the waters persisted for weeks to the extent that the Tientsin–Pukou railway line was still covered to a depth of over a metre at the end of August. The city itself was spared, however, until the third week of September when catastrophic rainfall caused all the rivers to flood again, and the Chinese town was inundated. Much of the population fled to the hills; others took refuge in sampans and junks. Still the waters rose until the foreign concessions, built on higher ground, were also awash. In the British Concession it was up

to two metres (six feet) deep on 25 September, but it did not interfere unduly with work in the MacKenzie Hospital in the French Concession, where the lowest floors remained just above the water.

The floods were slow to go down because the railway embankment close to Tientsin retained the water, and there was much debate as to how and where it should be breached. On 27 October the *North China Herald* reported gloomily: 'Tientsin stands at the edge of an inland sea estimated to extend for 15,000 square miles [38,850 square kilometres], the draining of which there is no possible hope until the spring.' So the memorable flooding of Gormenghast had an actual precedent in Mervyn's life, on a scale commensurate with his description of it. It is one of the few identifiable episodes recorded in his notes for an autobiography. What struck him particularly were the naked 'Adams', men who made a living by helping people across the floodwaters, linking their arms over each other's shoulders to form a human chain (*PP*, p. 482).

Having noticed this parallel between Mervyn's life and events in Gormenghast, we might compare the setting of the castle with the geographical situation of Tientsin. Gormenghast's dominion extends 'in the north to the wastelands, in the south to the grey salt marshes, in the east to the quicksands and the tideless sea, and in the west to knuckles of endless rock' (*TG*, p. 305). Tientsin is close enough to 'the wastelands' of the Gobi desert in the north to suffer from sandstorms. The Gulf of Chihli, which lies just 65 kilometres (40 miles) east of Tientsin, is a shallow and to all intents and purposes 'tideless' sea, little more than a large bay of the Yellow Sea. Its coast is flat and swampy, with 'grey salt marshes' created by the alluvial deposits of the major rivers flowing into it. The 'knuckles of endless rock' in the west would correspond to the Himalayas and the Sinkiang. So when Mervyn imagined where Gormenghast might be, he drew – consciously or not – on geographical features of the area where he spent his earliest years.

In the mission hospital compound the young Mervyn inevitably spent much time with the Chinese domestic staff – amah, cookie, number one and number two boys, coolies and others. He got on with them well and retained some vivid memories of them, particularly

Ta-Tze-Fu, the cook, and 'the way he killed hens and peeled sticks' (*PP*, p. 478). He also played with the few other boys of about his age, both Chinese and European. Once he went to the 'fantastic, tawdry gaudy muddle of a flat' where a 'particularly dirty' Russian boy from his school lived with his father. On another occasion, on his way to a polite tea party in the same part of town, he saw the boy climbing up 'an enormous Venetian blind . . . and whooping' (*PP*, p. 474). He rather admired such lack of inhibition.

A rare glimpse of Mervyn is provided by Andrew Murray, also the son of missionary parents, who became a well-known painter of greeting cards.[3] 'We used to play together, climbing trees and along the compound wall. Mervyn was always very kind and friendly to me, though I was much younger. One day he found me drawing a ship sailing through the sea. I had drawn the waves with curved, rounded tops; he suggested they would look better with pointed crests. Ever since I have put pointed tops to waves when I draw them' (*MPR*, 1980; 11: 7).

This neatly characterizes Mervyn (as well as Andrew Murray, with his wry humour): his unfailing kindness, even as a small boy, his artist's eye and his ability to communicate his way of seeing. At this time, too, according to Laura Beckingsale, a teaching missionary and frequent companion of the Peakes in Tientsin,[4]

> Mervyn simply drew, all the time. He hardly ever looked up from the table. A most extraordinary little boy. And then his mother wanted to clear the table . . . and he was most indignant, when he had to take [away] all these scraps of paper on which he was drawing. And the moment tea was over he was back there again with them. It was difficult to get him to bed simply because he stuck to this drawing.
> (Batchelor, p. 11)

He was reading for himself, too, and in the shade of the crown-of-thorns tree in the compound he discovered *Treasure Island*, which he enjoyed so much that he learned much of it almost by heart (*PP*, p. 477). In later years the family invented a game: one of them would quote a line from *Treasure Island* and the others had to identify the

speaker and the circumstances. Otherwise Mervyn was not a scholarly child and never distinguished himself at school. In the books that reproduce his handwriting, such as *Captain Slaughterboard*, or his typing, such as *Letters from a Lost Uncle*, his spelling is erratic and he invariably misplaced the apostrophe in such contractions as 'don't'.

In Tientsin he attended the grammar school in the British Concession, riding to it on a donkey at first and later on a bicycle. In Mervyn's memory it was as out of place as the houses in the compound, 'horrid and ugly among the sweetstalls on the wide road'. For him its windows shouted, 'I know I'm ugly, and I like it.' Most of the teachers were women, but there was 'a sprightly devil-may-care sort of man who took Latin, whom we could see the headmaster and his lady staff thought too flippant' (PP, p. 474–5). He particularly resented the irrelevance of its teaching to the life he was living: outside the rickshaws would rattle by in the street while he was trying to remember the name of the longest river in England. And when you've been on the Yangtze, the longest river in England is a mere trickle. In fact England itself 'was as faint and far as the echo of a rumour', as he put it later (PS, 2007; 10: 3, 3).

One day, while riding to school, he put out his hand to stroke a camel. A coolie intervened just in time, and for ever after Mervyn could hear the sound of those teeth as they met where his hand would have been. The potentially fatal nature of such an accident is recalled when the eponymous Mr Pye offers a horse some fruitdrops: its lips 'curled back to reveal two rows of such dreadful yellow tombstones that Mr Pye withdrew his hand at once' (*Mr Pye*, p. 23). The relief that Mervyn felt remained with him, too; as a grown man, whenever he felt the need for a little humour he would bring the camel into the conversation, ordering camel stew at a Lyons Corner House or saying, to a couple who had just given him directions in the street, 'Oh, if I'd known, I would have brought my camel.' Camels also crop up in his drawings and nonsense poems.

Living so close to the hospital where his father worked, Mervyn was inevitably confronted with some of the more uncomfortable realities that are usually hidden from children: suffering, sickness, disease and death. In his notes for an autobiography he describes

one case that, from what I have seen in Dr Peake's reports, was undoubtedly unique but not untypical. A girl who had been picking melons was brought in with black bands all over her body as a result of snake bites. To help her breathe she was given a tracheotomy, but she was so frightened that it took two girls to hold her down. As she struggled, the little tube in her throat kept popping out of place, which caused her to make terrible noises. It would appear that she survived, however, and thanked everybody afterwards very cheerfully. Others were not so fortunate. They would come in with bullet wounds inflicted by the roving bands of armed brigands (mostly deserters from the army) or with horrendous injuries caused when their pigtails or loose clothes were caught by the unfamiliar machinery that was now being imported. The railway alone was responsible for numerous accidents: the Chinese would leap off moving trains, expecting to land on their feet, and end up with multiple fractures. Others lost limbs while resting from the heat under railway wagons that suddenly started to move. Mervyn would be spared nothing of the sight as they were brought in on wheelbarrows or in makeshift hammocks slung from poles. Nor did he seek to avoid it. On one occasion he surreptitiously witnessed his father amputating a boy's leg and then, as the limb was carried off, fainted and fell to the floor. The fall was memorable: it apparently inspired a scene in *Titus Alone*. Dr Peake described the case in detail in his annual report and again in his memoirs; it also features in Mervyn's very first publication.

He was a reader of *News from Afar*, a monthly magazine for children issued by the LMS; it contained edifying anecdotes and news from missionaries in the field, stories, games to play and exhortations to collect more money for mission funds. In the early years of the century there were frequent contributions about the lives of missionaries and their children; Lonnie once featured in a piece about 'LMS Children in Central China', next to last in a line-up of ten toddlers photographed in Kuling in the summer of 1907. The second decade of the century saw few such articles (so there is no corresponding photograph of little Mervyn), but monthly competitions were instituted. Owing to the long time-lag between publication and the receipt of responses from children in

distant parts, participation was at first limited to children living in the British Isles. At the end of 1921 this restriction was lifted, and in May 1922 'Uncle Jim's postbag' contained entries from three new 'nieces and nephews', two in China and one in Canada. Presenting them, Uncle Jim committed a dreadful *faux pas*: 'Mervyn Peake is another new niece who belongs to a famous missionary family. She is ten and likes drawing. Some day Mervyn must send us a picture for *News from Afar.*'

The May issue will have reached Tientsin two months later, in time for Mervyn's eleventh birthday. Did he write to protest? Uncle Jim did not print a correction, but in November he reported, 'Another nephew, Mervyn Peake of Tientsin, is coming home to England to go to school. He sends me a nice letter about three Chinese boys in his father's hospital in China. Mr Editor will please print the story and the picture which Mervyn drew to go with it.' Mr Editor was happy to comply and printed them both on page 172 under the title 'A Letter from China by Mervyn Peake'. (Both the letter and the rather scratchy little sketch that accompanied it, depicting three Chinese boys on crutches in front of the hospital building, are reproduced in MPMA, p. 25.)

This was the first thoroughly juvenile production to appear in *News from Afar,* and we may wonder whether Uncle Jim was really influenced by its modest quality – did he wish, perhaps, to make amends for his blunder?

After this, Mervyn must have continued to enter the monthly competitions – or at least one of them – for he won first prize (which was any book, selected by the winner, of a value not exceeding 4s 6d) in June 1923. The subject for Seniors (ages eleven to fifteen) was to 'write, in not more than 400 words, an account of your favourite incident in the life of David Livingstone, or any other African missionary, and add a small drawing in ink to illustrate any part of the story'.

Mervyn's second publication, 'Ways of Travelling', appeared in the same periodical in January 1924. A beautifully finished piece (reproduced in facsimile in MPMA, p. 26), it describes in words and drawings the numerous means of transport that he had experienced,

from bullock cart to motor car and from sampan to steamer, ending with his own two feet and a sketch of a running figure. Apparently the donkey he rode to school used to gallop like mad.

I have not been able to ascertain how or why this piece came to be published or the precise date of composition. Uncle Jim made no comment, nor does it derive from a competition subject; the theme, however, was a favourite with *News from Afar*. According to the caption, 'Ways of Travelling' was written when Mervyn was only ten and a half, which is just the time when the competitions were laid open to all readers, but it was not printed until he was twelve and a half. The 'Letter from China' was signed 'Mervyn Peake', but both the competition entry and 'Ways of Travelling' were signed 'Mervyn L. Peake'. To me this would suggest that 'Ways of Travelling' was submitted only after Mervyn went to boarding-school, where names and initials take on particular importance. At day school in Tientsin he would have been plain 'Mervyn'; at Eltham College it was the initials 'M.L.' that distinguished him from his brother, his father and his uncles who had preceded him there. In this case, then, his age as printed on the article would be anomalous.

It was at this time, too, no doubt encouraged by seeing his work in print, that Mervyn wrote his first short story, 'The White Chief of the Umzimbooboo Kaffirs', about a boy called Hugh Silver – the name echoes *Treasure Island* – who is separated from his parents during an attack by Hottentots and rescued by the Umzimbooboo Kaffirs, whose chief he becomes. Ultimately, he is reunited with his parents in England and goes to Eltham College which, he adds, he thoroughly enjoyed (*PP*, p. 44).

The title derives from 'The White Chief of the Umzimvubu Caffres' by Major-General A.W. Drayson, which appeared in twelve instalments in *Everyboy's Annual* in 1885, a copy of which must have fallen into Mervyn's hands. In Drayson, ten-year-old Julius has been brought up in India, the son of a major in 'the old East India Company'. As his family felt that he 'could not be properly educated in that country', he is sent back to school in England. But he is shipwrecked on the coast of Africa, in what is now the Transkei, close to the Umzimvubu River (usually called St John's River today). All

the male passengers are slaughtered by the local Caffres; Julius survives because, with his curly blond hair, he is taken for a girl. (How reassuring for little Mervyn that such a mistake could preserve the hero's life!) Ultimately he becomes the leader of the tribe, and only after several years does he return to England.

Mervyn's story dispenses with the shipwreck and opens in Africa, where Dr Silver cries to his wife, 'We must get him to England, for he gets no education out here!' But thereafter Mervyn shows considerable independence in his writing. His hero may learn to throw a spear the same distance at the same target as Julius, but the story itself owes little to Drayson. Furthermore, Mervyn's is told in the third person, whereas Drayson's is a first-person narrative.

Mervyn showed excellent taste in choosing this story as a springboard for his own. Quite apart from fortuitous reflections of his own life, it happens to be much better than the run-of-the-mill serial in nineteenth-century boys' magazines. The details are authentic, and Drayson, who spent many years in Africa, was an experienced storyteller with a wide range of interests. Moreover the story is memorable; it stuck in the mind of Howard Spring in particular. He refers to it – or at least to the Umzimvubu Caffres – several times in his own writings, both in his autobiographical fragment *Heaven Lies About Us* (1939) and in his novels *Dunkerley's* (1946) and *These Lovers Fled Away* (1955).

It is not known exactly when Mervyn wrote this story; it was either on the long voyage back to England or soon after his arrival in 1923. For return the family did. Mrs Peake's constitution had been undermined by the typhus infection of 1914, and, according to her husband's report to London in February 1922, she suffered from 'pain, palpitation, fainting condition, weak and irregular pulse, etc.' Furlough was granted, and they left Tientsin on 16 December 1922, two days after the arrival of Dr Peake's successor at the hospital, a Dr E.J. Stuckey. On 31 January 1923 they were back in England for good: by the end of their furlough they had decided not to return to China, and Dr Peake resigned from the LMS.

So during the first eleven years of Mervyn's life he spent just

twenty-nine months in England. Returning to China at the age of five and a half, he would have but vague memories of his earlier life there; things would seem strangely familiar at the same time as new. It would be much the same when he returned to England at the age of eleven and a half, with his infant memories of that country. This mix of familiarity and novelty can be found in Gormenghast, when Titus, Dr Prunesquallor and Flay are tracking Steerpike through the maze of twisting passageways into 'a world unfamiliar in its detail – new to them, although unquestionably of the very stuff of their memories and recognizable in this general and abstract way' (G, p. 372).

In this respect, Mervyn was one of Kipling's 'twice-born', inhabiting two very different worlds, and for a time each was the centre of his existence. Eric Drake, whose personal history was not unlike Mervyn's, called it 'a personality with a dual background, English and Chinese, the former mainly conscious, the latter mainly unconscious, but neither of them entirely so; sufficient grounds for bewilderment at times but not schizophrenia' (MPR, 1977; 4: 6).

As China receded into the past, the lack of continuity between the two worlds gave Mervyn a sense of dissociation. In his notes for an autobiography he made several attempts to define it. It was not that his childhood in the hospital compound seemed far away, nor that his memories were confused or dimmed by the ever-widening gap between the present and his Chinese past. It was rather that there was no thread, no link between them. His memories seemed not to be a part of him, not his own, as though they were rather 'glimpses of some half-forgotten story in a book, or a character from a long-lost book' (PP, p. 472).

This separation between his present self and memories of his past self made Mervyn liable to call the child he had been 'he' rather than 'I'. Using the third person singular like this makes the past self an object rather than a subject, something external to be examined in terms of 'it happened' rather than 'I did'. It turns memory into story. So I have little doubt that it was not by chance that in the following pages of notes there is no reference to himself (PP, pp. 479–87). However, the reader is left in some doubt as to whether Mervyn is reporting the memories of others – particularly Laura Beckingsale,

who would appear to be a major mediating consciousness here – or expressing his own memories in fictionalized form. As already suggested, this process of objectivizing a blend of his own memories and those of others contributed substantially to his fiction writing.

These China years were crucial, then, to the formation of Mervyn's imagination. When he came to write his novels about Titus, many of the furnishings of his mind were Chinese, and he transmuted them into the life of another person. As for his birthplace, Kuling, the family holidayed there in the summer of 1913, when he was too young for conscious recollection, and again in 1919. They all remembered it with great affection though; it was a place, as Mrs Peake put it, where you could not help feeling well.[5]

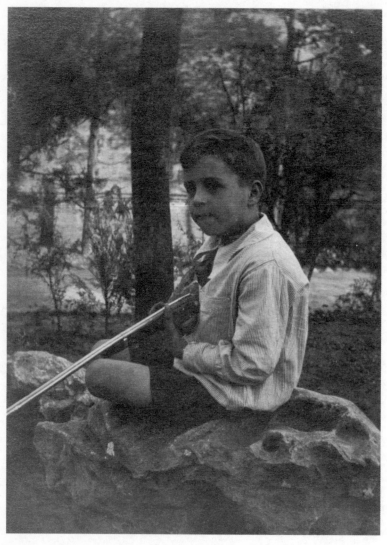

Mervyn Peake in China, c. 1919

PART 2

Education, 1923–1934

3
Eltham College, 1923–1929

WHEN the Peakes returned to England in January 1923, they rented a house called 'Abbotsbury' in the High Road at Mottingham while they decided about their future. It was convenient for Eltham, where Lonnie had been boarding since 1921 and where Mervyn joined him at once.

After Dr Peake had decided to retire from the LMS for the sake of his wife's health, he opened a general practice in well-to-do Wallington, Surrey, working from a large red-brick Victorian house called 'Woodcroft' in Woodcote Road. Having fourteen rooms, it accommodated a resident nurse assistant for Dr Peake and domestic staff, as well as the surgery.

> I will not swear that there was green and purple glass in the panels of the front door, under the pillared porch, but I think there was: at any rate, there were stone mullions, and finials here and there; and the general effect was comfortably pseudo-Gothic . . . When you came into the hall, the drawing-room was on the right. This also served as the waiting-room for the surgery, and adjoined a conservatory which was filled in summer by the leaves of a gigantic vine. To the left of the hall was the dining-room.　　(Smith, pp. 33–4)

A greater contrast with China could hardly be found, except that Mervyn's parents filled it with furniture and mementoes from

China, including a beautiful fawn-and-blue carpet that Dr Peake had bought in Peking – it was under his feet as he wrote his memoirs twenty-five years later – and a Moutrie piano from Shanghai, on which Mrs Peake liked to play and sing with her sons. 'Woodcroft' was to be home for Mervyn for a very long time, since he inherited it from his father and lived there with his wife and children from 1952 to 1960.

Going to boarding-school is a challenge for any boy. Coming from China, Mervyn had a lot to get used to – and a lot of learning to catch up on; he knew he was backward in Latin and Arithmetic. So the journey to the school and the signboard, 'To Eltham College', stuck in his memory; that and the dreaded moment when his parents drove away.[1] On the first night in 'A' dorm there came an awkward moment. too: after lights out Mervyn was talking to his neighbour when the door opened and a prefect came in. It was Lonnie.

'Who's talking?' he asked.

Mervyn owned up and was duly caned by his brother. But that was boarding-school life. Lonnie left at the end of Mervyn's second term.

Mervyn was actually quite fortunate in his school from what one can ascertain.[2] During the First World War it had declined as the younger staff left for the trenches, but now it was revived by the arrival of new and enthusiastic teachers, two of whom saw Mervyn's potential as an artist and defended him when his academic work failed to come up to standard: Matthew McIver, his art teacher, and Eric Drake, his English teacher.

McIver, or 'Mackie' as the boys called him, joined the staff in 1924, when a new Art Room was opened, and remained there until retirement more than thirty years later. 'On the first day, I dished out some drawing paper and told the [pupils] to do what they liked. Mervyn Peake did a drawing of a stable with a horse in it which was absolutely brilliant, and I thought, if that is the standard of art at Eltham College, they don't need me here' (Batchelor, p. 13). With McIver's encouragement, Mervyn spent as much time as he could in the Art Room. When he was sixteen his parents invited McIver to lunch in Wallington to talk over their son's future, and his

teacher frankly supported Mervyn's desire to be a painter. Not that his parents needed much persuading; it had been clear to them for a long time that Mervyn, who so loved drawing, would be an artist, just as Lonnie, who loved arithmetic, was destined to become a chartered accountant.

In Mervyn's final years at Eltham McIver again defended him, this time at a staff meeting:

> We'd all been discussing Peake's failure to work, and the Headmaster said: 'If that is so he'd better leave.' No question of his being 'chucked out', but he just wasn't working. And I remember I said, 'Well, you may be turning out one of our greatest future Old Boys.' And the Headmaster turned to me and he said, 'Well, if Mr McIver feels that, we'd better take a chance and keep him on another year.' (Batchelor, p. 15)

As it was, Mervyn left in the spring of 1929, without taking his school-leaving certificate, to study at Croydon College of Art. Art prevailed over academe.

The other teacher, Eric Sowerby Drake, was an Old Elthamian. Like Mervyn he was born in China (on 22 December 1898) where both his parents were missionaries, his mother a medical missionary. On leaving school he had enlisted, fought and been wounded on the eve of his nineteenth birthday; then he studied English at London University. Graduating with honours in 1921, he returned with his elder brother Burgess Drake to teach English at Eltham;[3] like a breath of fresh air 'they stirred the imagination of staff and boys and threw some doubts on the alleged virtues of orthodox pedagogy' (*The Glory of the Sons*, p. 200). They had adopted and adapted the 'playway' method of Caldwell Cook (the brilliant English teacher at the Perse School, Cambridge) which involved much creative writing, projects and individual assignments. Drake passed on to his pupils his great love of classical literature, English poetry – his nickname was 'Shelley-belly' – and, above all, drama; he was forever putting on plays of all kinds, especially Shakespeare, and this he did with exceptional artistry and competence. Indeed his interest in the theatre took him in

1927–9 to the Yale School of Drama as a Commonwealth Fund Scholar.[4] He was a romantic idealist who infected his pupils with his boyish enthusiasm for notions such as Art and Youth (with capital letters). He did not stay long at Eltham, but his impact on Mervyn was life-long, as was his belief in Mervyn's genius. 'What lies behind Mervyn', he wrote, 'is too big to be just a cult, or a protest, or what have you. It is the base of a surprising pyramid, a lotus with its roots in the primeval slime and its head in the sun' (letter to GPW dated 10 April 1977).

Drake's teaching was perfect for Mervyn, of course, calling as it did upon all his creative abilities. With his encouragement Mervyn spent a full year on a project called 'The Ilond Story' with another boy, writing and illustrating what must have been something like a cross between *Treasure Island*, 'The White Chief of the Umzimbooboo Kaffirs' and the as yet unimagined *Captain Slaughterboard*. It was Mervyn's drawings of horses ('a more exciting version of Chinese mules and donkeys') that alerted Drake to his genius, and he wrote and illustrated cowboy stories and poems. Sixty years later his teacher could still quote two of Mervyn's lines,

> In my broad-brimmed hat and my trousers of fur,
> Black Jim of the prairies!

For these cowboy drawings Mervyn was influenced by the illustrations of Stanley L. Wood in the *Boy's Own Paper*. In fact Wood became his secret god whose very signature was magic (*MPR*, 1979; 9: 15), and for several years Mervyn was happy to sign his own work 'Mervyn L. Peake'. His teenage taste was sure: Wood had 'lived for years on the plains of Western America. He camped, rode and worked in the cattle districts of Southern Texas and Southern California and virtually lived the life of a cowboy. All his rifles, pistols, saddles, cartridge-belts, horses, etc. were drawn from the real thing' (Doyle, *Who's Who of Boys' Writers and Illustrators*, p. 99); what is more, he had 'the reputation of instilling more movement and action into his pictures than any other book illustrator of the period' (Quayle, *The Collector's Book of Boys' Stories*, p. 142).

In a radio talk Mervyn confessed that Stanley L. Wood's illus-trations for a serial called 'Under the Serpent's Fang' made such a deep impression on him that twenty-five years later he could still recall them them down to the smallest detail: 'the stubble-chinned adventurer knee-deep in quicksands, his eyes rolling, the miasmic unhealthy mists rising behind him . . . the tendons of his neck stretched like catapult elastic and the little jewelled dirk in his belt' (MPR, 1979; 9: 15). Interestingly, not one illustration to this story corresponds to Mervyn's description, nor have I found one any-where in the *Boy's Own Paper* (or in *Chums*, for that matter, which was the other magazine that Mervyn and Lonnie used to read). I have no doubt that the illustrations were indeed so potent that he created one in his own mind, and in later years it was more vivid to him than the original pictures.

The one project that Mervyn carefully preserved was a 27-page series of illustrations to poems by Walter de la Mare that he executed in the autumn of 1927. Each page contains as many as four separate sketches, in a style reminiscent of E.H. Shepherd, the illustrator of *Winnie the Pooh*. Ten of the pages are reproduced in *Mervyn Peake: The Man and his Art*.

Eric Drake had another passion, rugby – he was 'a fly-half who swore like a trooper when damaged' (Smith, p. 29) – and Eltham was a great sports school; Eric Liddell, the Olympic sprinter and hero of the film *Chariots of Fire*, is their most memorable Old Boy in this respect. With or without these role models, Mervyn proved an excellent athlete; he played rugby in the First XV and one school holiday he joined a Kent team captained by Lonnie that toured Devon and Cornwall and acquitted himself extremely well. After leaving school he played for the Old Boys, although his captain, Billy Thorne, complained that Mervyn was so absent-minded about dates and times that he had to telephone Mervyn's mother every Saturday morning to make sure that he turned up (MPR, 1982; 14: 11). Another Old Elthamian, Leonard Whatton, remembered that 'Mervyn gave the impression of being languid, both in general and on the rugger field. This certainly deceived opponents. Then the true Mervyn would be revealed as he suddenly accelerated and broke

through their defences. He was particularly adept at touch-rugger, being so elusive and having such good hands' (*MPR*, 1982; 14: 14).

There was football, too, which Mervyn played seriously for the first time on Sark in a friendly match against Guernsey in 1934; his performance that day made newspaper headlines and has gone down in the history of the island. (See, for example, *Sark* by Ken Hawkes, pp. 130–1.) According to Eric Drake, he was so good at goal-keeping that he should have been a professional. With his tall, lithe figure he was good at jumping, too, a good hurdler. He is reputed by John Watney to have held the Eltham high-jump record for so long that 'it was only recently bettered' (p. 35), but *The Glory of the Sons*, which lists every sports exploit in the school, is silent on this one.

Of Mervyn's other teachers, Gordon Smith suggests that Dr Bakker, the French teacher from Leyden, may have 'influenced him, or caught his imagination for future use' (Smith, p. 29). John Watney suggests that the then headmaster of Eltham, 'Rabbi' Robertson, served as a model for Bellgrove, save that 'the character of Bellgrove . . . far outstripped the original model and became a "person" in his own right' (p. 40). However that may be, Smith observes that

> The Masters' Common Room, a shabby and inadequate place down the passage from the Central Hall, reappears in one of the Gormenghast books, as [Mervyn] used to glimpse it, skating past the half-open door: the petty squabbles, the anthracite fire, and the rows of shiny greenish gowns hanging from the wall.
>
> (Smith, pp. 29–30)

Smith, whose memoir I have been quoting, was born in China in 1907, roughly midway between Mervyn and Lonnie; his younger brother shared a desk with Mervyn in class, and thus they became acquainted. He, too, played for the Old Boys under Lonnie's captaincy, and as soon as Mervyn left school the difference in age was eclipsed and they became lifelong friends, exchanging numerous letters over the next thirty years. At Eltham, Smith had 'acquired a

reputation for amiable daftness and was given the unlovely [nick]name of "Goat" or "Goatie"' (Smith, p. 30), and it is by this name that I shall refer to him.[5] Mervyn, insensitive as ever to spelling, addressed him as 'Goaty'. His own letters he often signed 'Muffin' – a deformation of the Welsh pronunciation of 'Mervyn'. His family called him 'Merv'.

In his memoir Goatie gives a thumbnail sketch of Mervyn at Eltham:

> He was well liked: for his extravagant sense of humour, the general air of piratical gusto he exuded, his notoriety as an artist, and, no doubt, because he was a pleasant and sympathetic person.
>
> (Smith, p. 32)

His choice of words is most apposite. The word 'piratical' may be underlined; after identifying himself with cowboys, Mervyn moved on to pirates – more conventional, and derivative in Eric Drake's view – and in one of his early self-portraits he depicted himself as a pirate.

Overall, Eltham seems not to have left him with many memories. In fact, twenty-five years later he was appalled at how little he could recall of his schooldays. Just as the 'long summer holidays have left no trace', so 'long terms at boarding school' left him 'with less to focus on than the way the ink from a pen-nib can stain one's thumb, index, middle finger indelibly', with the result that he 'had to spend the first five minutes of each meal standing at the table' (*PP*, p. 474).

Floating islands; brush, pen and ink, c. 1933

4

Art Schools, 1929–1933

A CCORDING to the school archivist Mervyn left school in the spring of 1929 and spent the summer term at the Croydon School of Art, commuting each day from Wallington.[1] He always thought of himself, first and foremost, as a painter, and in his day the only true place to be trained as a painter was at the Royal Academy Schools; so he applied, was admitted provisionally for the autumn term, passed a test on 17 December 1929 and was finally accepted to study for the Diploma, a five-year course.

I suspect that he was rather disappointed with the Royal Academy Schools, as the curriculum consisted mainly of copying paintings, or parts of paintings, with slavish accuracy. However, the discipline of close observation was precious, and there is no doubt that Mervyn's skill progressed rapidly, although it is not possible to assess how much may be attributed to his formal training and how much to his own ability to improve on his innate talent. From the start it was the human form that interested him most; the portrait and the figure study were his favourite genres (so in selecting works to illustrate this book I have given priority to portraits, of real and imaginary persons). Animal studies came next, with landscape in third place. His, then, was very much a representational art; only after he became ill in the mid-1950s did more abstract designs appear in his *œuvre* with any frequency.

At the Royal Academy Schools Mervyn could do the copying well

enough, but it was no outlet for his restless creativity. The journey by train up from Wallington to Victoria sufficed to set his mind going: he would make up little ditties around the names of the stations, punning on Streatham Common and Thornton Heath or simply delighting in the play of sound around a name like Norbury, as in 'Snobbery Norbury goes in for fobbery / Where every strawberry costs you a bobbery'.[2] He would also sketch his fellow passengers, becoming a connoisseur of the infinite variety of the human face and hand.

Throughout the period of his studies, he worked on numerous projects of his own. The first, or one of the first, was a long narrative poem, 'The Touch o' the Ash', which reads as though Edgar Allen Poe and John Masefield had collaborated on a rewrite of *The Rime of the Ancient Mariner* as a ghost story. An old sailor foretells the death of his brutal captain. Overhearing him, the captain hopes to ward off his fate by tossing the clairvoyant deckhand into the ship's engine-room furnace, but the sailor's ashes rise up and throttle the captain at the predicted hour. Told in the first person, with a frame narrator who reports the sailor's words, it is an accomplished piece of work for an eighteen-year-old, but it was not published until 1978, in *Peake's Progress*. The sea was a major theme for Mervyn in the early 1930s: his first published poem (titled 'Vikings' and printed in *Cassell's Magazine* for March 1932, p. 59) was also about sailors, and his image of floating islands dates from the same period. It punningly recalls Hokusai's famous engraving 'The Great Wave'; in Japanese the name for this genre depicting everyday life is *Ukiyo-e*, 'pictures of the floating world'.

In 1930 Mervyn told Goatie that he was planning to write an opera and needed someone to write catchy lyric tunes for it. The story – such as it was, for Mervyn was well aware that plot is largely irrelevant to light opera – takes place in China: the Captain of the Guard falls in love with the Emperor's daughter. Caught wooing her, he is dismissed and becomes a bandit. Of course he takes the Emperor's daughter hostage and holds her up to ransom, threatening to execute her if the Emperor does not pay up. But the price he asks is too high, and she is faced with death at his hands. There was, naturally, to be a conventional ending in which all was resolved.

From the frothy verse with feminine rhymes and corny comparisons, it is clear that Mervyn was suffering from an adolescent attack of Gilbert-and-Sullivanitis, and no more was heard of the project. But thirty years later he did envisage an operatic adaptation of *Titus Groan* and *Gormenghast*.

Another project involved Goatie. While they were both students in London they collaborated on an illustrated book which Mervyn hoped would make them rich and famous. Here we find for the first time a characteristic in Mervyn that was to amplify over the years: he would get excited over a project, invest great hopes in it and be vastly disappointed when it failed to come off. This pattern climaxed in the mid-1950s when he placed excessive hope in his play *The Wit to Woo*; the shock of its singular lack of success seems to have precipitated his fatal illness.

In his collaboration with Goatie, Mervyn was the illustrator and Goatie the writer. The inspiration was joint:

> He had always been a great creator of monsters, even at school, fantastic creatures that took on an immediate life of their own. Some had long limp necks, some ears like a lynx, some pudgy toes, some incipient wings: but they were not merely amalgams, and their expressions hinted at deeper things . . . We discovered, in our childish way, that they could be even more easily evoked if I first supplied a nonsensical name and a rhyme . . .
>
> The Dusky Birron was a rather special case, for he became the hero of a book which we created together. We made up the story in consultation, as we went along; I did the actual writing of the story; and Mervyn supplied the map and the drawings. (Smith, pp. 34–6)

Readers of *Peake's Progress* and *Writings and Drawings* (and more recently MPMA, pp. 36–41) will have seen some of these creations, as well as drawings for *The Three Principalities*. This was an alternative title for *The Dusky Birron*, which tells the story of a Sailor-Man who is marooned on an island; the Birron undertakes to show him the three principalities on it. The first two, Soz and Foon, are very grand, having 'Semper Soz' and 'Floreat Foon' as their respective

mottoes. 'Cheerio Chee' sums up the third. There are echoes of China (which is perhaps inevitable since the two young men had both spent their childhoods there), echoes of their reading and anticipations of *Captain Slaughterboard*. They got as far as submitting the book to the publishers Chapman and Hall, who turned it down, and they never finished it, but at the end of 1931 Mervyn was still promising Goatie that Woolworth's shelves would soon be groaning with toy Birrons (for he was already into spin-offs and merchandising), while Marks and Spencer would have the sole right to sell Subas and Pleekas (see Smith, p. 46). And for years afterwards Mervyn's letters to Goatie were punctuated with allusions to the fabulous creatures they had invented.

The Dusky Birron and the ephemeral light opera are the only two works – whether realized or merely envisaged – by Mervyn that make specific allusion to China, and they are the two most closely connected with Goatie. In his independent writings, particularly the Titus books, Mervyn generally eliminated all reference to China, deleting the Chinese word *wonks*, for example, from the manuscript of *Titus Groan* at the point where he was describing the starving dogs that hung around the hovels of the Bright Carvers at the foot of the walls of Gormenghast. This ensured that his stories gained in universality by referring to no specific time or place.

In the summer of 1930 Mervyn and Goatie took a holiday together in France. For Goatie foreign travel was an abiding love, Africa, Italy and France being favourite destinations; he took many parties of schoolboys to Venice, for example. But this trip stood out in his memory and when, in 1976, I invited him to contribute a reminiscence to the *Mervyn Peake Review*, it was this episode in his friendship with Mervyn that he chose to recount. With slight revisions it forms Chapter 1 of his memoir of Mervyn.[3]

Goatie's account of that trip – their stay in Paris and walking in the Puy de Dôme – evokes all the carefree insouciance of those days and the playful lightheartedness of their relationship. It also provides a unique glimpse of Mervyn the art student, familiar with painters from Botticelli to Velázquez and prepared to debate their respective merits.

Alongside his studies at the Royal Academy Schools Mervyn was already carrying out commissions. Starting with invitation and greetings cards drawn and lettered for his parents, he moved on to various jobs that Dr Peake found for him among his patients. One of the first was to decorate the walls of a room that was to serve as a nursery in a house in nearby Heathdene Road, Wallington. He covered them with animals, elephants, giraffes, lions, rhinos and the like. They were just right for children – about 60 centimetres (two feet) high, with their feet on the skirting board – and seem to have met with approval for they were still there when the house was sold in 1944. Thereafter Mervyn made a habit of painting on the walls of the flats and houses that he lived in.

According to John Watney, Mervyn was less successful with his first commissioned portrait: 'the result was an almost complete "nightscape" in which the sitter appeared to be coal black. It was with some difficulty that Dr Peake persuaded the irate customer to accept the painting and pay up' (Watney, p. 45). Another commissioned portrait, painted in 1932, made the young actress Monica Macdonald (whose family lived only about a hundred yards from the Peakes) look like a Modigliani, or so she thought.[4] These early portraits are extremely difficult to trace; if they are like Mervyn's later work, they share a characteristic with his descriptions of characters in his novels: they show a person's beauty at the same time as having a touch of the grotesque.[5] The only people that Mervyn Peake depicted, whether it be with his pen, his pencil or his brushes, wholly without an element of grotesque exaggeration at some point or another was Goatie, his wife Maeve and his children – and there are exceptions even to these. Right from the start Mervyn Peake had a eye for the grotesque. No one is perfect, no one wholly beautiful – and, we might add, thank heavens it is so, for it would be unbearable to live with a perfect being, just as perfect beauty is not human; our affection for one another feeds on imperfections. Mervyn fastened upon lovable shortcomings of form and character and enlarged them, not out of mockery but out of playfulness; it was the way he saw the world. As he wrote in his book on drawing, *The Craft of the Lead Pencil*, 'there is a lot to be said for exaggeration; it is at least a

proof of having seen something worth exaggerating' (p. 12). This makes for wonderful reading in his novels, but it was not likely to endear him to people wanting flattering portraits. Moreover, Mervyn occasionally went too far, for his sympathy had its limits and his humour could be acerbic.

Satire is an appropriate medium for such a mind, and in December 1934 and January 1935 he contributed several drawings, under the pseudonym Nemo, to a short-lived journal called *Satire*. One of them depicts a lecturer in what must be an art school saying to an audience composed entirely of grotesque figures, 'It will be my endeavour, ladies and gentlemen, to convince you of the miraculous beauty of the human body!' Another is closer to social criticism, the only instance of such a work by Mervyn that I know of, for although he had the mind of a satirist he had no interest in politics. (Cecil Collins, who taught beside Mervyn at the Central School of Art in the 1950s, could not remember him ever talking about religion or politics.)

Satire also printed a couple of verses by Mervyn, with illustrative cartoons, a combination that he did not practise often in print. One of them (reproduced in *Voice of the Heart*, p. 281) derides the traditional unkempt appearance of the artist, for Mervyn could be satirical at his own expense.

As a student at the Royal Academy Schools he experimented with his appearance, starting with flamboyant shirts and flowing ties, veering to a pinstripe suit, bowler hat and rolled umbrella some terms later, but as a rule he preferred to be casually rather than well dressed; photographs in *The Sphere* of 4 April 1931 show him in a long raincoat over a shirt, tie and woollen pullover; his trousers are the somewhat baggy tweed of the day, and his black shoes are well polished; he has a beret on his head – it was always pulled well down over one ear. At other times he indulged the exhibitionist in himself and provoked the very conservative inhabitants of Wallington by strolling down to the shops wearing a large floppy hat (PS, 1992; 2: 4, 19).

He was tall, 1.82 metres (six feet) when he held himself straight, but he tended to slouch. 'His hair was luxuriant and black, flowing back from a peak; and his eyebrows were heavily marked' (Smith,

p. 43). These features are particularly evident in a self-portrait painted around 1931, reproduced in *Mervyn Peake: The Man and his Art* (p. 30). At this time his eyes were not so deep-sunk; that seems to have happened in the mid-1930s, perhaps during his stay on Sark. He was an attractive figure, gregarious, high-spirited and humorous, and he had no shortage of girlfriends.

For a while he went out with an art student called Joan Jolly, who used to wait for him in the mornings at Victoria Station, and they would walk together through St James's Park to the Royal Academy Schools. They drifted apart when she moved on to the Slade School of Fine Arts. It is typical of Mervyn that she should have remained a faithful friend throughout his life; they met again on Sark both before and after the war; on the latter occasion he entertained her ten-year-old son, who was recovering from an operation, with drawings of fantastic animals. In Mervyn's last years, before he went into an institution, she sometimes came and sat with him at Drayton Gardens while his wife went out (letter to GPW dated 24 June 1975).

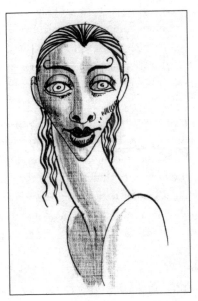

Fantasy portrait, from a letter to Goatie Smith dated 13 February 1932; pen and ink with crayon shading

He worked sufficiently hard at his studies to pass his annual examinations in 1930, 1931 and 1932. He entered for the 1931 Arthur Hacker Prize, choosing to depict a woman in an evening gown – the alternative to a portrait – for which he won first prize: a silver medal and £30. That same year he sold five paintings, making £12 on them, and he had a painting accepted for the Royal Academy's summer exhibition: a still life called *Cactus*. Very much in the style of Van Gogh, with the paint applied heavily, it was signed 'Mervyn L. Peake'. This was to be his sole exhibit at the Royal Academy.

Mervyn spent much of his free time wandering the streets of London, observing people and sketching them – what he called 'head-hunting' – the fruits of which can be seen in his illustrated article, 'London Fantasy'. Goatie writes:

> From the tops of buses, from circuses and foreign restaurants; out of a wild variety of lodgings and town houses and dance-halls, Mervyn took his spoils: little men with placards proclaiming 'The End is Nigh!', waiters in sleazy bars, grotesque but pitiful women saying goodbye at railway termini to fantastic men, or the gazelles and rhinoceroses and eagles of Regent's Park. On an old envelope from his pocket or on a sketching-pad he took them: strangely transformed, yet always real and convincing. (Smith, pp. 51–2)

Again, Goatie finds apposite terms: 'strangely transformed, yet always real and convincing'. Mervyn possessed an intuitive ability to apprehend something of these people's lives and to render it in his sketches. He was fascinated by 'the story that is told by the tilt of a hat, a torn sleeve, the stare that is out of focus, the humped shoulders', by the hidden and the unfulfilled life of every person who passed.[6] It is this sympathy that gives them their solid physicality, their 'is-ness', in his drawings.

Mervyn was full of ideas and projects; at one time he was going to make a book called *Head-Hunting in London*; before that there had been 'a series of articles for one of the London evening papers, to be called *Travels with a Zebra*'. He and Goatie were to travel around England with a zebra – where it was to come from

Studies made in life classes at the Royal Academy Schools, 1932

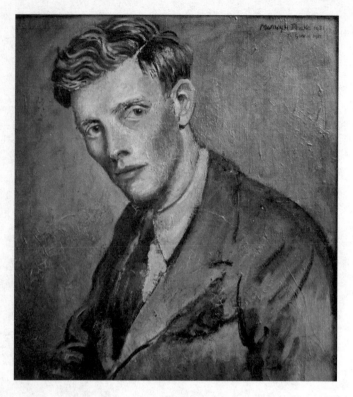

Portrait in oils of Goatie Smith, 1931

is not quite clear – and Goatie would write a commentary on their adventures while Mervyn provided illustrations. 'To Mervyn's disgust, the prosaic editor suggested that we should try a donkey' (Smith, p. 39).

Mervyn was not on the move all the time. He also enjoyed sitting in cafés, such as the Lyons Corner House and the Café Royal, sketching the customers, or fantastic creatures from his imagination, on whatever scrap of paper came to hand. Everyone noticed and commented on the peculiar way he held his pencil while drawing. 'Chimpanzee-wise' was how Goatie described it. Eric Drake saw it as Mervyn's adaptation of the standard Chinese way of holding a brush for writing and painting, and he quoted from a book on *Chinese Calligraphy* (Methuen, 1938) to make his point:

The finger-grip required for the brush is hardly suitable for the pencil; Mervyn invents his own finger-grip, but retains the essential position of the wrist, which 'must be held level; that is to say, the small bone on the outer side of the wrist must not incline towards the table'. Mervyn's apparent awkwardness gives the pencil something approximating the fantastic sensitivity of the Chinese brush, which is like the needle of a seismograph. (MPR, 1977; 4: 7)

Mervyn loved the pencil as the instrument of his art, comparing it with the keyboard of the pianist; both permit a wide range of tones. The pencil can go from the palest grey to the darkest black – 'Hell in a cedar tunnel', as he put it.[7] The pencil can also produce very fine and delicate lines or thick and violent ones; it is a medium of a thousand moods, from the most delicate to the most violent. And he exploited the whole range that his instrument was capable of.

People used to notice Mervyn's hands as they held his pencil in their characteristic manner; 'long and sensitive, but not without knuckle; and the left one carried a silver ring set with a large, almost vulgar, green stone: a malachite which he had been given by a friend of Dr Peake' (Smith, pp. 43-4).

In Soho coffee houses and cafés he joined his fellow students, discussing life and art and artists. Bill Evans, the portrait painter, who stayed only a year at the Royal Academy, was one of these; he encouraged Mervyn to do his own thing, go his own way.[8] Small groups of these students used to get together and persuade the café owners to allow them to mount exhibitions of their work. With two others, Mervyn put on a show in a café called Au Chat Noir in Old Compton Street, where there was plenty of wall space for paintings.[9] They sent out a hundred invitations to the private view, and seven people of any importance turned up, one of whom was Jacob Epstein; Mervyn was to meet him again later. Another significant visitor was the art critic of the News Chronicle, which had a wide circulation in those days. He brought in a photographer from Wallace Heaton's (the Bond Street photographic shop) who took a picture of the painting that Mervyn thought was about his best to date – or so he told Goatie (Smith, p. 46). This was a portrait called The Chef,

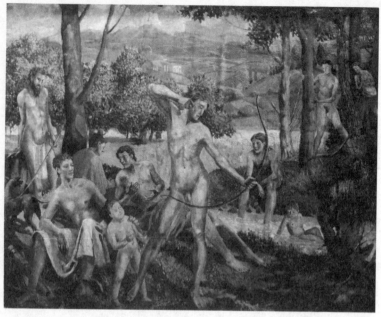

Echo and Narcissus, Mervyn's unsubmitted entry
for the Gold Medal competition; oil on canvas

and, according to John Watney, the photograph was printed in the *News Chronicle* (Watney, p. 49). Unfortunately he did not specify on what day it appeared, and, despite many readings of many issues, I have not found it. (As there were up to eight editions of the *News Chronicle* each day it may be that I have not had access to the right edition.) It would have been very interesting to discover whether this chef in any way anticipated Swelter, the loathsome chef of Gormenghast.

Shortly afterwards, between December 1931 and January 1932, half-a-dozen students calling themselves the 'Soho Group' put on an exhibition at the Regal Restaurant in Greek Street. This was a more polished affair, on the first floor, with forty-two paintings and drawings, of which twelve were by Mervyn, including the *Cactus* priced at twelve guineas.

This was immediately followed by a third exhibition, this time by the 'Twenties Group', so called because they were all in their twenties,

at the Wertheim Gallery at 3/5 Burlington Gardens, from 3 to 23 January 1932. Alongside three of Mervyn's paintings, *The Chef*, *Annie Tompkins* and a portrait of Goatie (which was apparently the most popular of his works at this point[10]), were works by Barbara Hepworth and Victor Pasmore. The following month the exhibition moved on to Worthing.

Besides exhibiting his pictures Mervyn was working away at his studies, preparing his Gold Medal entry: a 100-by-125-centimetre (40-by-50-inch) canvas depicting Echo and Narcissus. Then came a major source of distraction: Goatie heard from Eric Drake, who had returned from the United States and was announcing his intention of setting up an artists' colony on Sark. Mervyn wrote at once to tell Goatie that he could count on him. 'Sark and the Birron indubitably go hand in hand, if not foot in foot' (Smith, p. 46). Together they visited the island in the summer of 1932. It was to have major repercussions throughout Mervyn's life and work.

Recumbent sow, reproduced from *Drawings*, 1974; conté, 1939

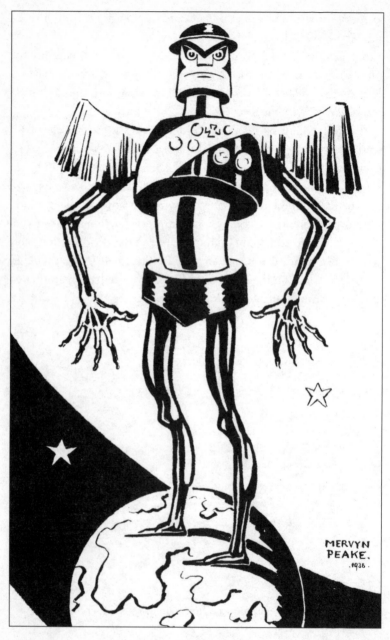

The Chief of the Ants, a costume design for the 1938 production of
The Insect Play

5
Sark, 1933–1934

SARK is a tiny island between Guernsey and Jersey, 40 kilometres (25 miles) off the coast of Normandy. A mere five kilometres (three miles) long and 2.5 kilometres (1½ miles) wide, its 5.45 square kilometres (1,270 acres) stand more than 90 metres (300 feet) above the sea, for it has precipitous cliffs on all sides. From the air it resembles two diamond-shaped pieces of land, joined together at the points. The larger, Great Sark, houses the harbour, the hotels, the minute prison that looks like an overlarge cabin-trunk, most of the houses and, especially, the Seigneurie, the home of Sark's hereditary seigneur or lord. Not part of the United Kingdom, Sark has its own government, laws and customs, acquired in 1565 by royal charter. Little Sark, with few houses and an abandoned silver mine, is joined to Great Sark by the Coupée, a narrow spine of rock some 90 metres (300 feet) long and equally high. Before the Second World War the track across it was mere gravel; today it is a cement path. No motor vehicles are allowed on the island; until recently all transport was horse-drawn, but now tractors pull the cart-loads of visitors and their luggage up the steep hill from the harbour.

Sark has excellent literary antecedents: Victor Hugo visited it to acquire background material for *The Toilers of the Sea*, and a cave is named after him; Swinburne wrote the 'Ballad of Sark' while staying at the Dixcart Hotel; and Turner made a celebrated painting of the Coupée, as did William Toplis, who had no less than fifteen paintings

of the island accepted by the Royal Academy. Both he and Ethel Cheesewright were living there in 1932.[1] Eric Drake's ambition was to build on these antecedents and make Sark a famous centre for the arts. To do this he had first to gain the support of the Sarkese, who much resented the colonial attitude of English visitors and feared that his project would reduce the income they derived from serving morning and afternoon teas and hiring out boats. On the contrary, argued Drake; his gallery would draw a better class of tourist, and he invited all the islanders to join in the social activities (such as the evening dance-suppers that he planned) on an equal footing with the visitors and residents. In addition, he promised to put on an exhibition of local talent. That earned their approval, and he started planning. Ultimately Eric Drake was so well accepted by the Sarkese that they initiated him into their lodge, the Royal Antediluvian Order of Buffaloes.

His negotiations with the islanders were still in progress when Mervyn and Goatie visited him in the summer of 1932. At this point they were happy to spend their time exploring the island, with its windblown trees, grassy clifftops and dizzying views down to lonely bays where towers of rock rise from the boiling sea. This land-scape – and seascape – figures frequently in Mervyn's subsequent work. The second illustration in *The Rime of the Ancient Mariner*, for example, shows the stricken albatross with a particularly angular iceberg in the background. According to Eric Drake, that 'iceberg' is a stylization of the great rock off the coast of Sark, at the Grève de la Ville, which could be seen from one of the bedroom windows of his cottage. 'In fact, the great bird is going to fall down my east chimney – a seagull once did, but an albatross–!' (MPR, 1977; 4: 5). Such stacks of rock also appear in Mervyn's illustrated nonsense poems.

One of the great temptations of Sark, once you leave the culti-vated 'plateau' and make your way down a precipitous path to a bay, is to climb the cliffs. Being granite, they do not crumble; being old, they offer numerous small handholds. Many are the stories of Mervyn's climbs, with or without a fledgling cormorant in his pocket. Goatie was with him on one of the first, when they found themselves in difficulty. 'I still do not know how we got up the face,'

writes Goatie. He reached the top first, and Mervyn scorned his offer of help. 'He was now facing outwards, looking down over the sea far below, with his arms spreadeagled behind him. All I could do was stay still, and watch. After long, agonizing minutes, he inched his way to safety' (Smith, p. 42).

Down in the bays there is also the fascination of picking up flotsam and jetsam. One year a dead whale was washed up, and Mervyn collected several bones from it which he kept for the rest of his life as ornaments. They apparently inspired his 'Reverie of Bone', written during the war. The dead whale figures odorously in *Mr Pye*.

When they returned to London after this invigorating break, Mervyn thought increasingly of returning to Sark and joining the projected community. He often met Eric's wife Lisel who was studying at the Slade School of Fine Art in London, and she kept him up to date with news. He passed it on to others, in particular Tony Bridge, who had come up to the Royal Academy Schools at the early age of seventeen in 1931. He was much impressed by Mervyn, who was four years his senior and seemed already to be an established artist. In later years he remembered him as 'bubbling with life' and gifted with 'an uproarious sense of humour' (MPR, 1976; 3: 32). Tony and his girlfriend Brenda Streatfeild agreed to go out to Sark with him the following summer and help found the colony.

In the autumn of 1932 Mervyn was given a most unusual commission: to design the costumes for a small repertory company's production of *The Insect Play* by the brothers Capek, an allegory of modern materialism that was translated into English at the end of the 1920s and enjoyed a vogue in the early and mid-1930s. Costume design is very different to painting and drawing, being three-dimensional among other things. That apparently posed no problem for Mervyn; he had already done some sculpture, to judge from a photograph in Watney's book (p. 51), and his designs were a great success. The play was performed on 25 and 26 November at the Tavistock Little Theatre.

The delightful prospect of returning to Sark distracted Mervyn from his studies; during 1932–3 he was present at only half his classes with the result that he failed his examinations at the end of

The Sark Gallery, which Eric Drake conceived and
Mervyn helped to build

the summer term in 1933 and his studentship was terminated. His
Gold Medal painting, *Echo and Narcissus*, on which he had worked
so hard, was never exhibited. (A few years later he used the back of
it to paint a picture of Maeve with a white cat climbing on to her
shoulder; see p. 132.) With his friends he hastened straight off to
Sark where the gallery designed by Eric Drake was taking shape.
Work on the foundations had been started as early as March, but
the actual building of the L-shaped structure, with its curved roof
echoing the shape of the prison across the lane, was carried out in
the summer in just seven weeks. The harmoniously proportioned
exhibition room featured natural lighting, cleverly channelled
down by a canopy-like inner ceiling to illuminate the walls with a
steady light, ensuring that glazed pictures could be viewed without
any unwanted reflections – an idea that Eric Drake owed to the prin-
ciples of stage lighting developed by Stanley McCandless of the
Department of Drama at Yale. Mervyn adopted it for Cheeta's room
in *Titus Alone* (p. 182).

The young artists helped build the gallery and, at Eric's request,
each completed a painting 120 centimetres (four feet) high and 180

Mervyn's painting of Sarkese playing darts can be seen to the right of
the staircase (which led up to his studio) in the Sark Gallery

centimetres (six feet) wide. These large canvases were hung on the
end walls on either side of the doors. Mervyn's depicted old Sarkese
men playing darts in a pub and can be seen in postcards of the
gallery in 1933, with avant-garde furniture from Heal's in the fore-
ground. On the other side of the door was Brenda Streatfeild's
painting, depicting a Sark fisherman looking down over a bay with
the small island of Brechou in the background; Tony's, depicting a
group of figures with the cliffs of Sark in the background, and
Lisel's, an island funeral, were at the other end of the room.

They all must have worked hard, at both building and painting,
for by the time the gallery was opened by the Dame of Sark, Sibyl
Hathaway, on 30 August, everything was ready, except for some
finishing touches such as the concrete on the spiral staircase in the
middle of the gallery.[2] In the exhibition there were thirty-two oil
paintings (of which eight were by Mervyn), nineteen watercolours
(eight by Mervyn), twenty-eight pictures in black-and-white (seven by
Mervyn) and four pieces of sculpture. In addition to *Darts* Mervyn
showed paintings titled *Orchard*, *Spring Song* and *Tiger, Tiger*: 'a

thing of dark trees, slumbrous shadows and wicked green light with, as centrepiece, a vivid yellow tiger' which, according to the *Guernsey Advertiser & Weekly Star*, 'captured admirably the spirit of Blake's poem. All his work, more so his *Five Heads* in black and white, is touched with the same charm and artistry, so that it is not surprising to learn that he is considered one of the most promising pupils turned out by the Royal Academy Schools for some years' (2 September 1933). Heady praise, especially when one ignores the ambiguity of 'turned out' in that last sentence!

Mervyn's paintings were the star of the exhibition, which included works not only by the four founding members of the 'Sark Group' but also by Iain McNab (principal of the Grosvenor School of Modern Art in London) and his pupils, Guy Malet and Elizabeth Maynard, Elmslie Owen[3] and Janice Thompson.[4] The sculpture was by R.N. Field, who had previously exhibited only in New Zealand. The Gallery was international from the start.

That winter, while the other three returned to their studies in London, Mervyn remained on the island. At first he was lodged in 'a disused storage hut about 12 feet by 9 [4 by 3 metres] alongside the Bel Air Hotel and opening on to the main road', recalled Eric Drake. 'We stretched canvas over the dark tongue-and-groove interior, which made it lighter and suitably textured and more spacious-feeling' (*MPR*, 1979; 9: 6). Then, when the gallery was finished, he moved into one of the two studios under the roof, just at the top of the spiral stair that formed such a feature of the exhibition room. From the studio a door led out on to the flat roof of the building, which in turn led to the flat roof of the domestic wing. It was not large but perfectly adequate for an artist, his model and a pet cormorant (which had the nasty habit of leaving its droppings on Mervyn's canvases).

He earned his keep by working in the Drakes' garden and by selling pictures. He made some excellent portraits of the Sarkese, not always to the satisfaction of the sitter, however; one old man thought that Mervyn had made him look like a monkey. Sark itself was a permanent source of inspiration; the ever-changing light is particularly striking to an artist, not to mention the exceptional

The view from Mervyn's studio above the gallery on Sark, 1934

Cutting hay on Sark; oil on board, 1934

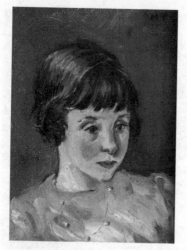 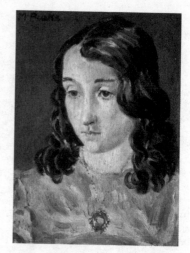

Portraits in oils of Barbara and Audrey Brown, Guernsey, *c.* 1934

variety of landscape. One of Mervyn's early paintings was a seascape showing the large rock called Tintageu; this was the name (modified to Tintagieu) he gave to the island's memorable sexpot in his novel *Mr Pye*. He painted so many that this may not be the painting that Goatie calls Tintageoue of 'a sweep of bay with high rhubarb-coloured cliffs. He had gone out one day to the bay so named, to paint: only to discover that he had left all his brushes behind. So he did it all with his palette-knife, impasto' (Smith, p. 42). Then, as he became better known, there were commissioned portraits. Sometimes these would be on Guernsey, and he would spend a week or longer there while he executed them. He also painted some of the Guernsey landscape and seascape, especially around Cobo (see p. 84), where he was commissioned to paint portraits of two sisters, Audrey and Barbara Brown.

This was Mervyn's first long period away from home since leaving school, and he began to affirm his separate identity and his freedom:

> He wore his hair long and flowing, had his right ear-lobe pierced, and wore a gold 'pirate's' ring in it. To this he added a cape à la Augustus John, lined with scarlet (and thoroughly enjoyed the

sensation caused among both down-to-earth peasants and fisher-
man and respectable middle-class residents).

(Eric Drake, quoted by Watney, pp. 58–9)

The 'pirate' earring caused endless comment. When Mervyn
went back to England on one occasion to play for the Old
Elthamians, the captain of the team wrote to Mervyn's uncle in
some concern. The latter was not to be moved and wrote back, 'If
you think he has persuasions which are not yours, don't worry.
Having sent him £25 for an abortion, I think you'll find all is OK'
(PS, 1992; 2: 4, 19).

Eric Drake recalled that in a pub one day a Sarkese made a com-
ment to the effect that Mervyn looked effeminate.

Mervyn put down his mug of beer, and quite leisurely strolled up to
the man and then let loose such an electric punch that it sent him
reeling across the pub and crashing to the floor on the other side.
Mervyn, still leisurely, apologized to the publican, finished his mug
and quietly strolled out. (Eric Drake, quoted by Watney, p. 59)

This is not the only occasion on which Mervyn is said to have
punched another man – calmly but most efficiently. Goatie quotes
two others in his memoir. Interestingly, all three relate to identity
and gender; at a student dance he punched a man 'who made a foul
remark about a girl' (Smith, p. 44), and he hit a homosexual who
invited him home for dinner and made a pass at him after the meal
(Smith, p. 56).

Mervyn may have been a little sensitive at this time, remember-
ing how 'Uncle Jim' had got his gender wrong, but a degree of sen-
sitivity about one's sexual identity was perhaps normal at his age. Be
that as it may, Mervyn surprised everyone by getting engaged to
Janice Thompson from Boston, Massachusetts, who was an early
recruit to the community. When Eric Drake asked him what he pro-
posed to live on, Mervyn said his father would have to make him an
allowance. Drake opined that he was more likely to do so if Mervyn
removed the earring, his surplus hair and his cape. Apparently

Cobo Bay, Guernsey; oil on canvas, 1934

Mervyn went home as he was, to be put straight by his father. A whirl-wind romance might have been acceptable in a far-flung place like Kuling – where potential life partners were exceedingly rare – but not in civilized Europe. Mervyn returned to Sark minus the earring, his hair freshly cut, but he rapidly reverted to his artist lifestyle. Janice, on the other hand, returned home and stayed there – years later she sent him a copy of a book of poems she had written.[5]

Straight after the first exhibition Eric Drake began advertising the gallery in *The Artist*, just a postage-stamp-sized reproduction of a painting and an evocative quotation, often from Browning. These intriguing advertisements brought in artists from Britain, the Continent and Canada, so Mervyn's life on the island could be cosmopolitan or solitary, as he chose.

One of the first to come, albeit briefly, was Stanley Royle, perhaps the most prestigious of the artists that Eric attracted to Sark. He did not, however, stay long, having ambitions in Canada.[6] Then

came Alfred Waldron from the Midlands. When he arrived, he said, 'Call me Pip', and everyone did. His particular gift was lino-cuts: 'The perfect balance of the black and white, the vitality of the figures, the texture, and the composition as a whole, is amazing,' wrote a critic after one of the exhibitions (*Guernsey Star*, 22 May 1934). For Eric Drake, 'he seemed to live in a world of fantasy that was private to him, if not completely autistic. I think we all felt his innate ability, but we also knew of his traumatic childhood; I hoped Sark would snap him out of it, but I guess it needed more than that' (letter to GPW dated 19 September 1977).[7]

Pip brought with him Alex Gannon – 'the two were hand in glove; I never tried to probe the relationship', writes Eric Drake. 'Once Pip had seen Sark, he could hardly be made to go back to Birmingham, yet Gannon could hardly be made to give up his business [also in Birmingham] and kick his heels in Sark. We solved the dilemma by taking Gannon on as "business manager", . . . keeping the books and looking after the transport of pictures, etc., [which] was a considerable relief to me' (letter to GPW dated 19 September 1977).

Then there was Frank Coombs, a good architect with ambitions to be a painter. 'He saved the top storey of the gallery from collapsing in the winter of 1934-5 owing to the builder having put in girders that were not listed as supporting their own weight over that span, let alone two studios and a 6-inch [15 cm] thick concrete roof' (letter to GPW dated 19 September 1977).[8] Eric Drake recalled that Frank 'fell for Tintagieu – the real girl – and was baulked by her reputation. Mervyn had fallen for her reputation and was baulked by the real girl. Not being serious, he rebounded; being serious, Frank didn't. They were not the first in either category' (letter to GPW dated 19 September 1977).

Right from the start of his venture Eric Drake had hoped that the Sark Gallery would make such an impact that a London gallery would want to put on one of his exhibitions, or at least a selection of works from one, and he pulled this off before the second season had even started: the Cooling Gallery, in New Bond Street, put on an exhibition by the Sark Group (which in this case included Janice Thompson, making five in all) at the beginning of May

1934. The *Daily Herald* wrote that 'their pictures are powerful, grim delineations of Sark characters. Old fisherman and farmers are portrayed just as they are, and the absence of pretence in the artists' nature and character studies is remarkable' (2 May 1934). Frank Rutter, writing in the *Sunday Times*, however, was severe with Mervyn:

> Why did Mr Mervyn Peake, who gave us a delightful and truly per-sonal landscape in his luminous Orchard, disappoint us so terribly in his portrait of a man in a chair, Hotton?
>
> The answer is easy. In the first picture, he was thinking only of the scene before him, of the fascinating design provided by the fruit trees; . . . in the second, he was thinking not so much of his sitter as of the paintings of Van Gogh. Fascinating as the work of this modern master may be, he is a dangerous model for a young painter. The slovenliness and carelessness which appear in some of his paintings are only excused by the genuine passion of Van Gogh's vision. To imitate his superficial mannerisms without his burning and artless temperament leads, almost inevitably, to mere affectation.
>
> (27 May 1934, p. 5)

There is nothing slovenly or careless about this particular portrait, any more than there is in any of Mervyn's portraits. On the contrary, it is a product of his customary careful observation of the sitter, especially of the man's hands. Hands always fascinated him; in the train, when the other passengers disappeared behind their newspa-pers, they unknowingly showed off their hands to Mervyn, who would sketch them until he could draw the human hand from memory in any position. Frank Rutter was none the less correct in identifying the influence of Van Gogh on Mervyn's work. The same point was made by Mervyn's son, Fabian, when he selected this very portrait to show to the BBC's television cameras in the 1998 *Bookmark* docu-mentary on Mervyn's life.

This portrait of J. Hotton was shown at the first exhibition of the second season at the gallery on Sark, along with a set of twelve animal drawings by Mervyn:

The simplicity of line and the extraordinary effect of movement which he has imparted to these lightning impressions won the unstinted praise of every artist present ... Polar bears balancing balls on their noses when Mervyn Peake draws them take on just that bearish note which makes one long to pat them every time they appear at a circus. Whether it is a dog or an elephant, the artist has the right intuition regarding each one, so much so that someone aptly remarked yesterday that you could almost smell them!

(*Guernsey Star*, 22 May 1934)

Mervyn always enjoyed the circus and produced numerous sketches and paintings of clowns and circus animals. This particular series was no doubt executed when Chapman's circus made its annual visit to Guernsey. This was the occasion when Mervyn had his right ear pierced; Brenda Streatfeild had both hers done at the same time, and they sat at the ringside afterwards with blood streaming from their ears.[9]

Brenda, 'a good artist and a very lovely person', was remembered by Eric Drake as 'uninhibited but unself-consciously so'. She lived with Tony in a barn on Little Sark, quite near the old barracks. They married in 1937. Tony was a most talented artist; at this first exhibition of the second season, he showed

some particularly good oil paintings, notably Portrait of a Boy and 'Sunrise', which, painted in Little Sark, where the cliffs are largely of blue granite, has a weird blue effect of light that is very striking.

(*Guernsey Star*, 22 May 1934)

Before ending the review, the journalist added 'a word of praise for the pencil drawings of Antony Bridge – his *Mrs Perrée* is most beautifully done'.

At this time Tony wore a full beard; this and his calm and gentle air won him the nickname 'Jesus Christ'.[10] So when Eric Drake, always ready for histrionics, organized a re-enactment of the landing in AD 596 of the first Christian monks on Sark, with all the members of his community taking parts, it was naturally Tony who played

Tony Bridge as St Magloire; kneeling before him is
Brenda Streatfeild, whom he married

a most convincing lead role as St Magloire. This was the Sark
Group's contribution to the various pageants on the island
celebrating King George's Silver Jubilee in May 1935, for which they
won the first prize.

Exhibition followed exhibition: during the second season, in 1934,
there were four in close succession, with work by the Sark Group and
up to twenty other artists at any one time. Mervyn remained a most
active contributor. He also returned to London several times, painting
a portrait of his brother's new wife, Ruth; it was unfortunately
destroyed during the war, when the Japanese overran Malaya where
Lonnie was working. The following year, however, tensions arose
within the community – Pip, Alex and Frank did not get along partic-
ularly well with Eric and Lisel Drake. Then Eric Drake's father died
and he spent the summer in England, leaving the gallery in the hands
of his wife and the manager, only to receive a letter from her to the
effect that he was *de trop*. . . . He returned in the autumn, and she left.

Mervyn claimed that his departure was caused by the Dame. An old man had died and was laid out in Sark's little chapel, with four tall white candles, his white beard spreading over the white cloth that covered him. Mervyn could not resist the temptation to draw it and slipped in during the night, only to be discovered and asked to leave (*PS*, 1992; 2: 4, 20).

Leave he did, although the precise date is not known.[11] Just as Kuling had been a remote haven for his parents, so was Sark for Mervyn. In later years he returned there when he could, drawn as much by the place as by his delightful memories of his time there.

PART 3

Making a Reputation, 1935–1939

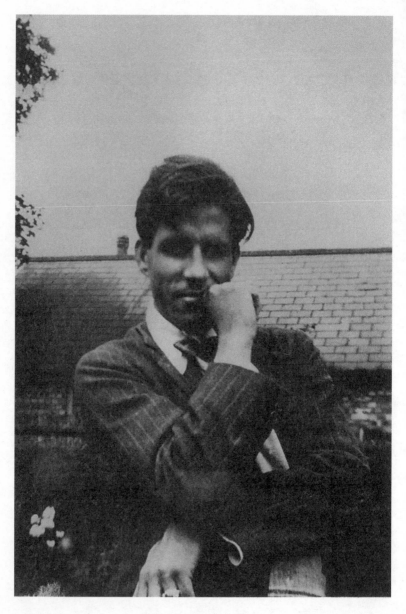

Mervyn Peake in 1934

6

Mr Slaughterboard, 1935

B ACK in England Mervyn picked up the threads of his old life:
living with his parents in Wallington and sharing a studio with
Bill Evans in London where he began head-hunting again. He
would stop people in the street and ask if he might draw them, using
an old envelope or cigarette packet if he had no pad to hand. Their
heads and postures remained in his memory, to reappear in the
books he illustrated in the 1940s. He would sit in his favourite cafés,
the Lyons Corner House and Au Chat Noir, not just sketching the
customers but writing as well. In Sark he had concentrated on paint-
ing and drawing; now he returned to his poetry and prose, and Bill
Evans saw him less and less often in the studio.

About this time he began a novel, or a novella, called Mr
Slaughterboard. The precise date of composition is not known, but
he had finished writing before he met Maeve Gilmore in the
autumn of 1936. The story comprises just three chapters, having run
itself on to the rocks. First published in Peake's Progress and hitherto
neglected by critics, it is a significant work for our understanding of
Mervyn as an artist and writer. But, first of all, the story: it intro-
duces the grotesque sea captain Mr Slaughterboard and his equally
grotesque crew aboard the Conger Eel. (As John Watney pointed
out, this was a familiar name for the Congregationalist church to
which his parents belonged.) By the end of Chapter 1 the ship has
run aground, impaled on a point of rock in the middle of the ocean.

Chapter 2 consists of a flashback: some three years previously, the crew had captured a 'Yellow Creature' – not described in the text – for Mr Slaughterboard; since then it has become an accepted part of the crew, a kind of mascot on board the *Conger Eel*. The brief final chapter records the captain's stoic reaction to the shipwreck and ends with a two-word paragraph: 'The Silence.' To me it sounds like a frank confession of what happens when a writer cannot get his story going and gives up on it.

Next, we might note the continuity between this story and 'The Touch o' the Ash', written six or seven years before: both captains are quick-tempered, bloodthirsty tyrants, given to persecuting their crew: Bully Shad, the skipper in the narrative poem, has his men flogged to the bone and tosses a clairvoyant deckhand into the engine-room furnace; Mr Slaughterboard reduces his crew of about forty to a mere seven hands by sacrificing them to the sea, lopping off heads when his orders are obeyed too slowly and organizing fatally dangerous games for the survivors. Compared with 'The Touch', *Mr Slaughterboard* may be seen as a regressive step, owing some of its inspiration to various characters in *Peter Pan*, including, of course, Captain Hook.

The second chapter of the story anticipates the picture book about the Yellow Creature that Mervyn produced a couple of years later, *Captain Slaughterboard Drops Anchor*, containing illustrations in place of most of the words. Some of the characters, including the captain himself, remain almost unchanged: in *Mr Slaughterboard* one of the sailors has such long arms and such short legs that he could scrub down the deck or pick something up from the ground without even bending, just like Billy Bottle in *Captain Slaughterboard Drops Anchor*.

Looking ahead to later works, the image of Mr Slaughterboard sitting in his library chair on a raft at sea is exploited with variations both in *Rhymes Without Reason* (1944) and *Letters from a Lost Uncle* (1946). The closed society of the ship, dominated by its captain and peopled with grotesques, anticipates Gormenghast, the castle being as isolated as any ship in mid-ocean. There are also motifs and incidentals that crop up again in *Titus Groan* and *Gormenghast*. Like

Lord Groan, Mr Slaughterboard loves reading and solitary reflection; he has a magnificent library which he allows no one but his servant Smear to enter. Even the burning of the library is evoked – as a hypothesis: they would still live, the captain supposes, if his library were burned out.

In the library are volumes of plays by Elizabethan dramatists covered in vellum and volumes of Dickens bound in red-leather. These reflect something of Mervyn's own tastes: Marlowe's *Tamburlaine* was a favourite and he had committed long passages of it to memory; Dickens's novels were a lifelong source of pleasure. In *Mr Slaughterboard* the moment when the dwarf, Shrivel, stands on the table and brushes Smear's hair to a gloss inevitably brings *David Copperfield* to mind: the dwarf Miss Moucher is described by Dickens and memorably illustrated by Phiz, standing on a table, brushing and combing Steerforth's hair which she has treated with oil. This, however, is about the closest Mervyn came to borrowing from Dickens. Subsequently he allowed him to be a stimulus to his inspiration rather than a source for it.

Two other references suggest something of the range of Mervyn's reading. There comes a moment when, staring down from his ship into the limpid sea, Mr Slaughterboard notices all the varied marine life below him 'and slowly he loved it' (*PP*, p. 79). This evokes the crucial moment in *The Rime of the Ancient Mariner* (which Mervyn was to illustrate a few years later) when the Mariner similarly looks down upon the sea creatures and 'blesse[s] them unaware'. Then the phrase 'the wilderness of the world' in the first line of Chapter 3 recalls the first sentence of *Pilgrim's Progress*. Significantly, *Titus Groan* is prefaced with a quotation from Bunyan. These may well be texts that Mervyn had encountered at Eltham, for there is little evidence of his doing much reading of classic works such as these once he had left school.

More relevant to our purposes here is Mervyn's choice of a pirate captain for his hero. That he had identified with pirates is already clear from his wearing a single earring and painting a portrait of himself as a pirate. Eric Drake may have thought that Mervyn's preference for pirates was less original, more derivative than the cowboys

of his schoolboy writings, but viewed from the perspective of origi-
nality and fidelity to one's inner voice it clearly reflects Mervyn's view
of himself. The pirate who lives at sea, outside society, a law unto
himself, is a far more compelling figure for an artist like Mervyn than
the law-enforcing cowboy.

Mervyn made his position clear in a discussion of *Titus Groan* on
the radio in the 1940s. Speaking of his experience of writing, he
claimed he felt intense excitement when he had a pen in his hand
and a clean sheet of paper before him, for at that moment 'no dic-
tator on earth' could say what word he was to write (*MPR*, 1980; 10:
8). This is an expression of total independence, and Mervyn culti-
vated this form of romantic autarky, encouraged no doubt by Eric
Drake's teaching. His determination to stand outside society is
reflected in Mr Slaughterboard, who had never been ashore and as
a result was terrified of land; similarly, he had once seen a picture of
a woman, and that had frightened him, too. Mervyn was aware,
however, that in the eyes of the rest of the world, who live on the
land rather than the sea, this could appear to be a sign of insanity.
Defending the notion of extreme individualism, 'in the Dickensian
sense', he observed that in the past people used to talk of 'a strong
personality', whereas now they spoke of a 'psychological kink'. For
him, a character like Gertrude, the Countess of Groan, would have
become neurotic 'if she hadn't allowed herself to have all those cats'.
People are neurotic, he opined, precisely because 'they're frightened
of walking down the street with fifty cats following behind them'
(*MPR*, 1980; 10: 12).

For the artist, this means being utterly faithful to his art. Rather
appropriately, *Mr Slaughterboard* is notable, for all its brevity, for its
comments on artistic integrity; there is also a debate about the writ-
ing and reading of books. In the opening scene the captain notices
that the ocean is 'the colour of a bruise' (the first appearance of a
favourite comparison of Mervyn's), and when the water is this par-
ticular shade of dark purple he feels it is hungry for drowned sailors.
So he decides, as a matter of conscience, to drown some that
evening. Clearly the captain's conscience, like his feelings for land
and for women, is the reverse of the average citizen's. What is more,

his conscience is aesthetic and will brook no denial. Its orders came to Mr Slaughterboard as imperatively as though a superior being or some inherent force were giving him orders, and they were the only orders he respected (or received). 'If ever I disobey the artist within me,' he swears, 'may my eyeballs turn to blood, and my tongue become a fungus' (PP, p. 69).

This is illustrated later in the story when the pirates are repainting the ship. The captain suddenly skewers Mr Joints to the mast with his cutlass. It is not so much that the pirate deserves to die for making geometrical patterns with his brush but, rather, that Mr Slaughterboard had realized in a flash that he should be hanging there by his neck, surrounded by his painted patterns. It was a question of artistic integrity. 'The effect justified the means' (PP, p. 82).

This extreme position in the sempiternal ends-versus-means debate, which was much aired in the mid-1930s – Huxley's *Ends and Means* was published in 1937 – is offered here as black comedy, but there is little doubt that Mervyn subscribed to an extreme position when it came to defending his art. In 1943 Chatto and Windus refused his powerful drawing of the figure of Life-in-Death for *The Rime of the Ancient Mariner*; he declined to offer a replacement and the book was published without it. In this case Mervyn ultimately won the day: thirty-five years later Chatto and Windus, recognizing the error of their ways, reissued the book in a handsome large format with the rejected illustration. This was an exception. In 1947 the Brewers' Society wanted Mervyn to move a tree in an advertisement that he had drawn for them, because, they said, its roots would undermine the walls of the adjoining pub; he refused, preferring to cancel the contract rather than to compromise his art.

This stance put him in a predicament: an artist has to live, and to live he must sell his work. If he remains faithful to his inspiration, as though a superior being were giving him orders, his work is liable to be at variance with the norms of the society he lives in and therefore hard to sell. The history of art contains abundant illustrations of this truism; great artists create a *post mortem* market for their *œuvre*. Wordsworth put it simply enough: 'The poet must create the taste by which he is to be judged.' This theme forms the plot of

Mervyn's play for radio, *A Christmas Commission*, that the BBC broadcast in 1954 (and repeated, after revision, as *The Voice of One* in 1956). *Mr Slaughterboard* is a case in point: neither an adult novel nor a children's storybook, it was written without consideration for its potential audience; it had no market. Much the same can be said of the three Titus books, which belong to no single literary category or genre; they are simply *sui generis*. Initially, they sold badly, but in the end they created their own market. Published in paperback at the time of Mervyn's death in 1968, they have remained in print ever since.

That Mervyn divined the secret behind such a process of forcing acceptance is suggested by Mr Slaughterboard's servant, Smear. He calls the captain's favourite books 'living passions' that lived as vigorously before he and Slaughterboard were born as they will long after they are dead. These passions are the creations of an eternal force, 'conquests of the spirit over the mutable' (PP, p. 74). This, we might conclude, was the perspective in which Mervyn wrote: for him, being faithful to his art meant tapping into something eternal.

The personal cost of such fidelity to art was enormous, not just in financial terms. Mervyn's stance required that the world be a benevolent place, willing to allow him to play the pirate in art. The shock when he discovered what Nazi Germany was doing to 'marginal' members of European society was very great. It also requires much courage to maintain such a stance; in any moment of self-doubt he could question the sanity of his chosen course – and lack of financial success made such moments uncomfortably frequent. Thus Mervyn's puckish humour was partly a mask; the tension between obeying the inner voice and composing with the outer world was tremendous, and it was a tension he was never to resolve.

Mr Slaughterboard is remarkable for dramatizing these very points through discussions between the captain and his servant Smear (in which they play roughly equal roles). Smear asks, for instance, whether there is any greater felicity to be found than in reading great books, to which Mr Slaughterboard can then retort: 'Nothing that I know of, yet I can imagine that to write such wonder must be the source of an enjoyment even more intense' (PP, p. 74).

The perils of disregarding the creative impulse are equally great; I have already quoted what would happen to the captain were he to disobey his artistic conscience. Where then, he asks, would the writers be if the world were to lose interest in books? And the terrible answer from Smear is 'in an asylum' (*PP*, p. 75). Writing, it would appear, is what keeps them sane; without it, their insides would rot. Considering that the asylum was precisely where Mervyn ended his days, these passages are chilling. Was it prescience, or does the act of making such statements help to create the conditions for their ultimate realization?

Turning now to the manuscripts of Mervyn's writings, from *Mr Slaughterboard* to *Mr Pye*, something that has struck commentators is the care he took with naming his characters (see Batchelor, p. 71; Watney, pp. 89 and 97). He would produce long lists of names, often with only small variations between them, until he found the sound or colour or association that exactly suited his purposes. And even then characters would change name as he wrote: Steerpike began life as Smuggerby, and Dr Prunesquallor ended up being called both Alfred and Bernard. Clearly, having the right name for the character was particularly important to Mervyn. According to Northrop Frye, 'In fiction the associative process ordinarily shows itself chiefly in the names the author invents for his characters' (*Anatomy of Criticism*, p. 277). So what do the names reveal of his associative processes?

In any novel there are three possible kinds of proper noun: those that already exist as such, like Cora and Clarice (for people) and Paddington (for places); those that already exist as common nouns and are promoted to proper-name status; and those that are invented by the author. In his stories situated in Sark or London Mervyn uses existing names; in both Slaughterboard books, as in the Titus books (including *Boy in Darkness*), he uses names of the second type for all but the principal characters (Titus, Lady Gertrude, Cora, Clarice and Dr Prunesquallor). Here Mervyn shows his affinity with Dickens, who was a great promoter of common nouns to proper-name status. Cower, Curdle and Cut, Dust, Dedlock, Fitz-Sordust and Gusher are all Dickens; Canvas, Chives, Crust, Sourdust, Flycrake and Spurter are from the Titus books.

Sometimes it is hard to tell the difference between them: compare Snagsby, Smuggins and Smuggerby, for instance; only the last is Mervyn's. Like Dickens, too, he enjoyed creating portmanteau names, most memorably in Prunesquallor and in Steerpike, whose name recalls Steerforth in *David Copperfield*. Dickens has Squeers, Pyke and Queerspeck; Squeertike and Queerpike are Mr Flay's variations on Steerpike's name in *Titus Groan*.

All these names are rich in associations with animals and vegetable matter and point to the way in which Mervyn envisaged continuity between the characters he created and all animate life – a 'grotesque' characteristic in the original sense of the word. To take just one name: like some predatory fish rising from the depths of the castle moat, Steerpike attempts to take over the 'steering' of affairs in *Gormenghast*, becoming even its Master of Ritual. He returns briefly to his natural habitat when he drowns Barquentine in the moat, and the floodwaters serve his purposes admirably when later he is being hunted. Numerous are the metaphors in Mervyn's writing which are literalized in this way, and there are moments when the reader is unsure whether to retain the literal or the figurative meaning, for Mervyn's metaphors work both ways; he compares trees with people and people with trees, for example. His novella, *Boy in Darkness*, is quite explicit in this respect: the demonic Lamb takes humans and transforms them into their animal counterparts. For all his similarities with Dickens, there is an underlying sense in Mervyn's writing that humans and animals are not so very different, and sometimes animals are more admirable than man.

Few names in his novels belong to the third category of entirely invented words; the main one is of course 'Gormenghast'. Eric Drake speculated that it might be Chinese in origin, since the first two syllables 'mean "every door", and "door" can stand for "house" as it can in English, e.g. "the people next door"' (*MPR*, 1977; 4: 9). It's a long shot. Let us return to Dickens and remember that Mr Peggotty swore that he would be 'gormed'. 'It appeared that nobody had the least idea of the etymology of this terrible verb passive to be gormed' (*David Copperfield*, Chapter 3). Gormenghast is something more than a portmanteau word; splitting it into 'gore' (and Mervyn

included the 'e' in his first spellings of the name), 'men' and 'ghast' (as in 'ghastly' and 'aghast') tells us no more than etymology in Dickens. It is the emotional aura that counts. Mervyn seemed to think that the name communicated the very spirit of *Titus Groan* (letter to Chatto and Windus dated 19 October 1940; *PS*, 1999; 6: 2, 7). Interestingly, Tolkien's 'Mordor' and 'Cawdor' in *Macbeth* share the same long vowel. Can we conclude that the 'or' sound is menacing to the English ear? It seems dubious, to say the least.

Yet attempts have been made to find universal significance in phonemes. When Ted Hughes set about inventing a language for the play he wrote for the twenty-fifth centenary celebrations of Persia, directed at Persepolis by Peter Brook in 1971, he drew out of his subconscious the sounds that he felt were most suited to basic actions and concepts. Tom Stoppard referred to it as 'the instinctive recognition of a "mental state" within a sound' (*Times Literary Supplement*, 1 October 1971). Hughes called both his play and the language he created for it 'Orghast', derived from his invented ORG, meaning 'life, being', and GHAST, 'spirit, flame'. For him, Orghast was 'the name of the fire of being'. Put 'men' in the middle of it and you get Gormenghast. Furthermore, in Orghast there was a close relationship between HOAN, meaning 'light' in Orghast, and a form of the verb 'to be'. Ted Hughes claims to have known little of Mervyn's work at the time.[1] Coincidence – or were they both tapping the same deep source (at least for English-speakers)?

Be that as it may, the play of light and darkness is fundamental to Mervyn's work, not least for their symbolism.

7
Maeve, 1936

IN London Mervyn experienced a further widening of his circle of acquaintance. He was naturally gregarious, equally at ease with the down-and-outs under the arches of Waterloo Bridge as with the aristocracy. Not being a great drinker, he was rather less at ease with the group of young poets, including Dylan Thomas and Roy Campbell, to whom Bill Evans introduced him: they spent rather too much time in pubs and at bibulous parties. Yet Thomas, who seems to have considered Mervyn as a fellow Welshman, did invite Mervyn to contribute to a travel book that he planned.[1] The project is poorly documented, unlike Thomas's anti-social habits. He 'would drop in unexpectedly at [Mervyn's] studio, usually drunk and homeless, to be sick on the floor and then spend the night on the couch' (Smith, p. 60). The one mention of Mervyn Peake in Fitzgibbon's biography of Dylan Thomas confirms that Thomas walked off with one of Mervyn's best shirts during his louche carousings in London, and Maeve prints a note in which Thomas begs to borrow one of Mervyn's suits for the day (Gilmore, p. 63).

Early in 1935 came an invitation that was to change Mervyn's life: Kirkland Jamieson, who was principal of the Westminster School of Art and who had seen some of Mervyn's work at a Sark exhibition, invited him to teach life drawing at the school as an assistant art master.[2] This was quite an honour; in those days such appointments usually went to much older men. He started in February 1935, teaching

Pencil drawing of Dylan Thomas sleeping – presumably after one of his
unannounced visits

for five hours on Mondays and Fridays and three hours on
Wednesday mornings, at five shillings and threepence an hour.
Mervyn proved to be a good instructor, and in due course his salary
was doubled (*PS*, 1991; 2: 2, 20–1).

He was remembered with unanimous affection by his students.
One of the first was Lady Moray, who considered herself an 'ignorant
and unskilled pupil'.

> I think it was in 1935 that I first met Mervyn at the school in West-
> minster where I was enrolled as a complete beginner in the life
> drawing class and he was one of the teachers.
>
> Looking back on it now, it seems pretty certain that Mervyn had a
> real gift for teaching, combining a passionate enthusiasm for his sub-
> ject with an extremely sensitive consideration for the feelings of his
> pupils. He was patient, incredibly generous of his time and attention,
> and never was I made to feel that my standard of talent was wanting.
> How lucky I was to have been one of those to profit from his teaching.
>
> As well as being my instructor at the school, Mervyn taught me,
> by visits to art exhibitions and galleries, so much about drawing and
> painting.

I had been living in Scotland in an atmosphere which was gener-
ally cultivated, even intellectual, but was not exactly conducive to any
interest in the world of the arts. Good books were acceptable, but
paintings and music not quite.

Through knowing Mervyn, therefore, my eyes were opened to
another world and this made all the difference to my pleasure and
happiness for the rest of my life, for which I shall always be grateful.
This took place in spite of the difference in our ages and the sort of
lives that we led and was entirely due to Mervyn's total unawareness
of and complete disinterest in any material values whatsoever.

(Unpublished reminiscence)

Lady Moray invited Mervyn to her house and Goatie recalled that

We went to the theatre with her on various memorable occasions,
and she was a charming hostess: though you never quite knew whom
you might meet. I remember her remarking that it was a pity Betty
couldn't come to tea after all, as she had a cold, and suddenly realiz-
ing that she was speaking of the (then) Duchess of York.

(Smith, p. 64)

Besides teaching and writing, Mervyn was as active as ever in
painting and drawing: both Lady Moray and the Duchess of York
bought watercolours from him;[3] he would go off and make drawings
of the animals in the London Zoo; and when he saw interesting
faces in the street – especially those of girls – he would invite them
back to his studio and sketch them.

Then, in the spring of 1936, he heard that the Little Theatre (by
Adelphi Terrace, off the Strand, the home of Nancy Price's 'People's
National Theatre') was going to put on the *The Insect Play*, and he
hastened to pull out his designs from four years before. Down at the
theatre he heard that a designer had already been engaged, but he
left his drawings there none the less. The following day a telegram
from Nancy Price informed him that his designs had been preferred.
They certainly contributed to the success of the play, which ran for
more than three months; one of Mervyn's designs was also used to

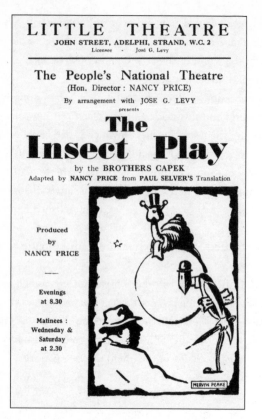

One of Mervyn's drawings used on a flyer
advertising *The Insect Play* in 1936

advertise it. *Theatre World* in its August 1936 issue printed several photographs alongside its review, saying, 'These illustrations convey some impression of the eerie fantasy and strange fascination of the costumes' (p. 93), and the great James Agate admitted in the *Sunday Times* that 'Mr Mervyn Peake's brilliant costumes could not be bettered.' Esmond Knight, who acted in the revival of the play, with the same costumes and much the same cast, in April 1938 at the Playhouse Theatre and at the Duke of York's in July 1938, commented that 'it's a tricky business designing insect costumes that look effective and are yet wearable. There are all those pinched-in and puffed-out bits that insects have. Mervyn had resolved the prob-

lem brilliantly. One could actually be an ichneumon fly and enjoy life' (Watney, p. 69).[4] The play met with little success on those later occasions; the shadow of war soured its satire.

However, this venture into the world of the theatre had several repercussions for Mervyn, the most long term of which were his own plays of the 1950s, both for the stage and for radio, from which he always hoped to make money, although he made only £15 from the Little Theatre's production of *The Insect Play*. An immediate effect was an invitation from Albert Arlen, who played an ant in the 1936 production, to design the costumes for a satiric comedy, *The Son of the Grand Eunuch*, which Arlen had adapted from a French novel by Charles Pettit. This had a brief run at the end of December 1936 and the beginning of 1937 at the Arts Theatre (where Mervyn's own play, *The Wit to Woo*, was put on in 1956). The oriental story gave Mervyn his first chance to show his knowledge of Chinese art, and he painted some pretty convincing dragons straight on to the costumes. His parents attended the first night, proud to see their son's work on the stage (Watney, pp. 70–1). It is

A costume design for *The Son of the Grand Eunuch*, 1936

strange that he did not design more often for the theatre, for he clearly had a gift for it.

In August 1936 a weighty literary periodical of the 1930s, the *London Mercury*, printed two of Mervyn's costume designs for *The Insect Play* - not photographs of the actors wearing them but the actual sketches he had made - and this led to a regular association with the journal which lasted until it ceased publication on the outbreak of war: at irregular intervals Mervyn drew portraits for them of leading figures of the day in literature and the arts. The first was Edith Evans, published in September 1936, and the last was James Bridie in April 1939. His portrait of the young W.H. Auden (February 1937) has been reproduced several times, and his meeting with Walter de la Mare, in order to draw him (December 1936), led to an enduring friendship. Not all his portraits were published; on 18 October 1936 he reported to Goatie that he had drawn Stephen Spender the week before and expected it to be printed in November. It never appeared. One wonders what it was like, since Mervyn had found him the most beautiful person he had met, as though he were Byron and Shelley rolled into one (Smith, p. 60).

In 1935 and 1936 Mervyn socialized a good deal with his students. They were, after all, but a few years his junior. Among them was Diana Gardner, who shared a flat with another girl in Campden Hill and they invited him to join them for parties with their friends. Now that he had an income, he took some rooms in Pimlico and invited them there in return.

So on the first day of the following academic year, September 1936, Mervyn had no hesitation about inviting a new girl he saw in one of the sculpture classes to go for a walk with him in the park. She was beautiful, blonde and perfectly formed. Blushing, she responded that she never went for walks and did not like parks. Finally she consented to have tea with him, though, and at the end of the afternoon she went down to the hall where he was waiting for her, wearing a very long, shabby, dark-grey mackintosh.

Here was the perfect Byronic romantic figure: jet black hair bursting upwards from a high forehead and a long, narrow face in which

were embedded bright blue eyes and sharply cut incisions on either side of a full, yet narrow and sensitive mouth. (MPR, 1980; 10: 17)

They went by tram to a Lyons Corner House, and by the time she went home that evening she was in love for life.

Maeve Patricia Gilmore was born on 14 June 1917, the daughter of an Irish surgeon who, after gaining his MD at Edinburgh (like Dr Peake), had set up a successful general practice in Acre Lane, Brixton, which was then quite an affluent area of London (so called because each house was built on an acre-sized plot). There he had married, late in life, a Miss Matty Carr, and together they had six children, three girls and three boys. He was a Catholic and all his children were brought up in the faith, the three girls going to convent school. He would have wanted all his children to become doctors, so it was only with difficulty – and the persuasive support of her mother – that Maeve obtained permission to study sculpture at art school. Up till then she had led a very sheltered life.

Thus it was natural to her, for her first date with Mervyn, to tell her mother's chauffeur Penfold to drive her to the address in Hester Road that Mervyn had given her by phone. It was an old warehouse that he had now moved into, just across Battersea Bridge and past a bus station. The chauffeur waited in the street outside while Maeve went in. Opening the door, she was confronted by a flight of stairs that had been painted chrome yellow, with vermilion banisters at the top. (Mervyn made a habit of painting the banisters, and a good many other surprising parts, of the numerous flats and houses in which he lived. In later years Maeve joined in, surpassing him in the murals she created for their house in Drayton Gardens. According to her, these stairs in the Hester Road warehouse became the stairs that lead to Fuchsia's attic in *Titus Groan*.) Climbing to the top, she entered what she remembered as the most beautiful and the most romantic place she had ever been to: a succession of unfurnished rooms, littered with paintings and drawings – and empty and half-empty milk bottles. By way of creature comforts there was nothing but an old chaise-longue before a hissing gas fire (Gilmore, p. 16).

Here their relationship blossomed rapidly, and Mervyn was soon as deeply in love as she was. Friends stared in disbelief; what, Mervyn going steady? That was something new. Not only was he going steady; he was painting and drawing for all he was worth. Maeve was undoubtedly the greatest single source of inspiration for his art. He drew her so often that it became almost a reflex; on one occasion, in the presence of Goatie, he made ten consecutive sketches of her, each drawn in less than a minute – and each one exquisite. (They are reproduced in Smith, pp. 92–4.)

Maeve has told her own side of their life together in her painfully moving memoir, *A World Away*. There she presents herself as incorrigibly nervous and shy, liable to be either tongue-tied on social occasions or to blurt out embarrassing platitudes. Other people saw her differently, for she usually behaved with a composure, dignity and charm that completely masked her shyness. This poise, allied with her beauty, gave her an air of serenity that contrasted markedly with Mervyn's nervous energy. Witness their very different behaviour on the escalators of London Underground stations: while Maeve would stand motionless, allowing the stairs to carry her staidly down into the depths, Mervyn would be sliding down the handrail with such speed that sometimes he could stride up the opposite escalator, waving gaily to Maeve as he passed, and slide down the handrail again, even faster than before (if that were possible), in time to take Maeve's hand as she arrived at the bottom with her customary elegance and grace. For Goatie, she had 'a Madonna-like composure, outwardly at least, that took her through all occasions; but behind this lurked a sense of humour, which was sometimes even (to Mervyn's great satisfaction) quite earthy' (Smith, p. 67). Thus she enjoyed his schoolboyish jokes, his pranks and his puns – as long as they were made in the right company.

Eric Drake had a similar point to make. For him,

Maeve was the best thing that ever happened to Mervyn . . . Isn't it odd that the very people who cry 'Gothic!' forget the 200 years that the troubadours dominated the poetic and musical scene, culminating in Dante's Beatrice by way of many a Tintagieu on the one

hand and La Princess Lointaine on the other, and they forget that when the reality and the symbol unite in one lady you have Abelard and Héloise – victims of the Gothic Gormenghast – or Mervyn and Maeve, who, happily, escape . . . but by what margin?

(Letter to GPW dated 19 September 1977)

They were a highly contrasting pair, the tall, black-haired man with the golden-blonde girl, and in their contrasts they suited each other down to the ground.

So Maeve got into the habit of visiting the warehouse in Hester Road – by public transport, despite the wolf-whistles of the drivers and conductors at the bus station, which she hated. One day in November, though, he was not there when she arrived. A kindly neighbour told her that he had been taken to the War Memorial Hospital in Carshalton, desperately ill. She hurried there by bus and found him cheerfully lying in bed. Taken suddenly ill at the art school, he had returned home to be examined by his father who, diagnosing acute appendicitis, had operated at once. 'But you mustn't stay,' added Mervyn. 'I haven't told my parents about you yet.'

It was time to tell them. Not that there was any problem with Mervyn's parents. If anything, they were delighted that their rather wild son (wild especially compared with Lonnie, now married and respectably earning his living as a chartered accountant in Malaya) had found such a nice girl. 'I think Mervyn's parents were very shocked after his return from Sark at the startling clothes he was wearing and some of the very strange girls he brought home with him,' commented Freddie Crooke (Watney, p. 69).

On the other hand, her parents, particularly Dr Gilmore, were not pleased: the boy was an artist, he had no money and he was not Catholic. Quickly it was decided that Maeve needed to spend six months abroad. Travel abroad was nothing new to Maeve; she had been to Spain with one of her sisters and, before that, to Fribourg in Switzerland (which, by one of those strange quirks of fate, is the nearest town to Donatyr, the village that Mervyn's Swiss grandmother came from). In addition, she was already taking lessons in German at a school in Bond Street, so it made good sense to pack

her off to Germany. She was to stay in a castle on the Rhine, Burg Hemmerich, and study art at a school in Bonn.

While she was away, Mervyn was busy, teaching two and a half days a week, executing commissions, doing his drawings and paintings, writing poetry and filling the rest of the time with writing letters and poems to Maeve. Of these early commissions, only two, the portraits for the *London Mercury* and a dust-jacket drawing for Longman's, came to fruition. For the others, he would do a drawing, or a series of drawings, and then the publisher would choose someone else's work (as in the case of *Sanfelice*, for Hamish Hamilton) or the project would simply fall through, as in the case of the illustrated walk through Wales planned by Dylan Thomas. In the end Thomas gave up the idea, finding good excuses for his failure to carry it out: 'Rhys Davies has just done it.'[5] For this project Mervyn spent Whitsun 1937 in the Rhondda valley, which was where Thomas's book was to end. This was close to Swansea, where Dylan Thomas was brought up, and even closer to Aberdare, where Mervyn's grandparents had spent their married lives.[6] During the three days he spent there, 'he slept on the wooden benches of doss houses at 4d a night and sketched the miners and their children' (*Daily Sketch*, 25 February 1939). The condition and the spirit of the unemployed miners impressed him deeply and inspired his poem, 'Rhondda Valley', which was published in the *London Mercury* for October 1937 with two quite uncharacteristic scraperboard illustrations, a medium rarely used by Mervyn. Was it the better to render the subject? At any rate, they rank among his least successful published works. It was also the only time that his writing suggests any kind of political awareness.

When I called the *London Mercury* 'a weighty periodical' I was thinking of the company that Mervyn was keeping. In the issue for October 1937 there were articles by T. Sturge Moore and Geoffrey Faber, reviews by William Plomer, V.S. Pritchett, Stephen Spender and Richard Church of books (in order of appearance) by Homer, George Bernard Shaw, Ella K. Maillart (the Swiss woman who accompanied Peter Fleming on his *News from Tartary* journey), Balzac, Forrest Reid, Edwin Muir, H.G. Wells, Frank Swinnerton

and Edith Sitwell. And I have listed only those names that are still familiar today, more than seventy years later. Then there were reproductions of works by Claude Monet, Reynold Stone, Modigliani and Van Dyke. Distinguished company!

The summer of 1937 saw regular publication of Mervyn's poetry, mainly in another respectable literary periodical, *The New English Weekly*, subtitled *A Review of Public Affairs, Literature and the Arts*. The first, on 13 May 1937, was 'Poplar'; a mere twelve lines long, it apostrophizes the tree of the title in lines as short as a single word, rather like paint-strokes, with little coordination. Like much of Mervyn's early verse, its structure may well owe something to the poetry of Dylan Thomas; it abounds with alliteration, assonance and consonance with hardly a hint at the characteristic voice of Mervyn's that was soon to emerge. This is probably why he did not choose to reprint it in any of the collections of his verse.[7]

It was followed on 27 May 1937 by 'The Cocky Walkers', a description of London's young men, smoking their cigarettes, whom Mervyn had glimpsed one evening at Clapham Junction, where he had a rendez-vous with Maeve.[8] Here we encounter for the first time Mervyn's richly figurative language in which he draws parallels between people and trees or people and animals (a characteristic of the grotesque), his wide range of vocabulary, including unusual and obsolete words, and his use of self-consciously 'poetic' terms which can be acutely embarrassing. The lines are frequently clotted and obscure, but every now and then there come moments when thought, feeling and expression fuse into a harmonious whole. In particular, as he observes London's 'wide boys', we find the correlative in words of his head-hunting, a strongly visual evocation of 'the little flower / ... / That lights the face that sprouts the cigarette / Into a sudden passion of fierce colour'. The tension between the visual and the verbal arts is quite explicit: 'Carved with a gaslight chisel, the lean heads / Cry out unwittingly for Rembrandt's needle.'

He evokes these same young men again in 'Sing I the Fickle, Fit-for-Nothing Fellows' (*Listener*, 1 December 1937). This time he calls them 'The empty-pocket boys who take no quarter, / For whom no childhood sings / And no hereafter rustles tremendous wings.'

Here the dominant sense is not sight but hearing, as in 'the yell / That rattles the round base of laughter's pail'. This deserves closer analysis.

One of the virtues of Mervyn's writing, both prose and verse, that critics have entirely neglected lies in the range of senses that he evokes. As an artist he might have been expected to express himself in primarily visual terms; instead he exploits all the senses. In addition to hearing in 'Sing I the Fickle, Fit-for-Nothing Fellows', there is also a strong physical sense, not just of subjective sensations and feelings but also of external objects whose qualities are apprehended through other senses. Thus we have 'cumbersome' clouds in 'Poplar', and in 'Metal Bird' (*London Mercury*, August 1937) he calls the sky 'thin'. It is a form of synaesthesia that Mervyn practises widely in his writing.

'Rhondda Valley', for instance, abounds in physical sensations and references to the human body rather than in the visual images we might have expected. The mines are situated in 'stiffen'd hills' where 'the rich cargo' of coal lies 'congealed in the dark arteries, / Old veins / that hold Glamorgan's blood.' Even those elements that relate to light are expressed in physical terms, either of gesture (so that 'swarming stars gesticulate like torches') or of parts of the body: the sunlight burning on the pit-head makes it look like a toothless mouth. Sound is introduced in the final lines of the poem, when the Welsh miners begin to sing. It, too, is expressed in terms that are physical rather than auditory, for they 'loose the Celtic bird that has no wing / No body, eye, nor feather'. Here Mervyn expresses nearly all his perceptions in language that relates to bodily sensations and to parts of the body. Sometimes his synaesthesia borders on punning, as in his next poem to be published, 'Coloured Money' (*London Mercury*, August 1937), in which he says that his eyes mint gold.[9] From the language of his verse, Mervyn might almost be taken for a sculptor rather than a painter.[10]

This, then, was the man who met Maeve at Victoria Station on her return from Germany at the end of June. He had grown greatly in confidence during those six months. There had been *The Son of the Grand Eunuch*, the book jackets, his visit to Wales, the published

portraits and the poems in which he had found his voice. His feelings
for Maeve were unchanged; hers for him the same. He proposed, and
they were engaged.

Unsigned and undated pen-and-ink portrait of Maeve

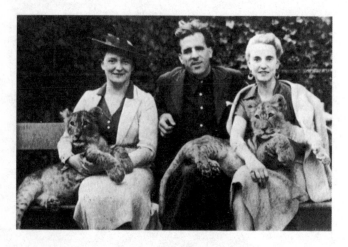

Maeve's sister Ruth Gilmore, Mervyn and Maeve
with lion cubs at Berlin Zoo

8

Engagement, 1937

THAT summer of 1937 Maeve's mother proposed a trip to the
Continent. She always holidayed there in her car, accompanied
by a van of furniture so that she could rent a house wherever she
pleased and enjoy the comforts of home, including her piano. This
trip was to be more modest, by car but without the van. There were
four of them: Mrs Gilmore, her daughter Ruth, who drove the car,
Maeve and her fiancé. From Antwerp they drove to Berlin, reaching
100 kilometres (60 miles) an hour on one of the new motorways.
There Mrs Gilmore photographed the trio at the zoo, with lion
cubs in their laps. They carried on to Vienna and then Budapest,
where Maeve noticed that the Danube was not blue, even when you
are in love; and back via Paris and its Exhibition, where Matty,
Maeve's other sister, joined them. Throughout the trip Maeve and
Mervyn sketched and painted, returning laden with tangible mem-
ories – for during her stay in Germany Maeve had switched from
sculpture to painting.

Back in London it was time to resume teaching, for Mervyn, and
studying, for Maeve. At the Westminster, Diana Gardner recalls,

Mervyn mentioned, almost in passing, that he was going to be married
in two months' time! And this was proffered by someone who had
been accepted as a kind of perpetual Don Juan! It was an equal sur-
prise to hear that the woman chosen was also a student at the

117

> Westminster – but not known to anyone in the Life Class because she worked quietly downstairs in Eric Schilsky's sculpture class, and no one upstairs had apparently either seen her or, least of all, seen Mervyn with her. A collection of students went down in the break to become acquainted. Mervyn shyly introduced them. Maeve Gilmore, in a linen smock, Roman sandals, and with her light gold hair scraped back into a knot and pinned, and with two-inch heavy gold earrings hanging from small earlobes, could be recognized instantly as an artist's archetypal human being, straight out of a Florentine painting.
>
> (MPR, 1980; 10: 20)

For the 'perpetual Don Juan', the challenges were to be great and the temptations frequent. Not only was Mervyn attractive to women, he was often in the company of students and artists.

Meanwhile the respective families began to prepare for the wedding, which was fixed for 1 December 1937 in St James's, Spanish Place. The date no doubt evoked fond memories in Dr Peake and his wife; it was after all on 1 December 1903 that he had left his station in Hengchow to marry her in Hong Kong. As for Dr Gilmore and his wife, St James's was where they had married, on Valentine's Day 1906.

It was not an easy time for Maeve. Her family insisted on a Catholic wedding and all that that meant, when she would happily have dispensed with any ceremony at all. Mrs Gilmore, who came from an agnostic family, had had to take the same step that they were requiring of Mervyn. If she had done it, he could, too.

This caused Maeve much heartache and distress. She loved her mother very much, and she loved Mervyn, too, and she had no desire to hurt either of them. So she could not understand why her parents should be so inflexible and hurt both her and Mervyn. The Catholics remained intransigent; the Congregationalists acquiesced. To Maeve it seemed that her family, through their compartmentalizing and lack of charity, may have won to all appearances but had ultimately lost (Gilmore, pp. 25–6). This problem was to arise again when her own children married non-Catholics forty years later.

Mervyn expressed his feelings in a poem beginning, 'How foreign to the spirit's early beauty / . . . / Are the tired creeds that can be so

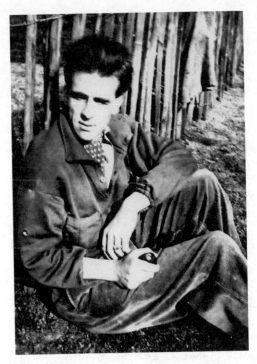

Mervyn Peake, mid-1930s

unkind.'[1] Tolerance seems to have come naturally to him, and at no time does religious belief appear to have played an important role in his life. He did not go to church, and he took a distant view of the Catholic faith in which his children were necessarily raised. Batchelor tells of an occasion when his daughter Clare, as a very young child, 'stole a grape and was so oppressed with guilt that she confided in her father who advised her, gently and wisely, to postpone the sense of sin until she was old enough to make her first confession' (Batchelor, p. 50). Furthermore, some of his lightest poems are parodies of hymns. In A Book of Nonsense, for instance, 'Jerusalem the golden' becomes 'Squat Ursula the golden / With such wild beauty blest' that old men are wise to take a rest; she 'can tire the young men too / Because her limbs are moulden / From honey, milk and dew' (p. 74).

That autumn the New English Weekly published an enigmatic poem of his called 'The Crystal'; it is the first occurrence of a motif,

'I could have kicked myself' from *Figures of Speech*, 1954

the smashing of a crystal or porcelain vase or globe, that was be repeated throughout his prose-writing and even illustrated in *Figures of Speech* (1954). Most of the occurrences (for example, Titus's christening, the end of *Titus Groan* and the death of the Thing) come at moments of major change, a point of no return. In the short story 'The Connoisseurs' two men break a Chinese vase in order to prove whether it is genuine Ming or not. 'The Crystal' may reflect something of Mervyn's complex feelings on his approaching marriage and on the physical relationship it involves:

> Hold her delicately,
> For she may break
> And shatter her beauty
> And wake
> The dead rose echo
> In man's heart no more –
> O never again!
> Hold her before the last
> And the final pain
> Bury the sudden splinter.

It ends with the command to hold delicately the shining thing, lest it slip from 'nerveless fingers' and smash 'on the stones of winter'. This closing word 'winter' is significant: Mervyn seems to have been particularly sensitive at this time to the passing of autumn into winter. The autumn of 1937 inspired him with two poems, both called 'Autumn', which were published in the *New English Weekly* the following year, along with another called 'Spring'. None of these poems appeared in the collections of his verse that were published in the 1940s, and never again do the seasons appear so prominently in his verse, although they are important in his novels, both for their structuring effect and for their symbolism.

Another poem, published as 'The Meeting at Dawn' on 30 December 1937 (the month of their wedding), was reprinted in *Shapes and Sounds* (1941), where it was called simply 'Poem'. Critics unaware of the date of composition, its personal significance and context have attempted to interpret it as a war poem! In reality it evokes all the magic of newly-weds waking in the morning to rediscover each other and question the limits of their own identities as they merge and separate. Mervyn was clearly very much in love.

About this time Mervyn showed Walter de la Mare his beautiful lyric 'To Maeve', beginning

> You walk unaware
> Of the slender gazelle
> That moves as you move
> And is one with the limbs
> That you have . . .

and de la Mare invited them both down to his house at Penn in Buckinghamshire. He was the first famous person that Maeve had met, and she was sick with anticipation at the prospect, but de la Mare and his wife proved kind and gentle, putting her at ease at once. They remained in contact for many years. Did Mervyn show his teenage illustrations to *Peacock Pie*? At any rate, it was probably de la Mare who got Mervyn to do a portrait of Ithell Colquhoun in

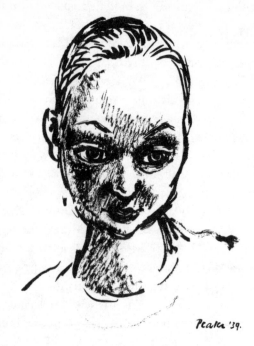

Ithell Colquhoun; brush portrait, 1939

1939, for he was an admirer of her work. In the early 1940s de la Mare encouraged Mervyn to submit a selection of his poems to Chatto and Windus; it was accepted and published in November 1941 as *Shapes and Sounds*, dedicated 'To Maeve'. He also sent Mervyn favourable comments on his illustrated books as they came out. In return Mervyn allowed de la Mare to reprint 'To Maeve' in his anthology called *Love* – more than seven hundred poems and extracts from poems and novels – that was published in 1943. Mervyn also put Goatie in touch with de la Mare as they had a common interest in the creative imagination, and they, too, corresponded while Goatie was writing his doctoral dissertation.

That autumn Mervyn worked on illustrations for a book by Eric Drake's brother, H.B. Drake – another commission that never came to fruition – and also on two works that were not for publication: *The Book of Maeve* and 'The Dwarf of Battersea'. The first was a

wedding present: a hand-made book, 18 inches by 12 inches, the front and back decorated with watercolour, containing a portfolio of his drawings and paintings of Maeve. The second was the delightful ballad that he gave to Maeve as soon as he had made a fair copy; she included it in the volume of Mervyn's nonsense verse, *A Book of Nonsense*, that she compiled in 1972. It tells of how a painter saves 'a maiden fair / With tawny eyes and tawny hair' from the attack of the vicious dwarf of Battersea who slithers through the letterbox into the house where she is sleeping. The hero, a caricature of Mervyn, runs him through with a paintbrush, and together they shut him in a tin of linseed oil and send him 'down the Thames afloat / Within a papier-mâché boat.'

The story is situated at No. 163 Battersea Church Road, an ex-barber's shop to which Mervyn had moved at the beginning of 1937.[2] It was no distance from Hester Road and only slightly more salubrious, being already condemned for demolition; it was finally pulled down in the mid-1970s. (The site is now beneath the glass mountain of Battersea, the Montevetro.) It was situated almost directly opposite the church of St Mary, where William Blake married Catherine Boucher in 1782. Mervyn believed – or at least he told Maeve, and John Watney repeated the story (p. 80) – that this was where Blake had his vision of the ghost of a flea, but this was not in fact the case. Still, Maeve was suitably impressed.

The wedding took place as planned, with Goatie as best man and very mixed feelings on the part of the two families. For Mervyn and Maeve it was the beginning of an extraordinary partnership. In the first years, being more socially experienced and at ease, Mervyn served as the interface between their public and private worlds. Then, as Maeve matured – she was a very young twenty when they married – they became more like equal partners in a team: she looked after the finances and the family, as well as painting and exhibiting in her own right, while he followed his inspirations into prose, verse and paint. In her memoir Maeve emphasizes Mervyn's inability to deal with practical matters. I suspect that he downplayed his competence, as part of his role as the artist and also as a result of the dynamic between them. Mervyn certainly deferred to her in

many things; his nephew Kit noticed how 'before he really let himself laugh he would look towards Maeve for some signal. He seemed to want the OK. It struck me then that he was a little subservient to her' (letter to GPW dated 15 November 1998). Certainly, when submitting work to Chatto and Windus in the early years of the war, Mervyn would send it first to Maeve for her approval. Then when Mervyn's health began its remorseless decline, less than twenty years into the marriage, Maeve took over entirely, nursing him, writing letters for him, negotiating contracts on his behalf and visiting him regularly in the mental home.

He was not always faithful to her, and when he strayed he would admit it if she asked him and be truly sorry for the hurt he caused. There were crises, but no other woman ever seriously challenged the place of Maeve in his heart. In the eyes of the world they were unusually loving and tender, respectful of each other's needs and feelings.

9
Married Life, 1938–1939

A FTER the wedding ceremony and the reception (which they would both have gladly forgone) at Mrs Gilmore's club, the Forum in Grosvenor Place, Mervyn and Maeve went down by train to the little village of Burpham in West Sussex to spend their week-end honeymoon in the house called Reed Thatch that Dr Peake had recently finished building for his retirement. It was a fine house on the banks of the river Arun, with views over the fields to Arundel Castle, which has been credited as one of the inspirations for Gormenghast.

They had planned to start their life together at 163 Battersea Church Road, but Mrs Gilmore had other ideas; an old barber's shop due for demolition was no place for her daughter. She found them a flat in Primrose Mansions, on Prince of Wales Drive facing Battersea Park, and generously equipped it, including some fine Irish linen. Two rooms were left unfurnished for their paintings. They moved in before the end of 1937, but they preferred something more in keeping with their lifestyle, and the following autumn they moved to two floors of a house at 49 Portsdown Road (renamed Randolph Avenue in 1939) in Maida Vale. It was rather run down, but the rooms were large and airy, and with what they saved on rent – at £90 a year it was £20 cheaper than Primrose Mansions – they could pay a charlady to come in and clean once a week. Their domestic arrangements were bohemian; by her own confession,

Maeve knew nothing of cooking, nothing of cleaning, and they frequently made Lyons Corner Houses their home from home.

One of their first visitors at Primrose Mansions was Andras Calmann, who had recently opened a gallery in St James's Place and was proposing to give Mervyn his first solo exhibition. He selected thirty-three drawings and twenty paintings and showed them from 4 to 26 March. The critics were puzzled by the mix of grace and the grotesque in Mervyn's work, but sales were good.

It was Maeve's first experience of seeing pictures of herself sold and carried off into the world, and it was a painful one. The first drawing to go had been made in intimate circumstances, and, in her mind, it belonged entirely to her and Mervyn. To think that it should go and hang on the wall in a stranger's house, to be scrutinized, discussed and debated, liked, or disliked, seemed inconceivable, a violation of their intimacy. She, too, had to learn that the artist must live and make concessions to the philistine world of land-dwellers.

For her, the exhibition was also overshadowed by the entry of German troops into Austria: the *Anschluss* was declared on 13 March and Hitler made his triumphal entry into Vienna the following day. Only two years before she had seen Hitler in a parade at Nuremberg and not taken him seriously. The Nazi salutes, which she had unthinkingly returned, had seemed like a charade. Suddenly the menace was real; a far cry from the drawings of monsters and designs for *Captain Slaughterboard Drops Anchor* that Mervyn was showing.

At this exhibition, the Peakes met the recently knighted Sir Edward Marsh, who had probably heard of Mervyn through the Contemporary Art Society, of which he was the prime mover.[1] He invited them one evening to his flat in Gray's Inn, and Maeve was much impressed by the number of paintings on the walls – and against them, stacked three or four deep. Thus they became acquainted with the most influential person in art circles at that time: Marsh was a Trustee of the Tate Gallery and the favoured proof-reader of Sir Winston Churchill and Somerset Maugham. So it is all the more intriguing to learn from Christopher Hassall's biography that about this time Marsh was 'working on some poems in manuscript by Mervyn Peake'.[2]

It would appear that Mervyn covered all the expenses of this exhibition out of his own pocket and made a small profit, on the strength of which he took Maeve over to Sark that Easter and introduced her to all the people he had got to know there, including Miss Renouf, an elderly woman who had taken him under her wing in 1933 and 1934. (The wing was almost literal, for she habitually carried a parrot on her shoulder.) Sark was still Sark, but the gallery was closed and Eric Drake elsewhere. He did not meet Maeve until the autumn of that year, when he came to London and Mervyn let him have the use of 163 Battersea Church Road for the remaining months of the lease. According to Eric, there was still a painting on an easel in there, so it is possible that Mervyn had continued using it as an occasional studio (MPR, 1979; 9: 7).

Was it in memory of those earlier, carefree days on Sark or just out of a passing whim that Mervyn grew a full beard and moustache that year? He drew a self-portrait, in which he looks distinctly worried, and then reverted to his customary clean-shaven appearance.[3]

Despite – or perhaps because of – the shadow of war they took a holiday in Paris that September and bumped into Leslie Hurry, who had been a student with Mervyn at the Royal Academy Schools.[4] He invited them to join him in a boarding-house in Montmartre, where Mervyn ran into trouble with the landlady for getting indian ink on the sheets and even on to the curtains (Watney, p. 83). There was no holiday from his creativity. It was then or shortly afterwards that he composed 'Watch, Here and Now' about Paris fashion models: 'From toe to tress they flaunt the season's pride / With a conscious self-assurance.' With a drawing by Leslie Hurry it was published in a women's magazine, *Pinpoints*, in May 1939. Another one, 'Au Moulin Joyeux', also illustrated by Hurry, appeared in *Eve's Journal* in July 1939: it records Mervyn's perception of the contrast between the 'September Crisis, 1938' of the subtitle, when Germany annexed the Sudetenland and precipitated the Munich crisis, and the women in the Paris café: 'Here with their burning flags / Of pride unfurled, / All women raised bright goblets to the world.' (These are the only pieces by Mervyn that were illustrated by another artist during his lifetime.)

The friendship with Leslie Hurry flourished for a while before the war separated them. He was then living up at Thaxted, and the Peakes' visit to him in June 1939 was the occasion of one of Mervyn's memorable pranks. They had gone to a pub for lunch and, while they waited for their meal in a spacious dining-room, Leslie went off to make a phone call and Mervyn took the opportunity to hide in a vast cupboard. Before Leslie returned, two very respectable old ladies came into the room. However, Mervyn thought the footsteps were Leslie's and made his appearance. Naturally the ladies turned to look as the cupboard door creaked open. Nothing in their education had prepared them to encounter such a cheerful bohemian with long hair and brightly coloured clothes as emerged from that cupboard, and the expression on their faces clearly reflected their astonished horror. It stuck indelibly in Maeve's memory (*MPR*, 1977; 4: 18).

For some time Mervyn had been reworking the central episode of *Mr Slaughterboard*, the discovery and capture of the Yellow Creature, and transforming it into an illustrated storybook for children with hand-lettered text, *Captain Slaughterboard Drops Anchor*. He fleshed out the story with a section on the weird and wonderful beasts inhabiting the Yellow Creature's island, derived partly from the menageries of *The Dusky Birron*, and solved the problem of the ending by taking up a suggestion from Goatie. (Ending his stories was always problematic for Mervyn.) By the autumn of 1938 he had found a publisher for it, Country Life.

To ensure that he got a fair deal he joined the Society of Authors in December 1938, quoting his profession as 'artist and writer', and submitted the contract to them in April 1939. Maeve would have us believe that Mervyn had no idea what interest meant, in the financial sense. To him it meant only 'to be interested' (Gilmore, p. 95). Other commentators, John Watney in particular, have echoed this opinion, stressing Mervyn's incompetence in money matters. Yet in his correspondence with the Society of Authors Mervyn comes over as perfectly clear-headed, not always well informed but well aware of the value of his work and determined to protect his interests, in both senses of the word; and not just on one

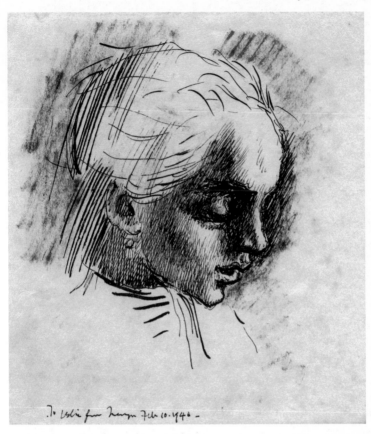

A portrait of Maeve that Mervyn gave to Leslie Hurry; pen and ink with
background shading in charcoal or crayon, 1940

occasion but repeatedly over a period of more than ten years. He
was surprised, for instance, by some of the clauses in the contract
for *Captain Slaughterboard Drops Anchor*. He had had the impres-
sion that the film rights would be his and nothing to do with the
publishers. What percentage, he wanted to know in a letter dated
27 April 1939, ought they to get in the event of the story being
sold to a film company? (As with *The Dusky Birron*, Mervyn was
already thinking of spin-offs and adaptations for the cinema,
nursing the hope that the Disney studios might be interested in
his work.) He consulted the society again over the royalties for

Ride a Cock-Horse in 1940 and over the contracts for *Shapes and Sounds* in 1941 and for *Titus Groan* in 1944. In the latter case, he was again concerned about possible film rights, and he wished to reserve the right to make an illustrated edition of the book at some future date when paper was better and more easily available (12 April 1944). Finally, in 1949 he questioned the Castle Press's claim to the exclusive rights to the illustrations he had prepared for a selection of Oscar Wilde's poems. In the event – possibly because he refused to relinquish his rights – the book was not published by them. So Mervyn may have been trusting, executing drawings before signing a contract, but he was certainly not blind to the financial and legal aspects of his relationships with publishers. As for interest, he knew what it was well enough to refer to the effect of poetry as being like that of compound interest (letter to Chatto and Windus dated 3 June 1941; *PS*, 1999; 6: 2, 22). Consequently, I echo the words of his brother Lonnie, who affirmed that Mervyn 'was not the impractical genius his wife would now have him be' (letter to GPW dated 19 June 1974).

Mervyn took great care over *Captain Slaughterboard Drops Anchor*, repeating the drawings time and again until he achieved the precise effect he desired. He also mischievously added details that only his family and friends would recognize. In the tattoos on the back of one of the pirates are portraits of his father, Goatie and himself, while Maeve – both name and portrait – figures on the left arm. She features in the story in another way, too: there is something about the Yellow Creature, for all its androgynous ambiguity, which is unmistakably Maeve – 'an affectionate transmogrification', as Goatie put it (Smith, p. 72).

Meanwhile, he was painting as hard as ever. Marriage did not put an end to his habit of stopping girls in the street and asking if they would sit for him. Maeve recalled that when she was still a young bride Mervyn regularly used the excuse that the girls had good bone structure, which made her feel less jealous of them (Gilmore, p. 18). Thereafter 'bone structure' became one of those private jokes that they enjoyed between themselves.

Mervyn loved to paint children, too. One day a little girl called

Patricia Herington was playing near to the Peakes' home when she fell and cut or grazed her knee. Maeve took her in to bandage it and Mervyn took the opportunity to paint her. She was ten or twelve years old and very excited to be a sitter, having never before seen a painter at work. Mervyn captured that feeling; she sits on a wooden chair in her red dress with her hands crossed in her lap, staring at us, wide-eyed and innocent, longing to know what the picture will turn out to be like.[5] Her parents were so impressed with the result that they sent Patricia's sister round to sit for Mervyn, too.

Maeve, of course, remained his most frequent subject. By the beginning of 1939 Mervyn estimated that he had already drawn or painted her more than 750 times. One of the most striking portraits, reproduced in *A World Away* (facing p. 33), depicts her with down-cast eyes, her hair swept back and triple pendant earring. More domestic ones include an oil painting of Maeve with a white cat (Moby Dick, no doubt; the Peakes always had cats, often several at a time) standing on her shoulder and uplifted arm, painted on the back of his unused Gold Medal entry. For some reason he took it off its frame and rolled it up, so that it was only discovered, at the back of a cupboard, at the end of the 1970s (see p. 132). As Maeve matured, Mervyn continued to be inspired by the fine form and features of the girl he had married, and they can be found in many of his later works.

Occasionally Mervyn and Maeve would hold a drawing party, engaging a model for the evening and inviting friends to come to draw the model, after which they would talk and drink coffee or dance together. Recalling it more than thirty years later, Maeve thought it seemed like a prehistoric way of spending an evening, but with the dreaded shadow of imminent war hanging over them any kind of entertainment was welcome (Gilmore, p. 33).

Yet 1939 started out as a most promising year for them both. They had a visit from Eddie Marsh, who bought a large oil painting of Mervyn's. Then, one evening, Sir Kenneth Clark, who was the director of the National Gallery, came by and bought eighteen guineas' worth of drawings. Mervyn took the opportunity to show him a project that he had just started on: an illustrated book of

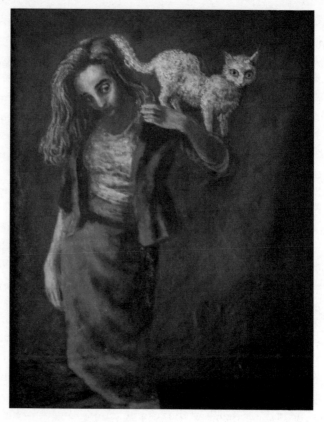

Maeve with a white cat; oil on canvas, late 1930s

twenty-six fantastical 'Kings from A to Z', to be accompanied by nonsense verses. It was the absurdity of the concept that appealed to him, without any whys or wherefores. Sir Kenneth gave him an introduction to Chatto and Windus – but they were not interested in the project. Today, only five of the drawings seem to have survived, and they can be seen in *Mervyn Peake: The Man and His Art* (pp. 97–9). Grateful for Sir Kenneth's interest and support, Mervyn remained in contact with him during the war.

In March both Mervyn and Maeve had solo exhibitions, he at the Leicester Galleries (with forty-six drawings, many of them portraits) and she at the Wertheim. The newspapers had a field day of course, printing photographs of them making simultaneous portraits of

each other – although in fact they always worked separately – and the *London Mercury* reproduced one of the drawings from Mervyn's show. On the strength of this publicity they were invited to participate in one of the BBC's *In Town Tonight* programmes, which was a forerunner of the television chat show. They took this opportunity to tell the story of how, one evening when they were in Mervyn's rooms in Hester Road, they heard strange noises coming up from the warehouse below. The floor itself seemed to move, rising and rippling like a hammock (Gilmore, p. 17). And they discovered that an elephant from a travelling circus was being accommodated down there for the night. After the broadcast (which of course was all live in those days), they spent most of the £6 they had just earned on a luxury meal at the Café Royal.

A description in the *Daily Sketch* (25 February 1939) of Mervyn at the Leicester Galleries exhibition gives some idea of how he dressed: 'At the private view, Mrs Peake's simple black dress was in striking contrast to her husband's bright blue shirt, copper tweeds and orange velvet tie. But Mervyn has always been a bold exponent of brighter dressing for men.' Indeed, the newspaper went on to claim that as a student at the Royal Academy Schools Mervyn used to wear a different-coloured carnation every day in the buttonhole of his brown corduroy suits, 'and once he made a highly original tie from the corner he cut off a Spanish cashmere shawl'.

That year they had more work on show than ever before; in June Mervyn was one of fifteen artists, including Edward Ardizzone, Nicholas Bentley and Felix Topolski, who contributed to an exhibition of 'Satirical Drawings of Our Time' at the Delius Geese Gallery; Mervyn's were considered 'bitingly unreal but acidly true satirical drawings' by the *News Chronicle* (13 June 1939). In the summer he had a *Nude Figure* in the long summer exhibition at the Leicester Galleries (alongside Graham Sutherland and Paul Nash, among others). And in December they both contributed canvases to an exhibition called 'Six by Eight', again at the Leicester Galleries: 132 pictures, all the same price and all the same small size, 6 by 8 inches (15 by 20 centimetres). Maeve's painting, called *Cherries*, was bought by Sir Hugh Walpole, author of *The Herries Chronicles*,

which enabled her to exclaim in delight, 'Herries has bought my cherries!' (Watney, p. 94). Walpole also bought work by Mervyn (or so Mervyn told Chatto and Windus in February 1941) but possibly not on this particular occasion.

That year, too, one of Mervyn's poems brought them into contact with another celebrity, the sculptor Jacob Epstein. His enormous statue of Adam, displayed at the Leicester Galleries in June 1939, had been widely censured – and featured in the *Picture Post*. Mervyn defended it in a poem that was published among the readers' letters to the *Picture Post* on 29 July 1939.[6] As a result Epstein invited Mervyn and Maeve round to his mansion of a house in Hyde Park Gardens. The meal was presided over by Epstein's first wife, an over-life-size woman with deep red hair, whom Maeve always remembered as being like Gertrude in *Titus Groan*. In her memoir she makes it quite clear that she had no idea whether or not Mervyn had been inspired by her to create the character (Gilmore, p. 27), yet more than one critic, following John Watney's initiative, has taken Maeve's comment as an affirmation that Mrs Epstein served as Mervyn's model for Lady Groan.

As the beginning of the war approached – everyone knew that it was inescapable – people took all the holidays they could to distract themselves from the unthinkable. At the end of August Maeve's mother lent Mervyn and Maeve a car, and they drove up to Stratford-upon-Avon, where they saw *As You Like It* at the theatre, and then they drove on to Chipping Campden to visit Goatie and his parents. They spent the night of 2–3 September in a hotel on the town square opposite the Smiths' house and woke to hear the town-crier, with his bell, tricorne hat and cape coat, announcing the long-expected news. As he finished, a man on a white horse, like something out of the Apocalypse, appeared on one side of the square and rode to the other, disappearing as suddenly as he had come (Gilmore, p. 35). It was one of those Peakeish events that characterized their lives.

Maeve remained for a while with her sister in Stratford while Mervyn went back to London. Hardly had he arrived when he heard that his mother had suffered a stroke. Maeve joined him down in Burpham, and they were with her in her last hours (Smith, p. 77).

Mervyn sketched her, with tears in his eyes, as she lay in bed. She died on 8 October, shortly after hearing that her daughter-in-law was expecting her first child.

It was therefore with mixed feelings that they celebrated the publication of *Captain Slaughterboard Drops Anchor* that same month. Published at five shillings, which was quite expensive for a children's picture book, especially as it was not in colour, it had to struggle to make its way. And the reviews were not positive. Today, after books like *Where the Wild Things Are* by Maurice Sendak, *Captain Slaughterboard Drops Anchor* appears mildly whimsical; at the time it was seen to contain 'a rather horrific gallery of portraits' (*Times Literary Supplement*, 18 November 1939) which were 'quite unsuitable for sensitive children' (*Punch*, 20 December 1939). Needless to say, it was not the bestseller of the Christmas season as Mervyn had hoped it would be, and sales were slow; indeed, they halted completely towards the end of 1940 when all the remaining copies were destroyed in a warehouse fire.[7] It was not reissued until December 1946, by Eyre and Spottiswoode, Chatto and Windus having turned it down on 20 November 1941 as an unsaleable juvenile – because of parents' whims, not the taste of children, they hastened to explain.

Bombing was what Londoners expected and feared most at the outbreak of war. Distribution of the 2.5 million Anderson shelters, to be assembled in a trench in the garden, had begun at the end of February. Everyone had already made black curtains for their windows and learned how to put adhesive tape across the panes to reduce the risk of injury from flying glass. Expecting to be called up at any moment, Mervyn sought to make himself useful and volunteered to fit gasmasks at the local distribution centre (Watney, p. 91). Evacuation had already begun, and at the end of the year the Westminster School closed down 'for the duration'. It was ten years before Mervyn was to take up teaching again, and it was to prove a golden decade of productivity for him.

Mervyn and Maeve spent that Christmas at Maida Vale and marked the occasion with acts that speak eloquently of their social conscience, for all their straitened finances and Mervyn's ideas about the independence of the artist. Maeve reports that they wished to celebrate

that first Christmas of the war in a way that affirmed the pre-war values of peace and goodwill, so Mervyn bought as many packets of cigarettes as their limited funds would allow, went down to the Arches beneath Waterloo Bridge and distributed them to the down-and-outs who congregated there. He also brought home a young Welsh miner who was out of work. They put him up for the night and sent him on his way the next morning to seek employment dressed in a suit that Mervyn had given him (Gilmore, pp. 36-7).

At New Year they joined Mervyn's father down in Burpham, leaving London and its dreaded bombs far behind. They found a cottage to rent in a nearby village called Lower Warningcamp, and it was to that new home that Maeve returned from a local nursing home after the birth of Sebastian on 7 January 1940. He had been delivered by Dr Peake, who subsequently planted a tree in his garden to commemorate the event (Peake, p. 9).

PART 4

The Golden Decade, 1940–1949

Waiting for war work

10
Warningcamp, 1940

WHILE Mervyn was waiting for war work, he was not idle. Having no job to go to, he was around the cottage in Lower Warningcamp all day long and made dozens of sketches and paintings of Maeve and Sebastian. The prospect of having a child had also inspired him to prepare an illustrated collection of nursery rhymes. Following up on Sir Kenneth Clark's introduction, he approached Chatto and Windus, whose director, Harold Raymond, had seen and appreciated drawings that Mervyn had exhibited earlier in the year. Mervyn left sample drawings with him before leaving London, and on 29 December Raymond wrote to say that he would like to publish the book, with eight coloured illustrations and eight black-and-white ones, the size of the book to be 8 by 10 inches (20 by 25 centimetres). It was followed by a contract offering an advance of £15, a further £15 on delivery of the illustrations at the end of February 1940 and £10 for every thousand copies sold after the first three thousand.

The result was assuredly Mervyn's most charming book, *Ride a Cock-Horse*, whose illustrations were enhanced with stencilled colour, an unusual process for a commercial production and one that must have added considerably to its cost. As with *Captain Slaughterboard Drops Anchor*, however, the grotesque in the drawings caused some concern. The *Observer* was of the opinion that *Ride a Cock-Horse* contained pictures 'whose weird, almost macabre manner has little to do with the freshness of the rhymes. The one

that jars least is "I Had a Little Nut Tree"' (29 December 1940, p. 4). 'Mervyn Peake is a very singular artist,' wrote Frances Bird in the *New Statesman and Nation*, 'and his drawings make an eerie and indelible mark on the mind.' Consequently she recommended the book 'for children from five to eight with visual and imaginative interests' (7 December 1940, p. 588). The *Spectator* had similar comments to make; after admitting that 'There is no young artist today with a greater sense of the grotesque and the mysterious than Mr Peake', it went on to warn about 'the strange, obscene Goya heads of the three men in a tub' that 'belong to deeper imaginative levels'. It concluded, 'This is a book of great beauty' – but who was going to buy a children's book with a drawing that could be called 'obscene'?

More positive assessments were to follow. For the *Studio*, in March 1941, 'Mervyn Peake's pen drawings (some of them coloured) are of exceptional merit and are designed to appeal to the imagination of youth and age alike. In all there are fourteen short nursery rhymes, and each is illustrated by a full page of special charm and character.' But it was to be the 1950s before critics realized that 'children are commonly a good deal tougher than parents appear to imagine, and most of them seem to enjoy the fantastic creatures of Peake's imagination' (Eyre, *20th Century Children's Books*, p. 32).

Edwin Mullins was given a copy by his aunt when he was a small boy, too old, he thought, for nursery rhymes:[1]

> I received her birthday present with hurt pride, and flicked through the pages only long enough to please her. 'How many miles to Babylon?' 'I saw a peacock.' 'I saw a ship a-sailing.' I had known them all for years. They were kids' stuff.
>
> Or were they? There was something, I had to admit, that stirred in me thoughts about nursery rhymes which I had never experienced before. They seemed to be charged with romance, all of a sudden. They were not about a nursery world at all, but an adult world accessible to a child's dreams. . . .
>
> What a real 'fine lady' she is from Banbury Cross, with her deep neck and slender hands sparkling with rings, and the mane and tail

of her cock-horse drawn like flames . . . As for Babylon, the child on
the bed, holding the huge candle into the dark is myself as a child in
the war, scared of the bombs whistling and bursting on to the
London suburbs, glimpsing in the candle-light that looming figure
of a lady with her mysterious jewellery and downcast eyes, who will
carry me out of the air-raid shelter to her own city – 'Ay, and back
again' in the morning when the Ack-Ack guns are silent and the All-
Clear has sounded. (MPR, 1985; 19: 33–4)

Mervyn was also preparing for his war. A few days after it was
declared he wrote to the Ministry of Labour offering his services as a
war artist and enclosing a letter of recommendation from Augustus
John. He and John had become friends after meeting in the Café
Royal in 1937, and Mervyn's portrait of him was exhibited in the
Leicester Galleries in March 1939. John wrote a second recom-
mendation for him, dated 28 December 1939, describing Mervyn
'as a draughtsman of great distinction, who might be most suitably
employed in war records' (Gilmore, p. 37). This one remained with
the Peake family.

Dubious as to whether he had sent his application to the right
place, Mervyn asked around, and a Mr Ernest Brown of the
Leicester Galleries told him of a clearing house called the Oxford
Arts Bureau that Paul Nash had just set up. Having served as an artist
during the First World War, Nash was hoping to provide government
bodies with lists of candidates for war work, but it proved such an
administrative nightmare that he soon pulled out (see Foss, *War
Paint*, p. 14). On 13 September, Mervyn sent an enquiry to the
bureau. This being early days the director answered him on the 14th,
telling him that his application to the Ministry of Labour would lead
only to work in propaganda. Artists could be employed in camou-
flage, but this was restricted to those over thirty-five or unfit for
military service. They could also work as recorders, a category that
had not yet been defined. Mervyn hastened to reply that this what
he was most anxious to do, adding that he was prepared to be sent
anywhere.

Two months passed. Reading in a newspaper that Sir Kenneth

Clark was to head a committee that would appoint war artists, Mervyn wrote to him on 21 November, reminding him of his desire to be of service. Clark answered at once, assuring him that he would, as he had already promised, put forward Mervyn's name to the committee, which was to meet on 23 November.

The recruitment and employment of artists (of all kinds) in the service of the war effort was something that Clark had been actively pursuing since the beginning of the year. After consultation with the Ministry of Labour he chaired a shortlived Artists and Designers Committee, which aimed to collect the names of potential artists. Only a week after its first meeting on 1 September it had found 140 candidates. In parallel with this, Clark was negotiating with the Ministry of Information to create a War Artists' Advisory Committee (WAAC) along the lines of the British War Memorials Committee that had been formed for the previous war. Under Clark's chairmanship, the WAAC united the Chief Inspector of Art Schools for the Board of Education, Edward Dickey, three personalities from the world of art – Sir Muirhead Bone, Sir Walter Russell and P.H. Jowett – and representatives of the Home Office, the Air Ministry, the War Office and the Admiralty. It aimed to commission artists to depict particular aspects of the war in order to constitute a national collection of war pictures. At its first meeting it established the categories of work for the artists:

1 Portraits
2 Figures in action (a) at the front
 (b) at home
3 Landscapes (a) at the front
 (b) at home
4 The sea and shipping
5 The sky and aeroplanes
6 Towns and factory exteriors
7 Subjects involving technical draughtsmanship,
 e.g. interiors of factories or battleships, etc.
8 General[2]

Thanks to the preparatory work of the Artists and Designers Committee, the Ministry of Labour was able to supply a provisional list of artists (which did not include Mervyn), and the WAAC at once began adding names of its own choice, assigning them to the various categories as a function of their known skills and interests. At its fifth meeting, on 20 December 1939, Mervyn's name appeared among the forty-eight artists who had applied or been recommended for service as war artists in Categories 1 and 2(a). Nineteen of them were judged unsuitable for inclusion; the remaining twenty-nine were either recommended, placed on a reserve list or reserved for portraits. Mervyn was placed on the preliminary list of portrait painters and draughtsmen to be reviewed at the meeting of 3 January 1940. Against his name was pencilled 'Drgs' (presumably for 'drawings'), and he was considered suitable for War Office employment.

In the meantime, Mervyn received application forms from the Oxford Arts Bureau on 29 November, and he again sought advice from Clark: should he offer his services only as a painter, or as a poet, too? I have not found a copy of Clark's answer; he probably told Mervyn not to bother with the bureau and suggested that he provide the WAAC with examples of his work.

By the eighth meeting of the committee on 17 January 1940 the number of potential portrait painters and draughtsmen had expanded to 123, of whom fifty-one were retained; five weeks later, at meeting fourteen on 28 February, the numbers had swelled to 255 artists, and the WAAC reviewed its comprehensive list of recommendations. Dividing them into 'Recommended' and 'Reserved' categories, it decided that 'Mervyn Peake to be transferred to Reserve List 2(a)' along with 154 other names. To give itself time to examine its recommended candidates, the committee drew up a list of artists whose specimens of work were to be reviewed on 10 October 1940. Among them was Mervyn – but his name does not appear in the minutes of that meeting, at which only one artist was recommended. Thereafter Mervyn's name is absent from the minutes until 1942: specimens of his work were due to be reviewed at the meeting of 4 March that year, but it was decided to postpone assessment 'until the

return of Clark'. At that point the secretary, Edward Dickey, resigned and returned to his post in the Board of Education. He was briefly succeeded by Arnold Palmer and then, on 23 September 1942, by Elmslie Owen, an ex-colleague of Mervyn's from the Westminster School. Only after this date was Mervyn given work as an official war artist.

From this we can draw a few conclusions. There being a great many artists on the WAAC's list, we can suppose that those whose work was consensual – known and appreciated by members of the committee – would be given preference. The postponement of discussion of Mervyn's case until Clark's return suggests that if he had the support of the chairman he may not have had the approval of the other members of the committee. Nor, as we shall see later, did the grotesque in Mervyn's drawings endear him to them. So it probably took the presence of a friend as secretary to the committee to make the difference.

While Mervyn was waiting for news from the WAAC, he was creating his own war art. In April 1940 he participated in an exhibition at the Stafford Gallery, 'War As I See It'. Eric Newton, writing in the *Sunday Times* on 21 April, denounced what he saw to be

> a set of half-digested intellectual and emotional clichés. 'This War As I Think I Ought to Feel It' should have been the exhibition's title . . . The result is a set of ungainly jigsaw puzzles that are doubly mediocre, for they are conceived without emotional sincerity and painted without visual conviction.

Among the exceptions he cited three paintings of 'things really seen' and three, including Mervyn's canvas *I Was Called*, of 'things truly felt'. The depiction of war is indeed a difficult art – the very notion of 'war art' is practically an oxymoron – and Mervyn would certainly have drawn the wrath of Eric Newton for his *On Guard: A Patriot Treatment of a Soldier* which appeared in the *World Review* that summer. It has neither emotional sincerity nor visual conviction.

By June 1940 Mervyn was tired of waiting. He telephoned the

WAAC and asked Edward Dickey whether he thought that drawings of German prisoners of war would be of interest as war records. He was told to put his proposal in writing, and on 22 June 1940 he eagerly repeated his suggestion in a letter, arguing that, quite apart from their intrinsic value as works of art, portrait studies of prisoners' heads might well be fascinating historical data.[3] Aware that he had anticipated the WAAC's invitation to draw as a war artist, he explained that he felt there was some urgency as the prisoners were being sent to Canada.

His eagerness was in vain. Three days later Edward Dickey reported that 'in no circumstances would it be permissible for drawings to be done as you suggest', adding that Mervyn should none the less bring drawings to show to the committee (*PS*, 1991; 2: 2, 5-6). One wonders on what grounds the idea was rejected: the principle of protecting the personality of individual prisoners of war from exposure to the public through photographs and other visual media was formalized only in the 1949 Geneva Convention relative to the Treatment of Prisoners of War. Moreover Mervyn had already suggested that his drawings might be kept under wraps until the end of the war. Perhaps the WAAC preferred to limit the making of portraits to Allied troops.

This refusal seems merely to have stimulated Mervyn's creativity, for next he came up with a unique idea: Hitler being a painter, he imagined an illustrated catalogue for an exhibition of his work, the pictures having stock titles like *Reclining Figure, Mother and Child* or *Family Group* - all depicting horrors of war, so that the captions became grim understatements of the paintings above them. He set to work at once; in July he took them to the Ministry of Information where (according to a letter he wrote to Harold Raymond at Chatto and Windus on 13 February 1941, printed in *PS*, 1999; 6: 2, 11) they leapt at them. Soon the Ministry was preparing to print nineteen of Mervyn's pictures in 100,000 propaganda booklets for distribution in South America. Apparently these booklets were going to be disappointingly small, so the drawings would have lost a great deal of impact - as readers of *Mervyn Peake: The Man and His Art* will realize - but Mervyn was overjoyed that they were going to be used. They

might do some good and that was what he wanted more than anything. Moreover, they paid him one hundred and forty guineas for them.

Then Mervyn discovered that government bodies can cool off even faster than they warm up, for there ensued a long silence during which Mervyn fondly imagined that the propagandists were feverishly printing the brochures and shipping them across the Atlantic. To his bitter disappointment he learned that there had been a change of policy: his pictures were not to be used at all. Worse, because he had sold them, he was unable to recover them, and all but one took up a permanent abode in the archives of the Ministry of Information.

Even today sixteen of the original twenty-five pictures are still in the Public Record Office (file Inf 3/645-660). They have never been published as a series; some were shown in an exhibition in New York during the war; others have been shown in posthumous exhibitions of his work; most recently, twelve of them were printed in *Mervyn Peake: The Man and His Art* (pp. 66-9). Some are truly horrific: a girl, obviously a hospital patient, lies raped and shot on her bed; what at first glance appears to be a beggar at a street corner turns out to be a mere torso, his limbs having been eaten to the bone (by rats, one presumes). In another picture the shrouded cadaver of a girl lies on a table; her left foot is missing, as is the flesh from half the shinbone. Yet another shows a dead girl draped over the end of a table, on which lies one of her severed hands beside a loaf of bread; *Still Life* no doubt.

There is something disturbing about the idea that these pictures were drawn entirely from Mervyn's imagination as he sat in the relative comfort of his Sussex cottage, long before he had seen anything of the horrors of war. (Goya, whose engravings surely inspired him, worked from personal experience and first-hand witnesses.) It puts me in mind of his father, safe within the walls of Wuchang in 1901, dreaming of adventure and a midnight escape down the rope he had in readiness. It reflects the Peakes' innocence and their romantic imaginings. And just as his father, a few years later, had to face the bloody reality of war in Hankow, so Mervyn was to come up against reality with a brutal shock when he visited the concentration camp

at Belsen in 1945. These drawings are of 'war in the head', with victims as bereft of individuality as the artist's lay figure; how different it was to encounter real people, suffering in the flesh and the soul, and look them in the eye. It made Mervyn feel ashamed of having used their suffering in the course of art.

No new poems of Mervyn's were published at this time, although the little magazines that sprang up with the war offered poets a wider market than ever before. It may be that living down in Burpham he was cut off from his usual contacts. On the other hand, the setting of the cottage he was living in, which overlooked the banks of the River Arun and offered a view of Arundel Castle on the crest of the hill-slope opposite, seems to have been conducive to the creation of another, very different work.

Mervyn started a new prose text, not yet a novel, just a page of nonsensical conversation between two pompous half-wits. This led him to imagine a scene in which two other characters converse while leaning back to back, at an angle of about forty degrees, in a high room with a window overlooking a river. This in turn triggered a flow of both serious and nonsensical fantasy which he allowed to pour out unrestrained on to the page, sentences growing out of their precursors involuntarily without any particular aim or purpose in mind. Apparently he had written about three chapters of this spontaneous material, which he called 'The House of Darkstones', when the idea of Gormenghast began to come to him.

Half-a-dozen pages from these abandoned chapters were printed in *Peake's Progress* (pp. 105-9). They show Mervyn moving away from the maritime context of pirates while retaining much the same dramatis personae in slightly different combinations. The two characters leaning back to back are Lord Groan, aged forty (or forty-three, depending on the draft) and Mr Stewflower, aged between fifty and sixty. Lord Groan's face, with a nose that 'emerged as might a polished crag from the shallow waters of a disturbed bay' and 'a kindly fissure' of a mouth that 'made its way tentatively across irregular terrain' (*PP*, p. 108) barely distinguishes him from Mr Slaughterboard. And just as Slaughterboard had his sidekick in Mr Smear, so Lord Groan has Mr Stewflower, an entomologist encountered on a desert

island, where 'a yellow lizard lay motionless in the sickening sun' (*PP*, p. 107). He is the author of 'seven enormous tomes' on the Rong Beetle, just as Mr Slaughterboard's father, a botanist, had written a definitive book on orchids that had 'run into thirty-four distinct editions' (*PP*, p. 65).

In the novel that ultimately evolved, Mervyn planned to tell the life story of this Lord Groan, now called Titus, starting with his birth and childhood, but the material grew under his pen. The events of the child's first year filled a whole volume, and he was still a teenager at the end of the second. By the time illness forced Mervyn to leave off, his hero had still not reached twenty, and we never get to read of his maturity nor of Mr Stewflower and the House of Darkstones.

At first the chapters with Titus in his forties served as a framing device. This we know from a letter Mervyn wrote to Goatie in mid-November 1940, reporting that he had written seventeen chapters (Smith, p. 80); at the same time he listed them in his notebook. All but the first two chapters, 'A Room by the River' and 'Goodbye to Stitchwater',[4] correspond to the opening of *Titus Groan* as it was published five and a half years later. Mervyn dropped the frame sometime in 1943, when Graham Greene commented that he was not sure that the novel gained by the loss of what he called the prologue.[5]

The main source of inspiration for the nascent novel was clearly the setting, the castle of Gormenghast itself, rather than the characters. In fact, it might be said that once Mervyn had imagined Gormenghast the place itself generated characters to inhabit it, and the story-line came only after that, developing organically rather than according to any preconceived plan. Consequently a plot summary of the Titus books misses the whole point, for it is obliged to omit the purely descriptive passages and neglects the interpenetration of person and place. Titus's father, Lord Groan, for instance, feels that he is part of Gormenghast; his feelings for the castle are indissociable from his feelings for parts of his own body (*TG*, p. 62). However, in order to situate my discussion of the writing of *Titus Groan* in the following chapters and to serve readers who are not familiar with the novels, I shall summarize them here.

On the day that Titus, the 77th Earl of Gormenghast, is born in the crumbling castle, where life is regulated by a Master of Ritual on the basis of age-old traditions, the scullion Steerpike escapes from the Great Kitchen and the drunken chef Swelter. He is caught wandering in the labyrinthine Stone Lanes by Flay, Lord Groan's manservant, and locked in a room from which he escapes by climbing out of the window, up the wall and over the roofs of the castle. At the same time Titus's mother Gertrude, Lady Groan, orders the aged Nannie Slagg, who had looked after her first child Fuchsia, now a young teenager, to seek a wet nurse for Titus from among the Outer Dwellers whose mud huts cluster at the foot of the castle walls. So Titus is suckled by Keda. She is loved by two of the Bright Carvers among her people, whose wooden sculptures are judged each year by the castle; selected works disappear into the castle gallery, guarded by the curator Rottcodd; the rest are burned.

By devious means Steerpike gets a job with the castle doctor, Prunesquallor, whose middle-aged spinster sister Irma still aspires to marriage. Steerpike manages to strike up a friendship with Fuchsia and, meeting Lord Groan's mentally deficient twin sisters, conceives a plan to set fire to Lord Groan's library at the moment when all the family are gathered there for a ceremony, thus enabling him to rescue them all (except the Master of Ritual) and become the castle's hero.

In the meantime the long-standing hatred between Flay and Swelter has escalated. Swelter plans to murder Flay who has been banished from the castle for throwing one of Lady Groan's cats at Steerpike. Returning at midnight, Flay fights and kills Swelter. Lord Groan (often called Sepulchrave), who has gone mad after the burning of his books, appears on the scene to drag Swelter's corpse over to the Tower of Flints where both he and it are devoured by the owls. By the end of the first book Titus is but one year old and being named Earl in a lakeside ceremony. Keda has committed suicide, and her bastard child, Titus's foster-sister, echoes his cries, a sign of the subtle link between them.

Gormenghast covers the period of Titus's life between the ages of

six and eighteen – his schooling, his escapades and punishments, and his simultaneous discovery of his identity and love. He falls for Keda's daughter, now a wild girl in the woods, but hardly has he held her in his arms when she is killed by lightning. Ultimately he prepares to commit the unthinkable in leaving Gormenghast to find out what lies beyond its horizons.

Steerpike, who has killed Nannie Slagg, drowned another Master of Ritual and starved the twins to death, has risen to become Master of Ritual himself, and he attempts to seduce Fuchsia. But Lady Groan suspects him of foul play, and the exiled Flay, continuing to make surreptitious visits to the castle, joins Dr Prunesquallor in unmasking him. Hunted down during a cataclysmic flood, Steerpike is finally killed by Titus. Fuchsia dies at the same time, slipping from the sill of her bedroom window into the flood-waters below. *Gormenghast* also develops the comic stories of the teachers in Titus's school and of Irma Prunesquallor, who marries the headmaster.

11
Dartford and Blackpool, 1940–1941

J UST as Mervyn was starting on what was to be his most famous
work, he received his call-up papers. On 29 July 1940, two weeks
after his twenty-ninth birthday, he reported to the Royal Artillery
recruitment depot at Gillingham.[1] Lovingly he arranged for a bicycle
to be waiting back at their cottage for Maeve when she returned
from seeing him off at the station. It was a wonderful gift – and an
extravagant one, for it was seven months since Mervyn had last
received a salary. It was also a very necessary present: Maeve had no
other means of travelling to Arundel where she did all her shopping.
She loved the bike, as did Sebastian, who was soon riding on the
back, and she kept it for many years (Gilmore, p. 38; Peake, pp. 10
et seq.).

Mervyn was assigned to the training school of the 35th/12th
Light Anti-Aircraft Unit at Dartford, on the Thames. He could
hardly have joined the war at a more dramatic moment or been
posted to a more strategic site, for it was the eve of the Battle of
Britain. On 1 August Hitler issued Führer Directive No. 17, order-
ing the Luftwaffe to 'overpower the English air force with all the
forces at its command in the shortest possible time'. Between 13
August (the Day of the Eagle) and 17 September (when Hitler post-
poned the invasion of Britain 'until further notice'), the decisive air
battle took place above south-east England. After trying to destroy
the air bases around London, the Germans turned their attention

on London itself: on 7 September, for example, three hundred bombers, escorted by four hundred fighters, attacked the London docks; the following day two hundred bombers targeted London's electricity power stations and railway lines. Their favourite line of approach was to fly up the Thames estuary, so the anti-aircraft guns that lined its coast were on almost constant alert.

After the briefest of basic training at Dartford, Mervyn was apparently posted on 21 August to a site on the Isle of Sheppey where he remained until early October (Watney, p. 101). Although this is one of the most fully documented moments of his life, for we have the reminiscences of two men who were in the same unit, the version of his biographer, John Watney, and Mervyn's own letters, the details vary widely. Watney would have Mervyn living beside his gun, 'so as to be ready for instant action . . . Curiously, during his periods of rest, even when the heaviest bombardments were in progress, he could sleep beside his gun, without tremor or twitch, and wake, when his turn of duty came round again, as refreshed as if he had just got up from his bed at home' (Watney, pp. 101–2). This strikes me as pure fantasy; it contradicts Watney's own assertion that Mervyn was transferred to the 228 Anti-Aircraft Driver Training Unit on 21 August 1940, which meant that he was not working the guns but assigned to other duties. At the same time, Watney affirms that Mervyn 'never could work out which was his left and which his right hand, and the mysteries of gun-laying were completely beyond his powers of comprehension' (Watney, p. 99). If this were the case he would not have been put on the guns at all; there were plenty of other jobs to do.

Philip Best was apparently on the same gunsite as Mervyn.[2] He portrays him as 'the only man to succeed in losing almost all his personal equipment' on the short journey from the training depot to the gunsite and one who had an 'incurable habit of dropping the 60lb ammunition' for the anti-aircraft guns. To spare the nerves of his fellow gunners he 'finally became a permanent cookhouse orderly. In that steamy atmosphere, under the eye of the Sergeant Cook, he quietened down and we all felt more secure.' This is confirmed by a letter Mervyn wrote from the ATS camp at Fort Darland to Sir Kenneth Clark on 16 September 1940, in which he confessed

that he had been 'delegated . . . to the responsible position of washer-up in the sergeants' mess'. Later he added, 'my job here is quite fatuous. I've broken three plates already.' Best goes on to claim that 'problems arose over Peake's personal habits . . . In due course he was removed from his barrack room where his strange presence was making all his colleagues jumpy, to a corrugated iron lean-to by the cookhouse, and there he lived peacefully for the remainder of his short stay' (*London Magazine*, p. 279).

In addition to telling a highly coloured story of Mervyn allowing his alarm clock to go off during an alert, Best assures us that all Mervyn's off-duty hours 'were spent drawing on something, no matter what' and when he left, his fellow soldiers found

his wonderful drawings, masses of them. Drawings on the back of envelopes, on bits of packing paper and on squares of cardboard. Where they were smooth enough, even the walls of his small den were brightened by them. They were brilliant caricatures of many of us, galleons in full sail and discerning sketches of the bombed and devastated landscape in which we existed. There were also some that were frankly disturbing, grotesque and monstrous figures from depths of imagination we simply could not contemplate. There was keen competition in his absence to acquire them.

The skill of those drawings was undeniable, but it was the sheer quantity of his work that brought us to remember how, wherever he would be and whenever he was able, Gunner Peake would take a stub of pencil from his pocket, seek some scrap of paper, and he would draw. In complete happiness and wrapped within himself, he would draw, with tremendous purpose and concentration. That was Peake's discipline. (*London Magazine*, p. 281)

Asked whether any of these drawings survived, Best replied, 'I believe they were all destroyed when our gunsite was demolished by enemy action. I can certainly vouch from witnessing the fires that all mine were' (letter to GPW dated 16 October 1996).

This may explain why so few of these drawings have ever been seen. In his letter to Sir Kenneth Clark, quoted above, Mervyn reported

that he had 'been working at every odd moment and done about 40 drawings and water colour notes'. He was preparing to paint a 'Barrack Room Scene' which he hoped would be his passport to work as a war artist; he had outlined the project to Clark, who had thought it a good idea, in a meeting with him some days before:

> I think the feeling in the picture will be one of loneliness although the canvas will be filled with figures, for the spaces between the beds & the figures, the walls, & floor space (broken here by a fallen green gaiter, there by a magazine) will I hope convey the emptiness that lies behind the forced humour of the barrack room. I don't mean a pessimism or defeatism, but the fact that everyone in the room has been uprooted & poured into khaki. The limp overcoats, the shadows under the bed. So much can be implied by these things. I wish the figures to be drawn impeccably, but the massing of them, the great colour areas, and contours will be dominant. The psychology of the heads & hands & attitudes. In fact everything is there to tackle. The similar clothing has an extraordinary effect on the heads & hands for with this identical setting they become more individual, emerging from a common khaki prison. They seem to defy the army regulations by the personality in their heads.
>
> The colour will be strange. The curious greeny-ochre of the uniforms. The black forces of the iron bedsteads. The white towels with their red borders. The almost emerald colour of some of the gaiters. The whole thing with the common denominator of the shadows cast by electric light. But it will be a new kind of realism. I am sure of this. (Letter dated Monday 16 [September] 1941)

I quote at length because it is rare to find Mervyn making such a full statement of his aims and intentions in a painting. It is not known whether he ever found the time to execute it. He did, however, take 'realistic paintings of Gunners, etc.' to Sir Kenneth Clark later on (letter dated 7 February 1941).

Best depicts Mervyn as having grubby hands and wearing a 'filthy denim blouse'. For a man credited with being 'a bold exponent of brighter dressing for men' this sounds strange, but in Best's view

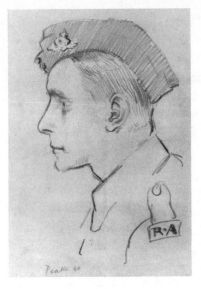

E.J.S. Parsons

Mervyn 'was merely "working his ticket". In that he succeeded is, I suppose, to his credit' (letter to GPW dated 16 October 1996). Certainly, if John Watney is to be believed, Mervyn made little attempt to conform to the military way of life: during his passing-out parade, 'instead of turning his head to the right and slapping the butt of his rifle, Mervyn brought his hand up to his cap instead, and gave a cheerful wave' (p. 101).

However, E.J.S. Parsons (who spent his professional career at the Bodleian, Oxford, ending as its head librarian) has a completely different view. He was in the same squad as Mervyn from the first day onward, in the same barrack room at the training camp and on the same gunsite on the Isle of Sheppey. He remembers Mervyn as

a man who was determined to come to terms with his new and strange surroundings . . . determined, in spite of his lack of enthusiasm, to pull his full weight and he entered into the spirit of this motley array's determination to be the best squad in this particular intake of recruits . . . The impression that stays with me is of a determined, kind and loyal person. (MPR, 1979; 8: 32)

Asked whether Mervyn worked on the guns, he replied: 'To the best of my knowledge, he never got to touch the guns at all, having other duties.' In short, for Parsons 'Mervyn was no fool, but a man of understanding' (undated letter to GPW received 5 November 1996). He confirms that Mervyn 'was never without pencil and drawing pad' and, on the occasion of the opening of a Mervyn Peake exhibition at the Bodleian Library in November 1978, he produced a portrait of himself that Mervyn had drawn (see p. 155).

These different stories, some at complete variance with the others, show how memories reflect the mind that carries them quite as much as they do the person remembered. Ultimately, it matters little what Mervyn was actually doing for the Royal Artillery. On the other hand, there can be no doubt that he was writing a great deal, as well as drawing and painting. Most of the manuscript of *Titus Groan* was written in notebooks, some of them publisher's dummies, and Mervyn frequently dated his entries, so that it is possible to ascribe some portions of the novel to specific times and places.[3] However, the first notebook is missing, so we cannot date precisely the first eleven chapters (pp. 15–86) of *Titus Groan*. The head of the second notebook (1: i) carries the comment 'Begun October 3, Dartford', so we know what he had completed by then. And it is a lot, almost 30,000 words – nearly half the length of the book you are reading now – and he seems to have written it in just two months. So I think we can deduce that the Army, finding little that Mervyn could do, must have left him very much to his own devices. And for this we can be thankful: being called up mobilized all his creative resources.

These early pages contain memorable moments, centring on the birth of Titus: the first view of Gormenghast; Flay's visit to Rottcodd (whose name, incidentally, derives from the wartime notice on the windscreen of Dr Peake's car: seen from inside the vehicle, 'DOCTOR' reads 'ROTCOD'); then Steerpike escapes into the Stone Lanes; Lord Groan learns of the birth of his son and the unusual colour of his eyes; the Countess calls Prunesquallor to her bedroom; and Fuchsia climbs to her attic. In view of what we know of Mervyn's cookhouse duties, we may wonder whether something of his Army

life seeped into the novel at this point, in the descriptions of the steamy kitchens of Gormenghast, Swelter the cook and Steerpike, who was determined to escape from the Great Kitchen. There is no doubt, at any rate, that Mervyn sometimes identified himself with Steerpike. In the mid-1940s he signed a letter to his typist, Hilda Neal, with 'alias Steerpike'; I know of none signed 'Titus'. Funnily enough, Parsons remembers the cook on their site, too, a Londoner 'who was proud of the fact that he never took baths!' (letter to GPW dated 2 October 1996). We may also wonder if the 'corrugated iron lean-to by the cookhouse' did not contribute to the creation of the squalid huts of the Outer Dwellers that clung to the walls of Gormenghast.

By this time Mervyn had moved Maeve and Sebastian from their cottage in Lower Warningcamp to the School House in Upper Warningcamp, and it was there that he sketched Sebastian on the pages of his manuscript (reproduced in *PS* 1996; 5: 1, 25). What he wrote about the infant Titus no doubt reflects his observation of his son: 'his weird little head changed shape, from day to day as the heads of infants do, and at last settled to its own proportion' (*TG*, p. 97). Similarly, Sebastian was a fretful baby, prone to crying a great deal, much to Maeve's distress,[4] and Titus probably reflects Sebastian in this respect, too. 'Even from the very first there was something lovable about Titus. It is true that his thin crying could be almost unbearable, and Mrs Slagg . . . was driven at times to a kind of fluttering despair' (also p. 97).

In a new notebook started early in October 1940 Mervyn recorded that 9 October was his last day at Dartford; it must have been a quiet day, for he wrote Chapter 14, 'First Blood'. The following day he was writing in a barn at Bankesbourne (where his unit had its depot), awaiting his new posting to the 228 Anti-Aircraft Training Regiment in Blackpool.[5] According to Maeve (and therefore John Watney, too), he was wanted as a driving instructor, but the current curator of the Royal Engineers Museum, Dr John Rhodes, who presumably has access to contemporary Army files, rejects this: 'The suggestion that it was because he had a driving licence seems to be apocryphal' (letter to

GPW dated 5 October 1998). Maeve adds that he was given a red-carpet welcome, but it was soon clear that Mervyn was not the man they had hoped for. According to her he was demoted and set to lettering elegant cards which said, 'Only officers may use this lavatory' (Gilmore, p. 41). Ironically, lettering was the one thing that Mervyn was unsure about on the dust-jackets he drew; he always preferred to leave that job to a professional letterer. Another task was to make large copies from a technical handbook of drawings of engine parts, such as sparking plugs and pistons, for the instruction of drivers.

This still left him time for writing his novel – and drawing. As Mervyn wrote some years later, confirming my observation about the primacy of sound in his work:

> As I went along I made drawings from time to time which helped me to visualize the characters and to imagine what sort of things they would say. The drawings were never exactly as I imagined the people, but were near enough for me to know when their voices lost touch with their heads.　　(New Romantic Anthology, p. 80)

These marginal sketches have been used to decorate the Titus books ever since the second editions of the 1960s. In addition to his characters, Mervyn's manuscripts have numerous drawings of Maeve, his children and other people around him as he wrote, plus, of course, fantastic figures from his imagination, designs and doodles. Some of them have been reproduced in various books, not least *Mervyn Peake: The Man and His Art*, and more can be found in the present volume. In all they amount to hundreds of sketches.

Mervyn found Blackpool itself to be 'undiluted nonsense'; 'for sheer sham-splendor there is nothing to touch the Blackpool "front"', he told Sir Kenneth Clark. Its 'fantastic vulgarity' soon ceased to be novel, and for a while he fell into 'a state of absolute apathy', despairing over the absurdity of his situation, with 'London being bombed – Europe tottering etc. etc., and here are a mass of us khaki robots footling about in Blackpool. I've ceased to try and understand the

workings of the army' (letter to Chatto and Windus dated 19 October 1940; *PS*, 1999; 6: 2, 7). His great desire was to do something useful, such as recording the devastation of London, but Clark could only tell him that there was very little chance of his being appointed an official artist to depict air-raid conditions. It was his opinion that Mervyn's skill lay not in depicting facts but in his imagined scenes.[6]

Out of sheer frustration Mervyn stopped writing for a short while, but the arrival of his first finished copy of *Ride a Cock-Horse* soon jolted him back to life. He hastened to tell Chatto and Windus that he was delighted with it. That day, too, he settled down at the back of Woolworth's to do just what Sir Kenneth approved of, writing his novel – which he told Chatto he wanted to show them some time. This flatly contradicts Maeve's assertion that *Titus Groan* was written with no idea of publication in mind (Gilmore, p. 49; echoed by Watney, p. 97). No one offers to show a publisher a novel without entertaining some hope of publication. Telling them that it was called 'Goremenghast', he predicted that because of its name it would not sell well. Faithful to his romantic stance as the solitary artist at odds with society, Mervyn condemned his book, of which he had written exactly one quarter, to unpopularity. And he was right – until it was published in paperback in 1968; since then there have been at least sixty printings of *Titus Groan* in Britain and North America combined and translations into more than two dozen other languages.

Telling Chatto about his book stimulated his writing: he continued on the North Pier the following day and again that evening, starting what is now page 114; he advanced a dozen pages, completing the lengthy christening scene. At this point he recorded the 'loose ends' to pick up: he had left Steerpike (still called Smuggerby at this point) locked in a room, and he was to escape. A 'vicious' and 'ambitious' character, he was perhaps to kill Fuchsia. Then he noted further ideas for the development of the story (to which I have added comments):

- Swelter goes mad. Attempts to murder Flay – and is himself murdered. [This is what happened, without the madness.]
- F[uchsia] takes T[itus] to the Attic as a truant. Quarrel in the Attic.

[Hardly a possibility at this stage, when Titus was only just born. Not used in *Gormenghast* either.]

- The Storm.

- Fuchsia sets light to the N. Wing. [Not used; it is the Twins who set fire to the Library.] (Endpapers of 1: ii)

Mervyn's notes continue cryptically, 'The Coast! The Pirates. Elephants. Terrible ears. Telescopes', which are themes he developed in his collection of poems for children, *Rhymes Without Reason*, published in 1944.

Although the Royal Artillery seemed to have had little use for Mervyn, they told him that he was to remain in Blackpool for some time, and so he arranged for Maeve and Sebastian to join him at 62 Coronation Street.[7] There they had but a very small room (Gilmore, p. 42) which was filthy (according to Mervyn, in a note in the manuscript), and on 23 November they were relieved to move into two rooms at 77 Bloomfield Road. And his writing picked up again: on 10 December Mervyn completed Chapter 22 (up to p. 153). He had got Steerpike out of the locked room, up the wall and on to the roofscape; he had described the Poet reciting out of his window, his face 'transformed by a sort of beauty. It had coloured . . . like a piece of blotting paper whose corner has been dipped into red ink' (p. 142) – Mervyn was using red ink that day. He had described Fuchsia's climb up the stairs to her attic and Steerpike's climb up the outer wall to its window and was ready for their meeting.

As before, he paused to record how he thought the story would or could develop. As before, it turned out rather differently, taking its own way under his pen. In his first sketch of their meeting he thought that Smuggerby/Steerpike would clash with Fuchsia before they agreed to 'exchange worlds', she introducing him to hers while he offered in part exchange the rooftop world he had discovered. (This was not to be; Mervyn did not develop the theme of the 'sky field' as he called it.) At this stage he foresaw that Fuchsia would become fascinated by Steerpike's hatred of Swelter, and, finding him to be not unlike herself, she would plot with him to burn down Gormenghast – or to seize power in the castle. He ended with 'S climbs back out of

window and calls to her from a battlement. He remembers her in the corridor. Tact, devilment' (1: ii; transcribed in *PS*, 1996; 5: 1, 26).

On 13 December, while writing the encounter between Steerpike and Fuchsia in the attic, Mervyn made more substantial advance planning at the end of notebook 1: iii. (All fourteen points of his notes are transcribed in *PS*, 1996; 5: 1, 26–8; I have summarized only half of them here.)

- Lord Groan was to take a more active part in the story.
- The Countess, on the other hand, was to remain a huge background figure, glimpsed occasionally with her birds and cats.
- Following her meeting with Steerpike, Fuchsia's character was to change; after going through a period of revulsion and then violent excitement, in which Steerpike was to encourage her, she was to be overtaken by melancholy (after the manner of her father perhaps). As the daughter of the house of Groan she felt she should be shown more deference and live in a palace surrounded by wonderful people and not in a mouldering castle. Ultimately, though, her inborn loyalty to Gormenghast would prevent her from actively siding with Steerpike in rebellion. Mervyn closed this entry with a poignant question to himself, wondering whether she would commit suicide or be killed by Steerpike (1: iii) – a topic that is developed in detail in 'Fuchsia and Steerpike: Mood and Form' in *MPR*, 1977; 5: 7–22
- Flay and Lord Groan were to be seen together more often and their conversation recorded to make the bond between them more evident. (This echoes Mervyn's concerns in *Mr Slaughterboard* and the early sketches for the novel, at the same time as showing how he perceived his characters as almost autonomous, separate from himself as their creator.)
- Sinister and immense, Swelter is always at the back of Flay's mind, for he has become aware that the cook is planning to kill him.
- The murder attempt is made on a night of storm; Mervyn planned to describe Gormenghast 'besieged by howling winds, lightning and tremors' – in the event, he retained the storm without the howling winds or tremors. Swelter himself is killed, and at this stage Mervyn foresaw that Flay would drag his body away and bury it.

- Steerpike, crafty and ambitious, was destined to clash with Fuchsia. After months of subtle approach, he suggests they should marry. This brings out all the Groan blood in her and causes a terrible scene in which she hits him and goes through agonies of conscience thinking that she has killed him. She revisits her attic; would she burn her treasures? Mervyn wondered. And is she burned with them? Or does she take some of the poison purloined by Steerpike? (Questions like these continue throughout Mervyn's notes, for he was not to find the right manner of death for Fuchsia until he was in the final stages of writing *Gormenghast* in 1949.)
- Finally, in the mud huts of the Outer Dwellers, Keda conceives her child, and her lovers fight to their deaths in the woods by starlight.

Armed with this, he commenced what was to be a most productive period. By early in March – the chapter called 'The Grotto' is dated 3 March – he had completed 120 pages of the published book.

Head of an old man, from the MS of *Titus Groan*
(Box 2, notebook vii); pen and ink

12
Blackpool to Clitheroe, 1941–1942

WHILE he was writing *Titus Groan* in Blackpool Mervyn asked the Ministry of Information to send him photographs of *The Works of Adolf Hitler* that they had bought from him the previous summer. He was hoping to find a publisher for them, although he realized that since they were no longer his property any royalties on them would have to go to the Ministry. Full of enthusiasm for the endless possibilities that the project seemed to promise, he approached Chatto and Windus on 4 February 1941, enclosing two fresh drawings and suggestions for redoing the whole series (see *PS*, 1999; 6: 2, 10); he was well aware that the ideas would be more powerful if they were understated, rather than expressed in the extremely horrific form he had used so far. Harold Raymond expressed admiration for the pictures but was not prepared to publish unless the Ministry of Information relinquished its right to them. Instead, he proposed that Mervyn should illustrate *The Hunting of the Snark*. This was a great new prospect.

Prevented by 'red tape' from travelling up to London to view the bomb damage, Mervyn turned to his imagination, as Sir Kenneth Clark had advised him to, and produced an oil painting. 'It is dominated by a personification of "London" in the form of a brick-and-mortar figure of a woman holding a child. They are half human, half masonry. It is a very dark canvas save for the child's dress, which is smouldering vermillion with wallpaper patterns on it, & it appears to

be peeling away from the bricks' (letter dated 7 February, 1941). At about the same time, he turned this image into a moving poem, 'London 1941', using the body of a woman as an extended metaphor:

> Half masonry, half pain; her head
> From which the plaster breaks away
> Like flesh from the rough bone, is turned
> Upon a neck of stones . . .

Of all his *œuvre* it is one of the most frequently reprinted poems. The painting itself (or the photograph of it that Mervyn had taken at this time so that he could show it to Sir Kenneth Clark), was used to illustrate the cover of the Village Press edition of *Shapes and Sounds* in 1974. To the best of my knowledge, it has not been seen since.

In March Mervyn had leave and the family travelled back to Warningcamp. Soon he was ready with sample drawings for *The Hunting of the Snark*, but when he and Maeve went up to London to dine with Harold Raymond, his wife and friends he was embarrassed to discover that they had brought only one drawing with them (letter to Chatto and Windus dated 25 March, *PS*, 6: 2, 13). The fact is, he and Maeve were just going down with flu, and on their return home they both took to their beds. At least that meant that his leave was extended, and he made good use of the time, preparing more sketches for Chatto's consideration. He wanted the illustrations to express tremendous dynamism and movement (letter to Chatto and Windus dated 25 March 1941; *PS*, 1999; 6: 2, 13). Harold Raymond approved his proposals and Mervyn returned happily to Blackpool to start on the definitive illustrations.

This time, since the Army was threatening to move Mervyn for the second time that year, Maeve and Sebastian did not go up to Blackpool with him; they stayed down in Warningcamp. Then a bomb hit Maeve's mother's house in Chelsea – a direct hit, which destroyed everything, including many of Mervyn's paintings and drawings, among them what he considered to be his very best portrait

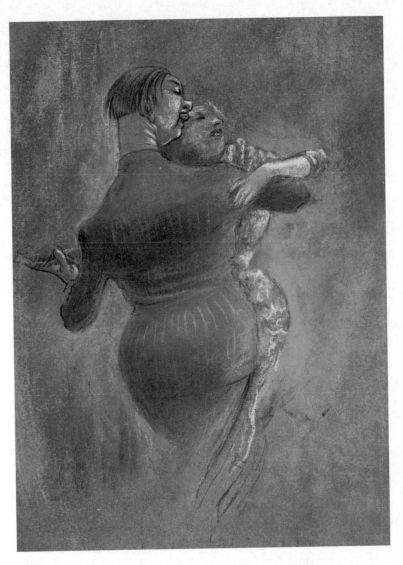

Dancing couple, probably in Blackpool, 1941;
coloured chalks with pen and ink on tinted paper

of Maeve – and Maeve went to comfort her mother in Stratford-upon-Avon, where she had taken refuge with her other daughter Ruth.

Also in April Harold Raymond invited Mervyn to submit some of his poems with a view to publishing them. Mervyn told him that he had had almost thirty poems published by then. I have found only nineteen (plus the few lines in *Satire*); either he was rather optimistic or else there are ten or so poems yet to be tracked down in periodicals. He submitted a total of thirty-eight poems to Harold Raymond in three batches, and in the end Chatto published twenty-five of them in *Shapes and Sounds*. Mervyn was, of course, thrilled at the prospect of publication and wanted to add drawings, too.

In a letter dated 29 April 1941 (printed in *PS*, 1999; 6: 2, 14–15), he argued cogently in favour of an illustrated book of poetry. He admitted that it had been done often enough before, but the illustrations had generally been poor and the result disappointing. If, however, the poems and drawings were equal in merit and imagination, the one not illustrating the other but attempting to convey a parallel experience in another medium, it would be well worth it, a completely different book, fresh and rare. As Mervyn put it without any false modesty, there are plenty of poets and even more artists, but the combination of the two in one man, in any degree of quality, is distinctly unusual. 'I'm mentioning this not in an attempt to squat on heaven's throne, Blake on my right hand and Rossetti on my left and Morris twitching between my feet but because it strikes me that there would be a freshness and a "difference" in such a book.' And he had a point there.

Chatto considered his argument and the drawings he submitted, but in the end they were not prepared to make such a bold stroke and limited Mervyn's visual contribution to the dust-jacket design. This was one of his rare symbolic works, depicting a draped figure receding between high walls; in the foreground is a large shell-like object with excrescences, embodying a human eye and ear. (The finely cross-hatched drawing is reproduced in *CP*, p. 98.) For Mervyn the shell was symbolic of sound and sight and the figure was the 'I' of the poem 'If I could see, not surfaces' which was included in the collection.

By the end of April the *Snark* illustrations were ready and Harold Raymond was full of praise for them. They were destined for a series of quite small books, and so Mervyn was delighted to hear that Chatto also planned to issue them in a slightly larger, more expensive edition.

Up in Blackpool Mervyn enjoyed another period of great creativity; his Army duties (of which he mentions but two in his letters, drilling and 'roof spotting', that is, watching for enemy aircraft from the roof of tall buildings – Steerpike's view over the rooftops of Gormenghast probably reflects this activity) left him time for himself. He made the fortunate acquaintance of the matron of a home for the blind. (In his letter to Chatto and Windus, 19 May 1941 (PS, 1999; 2, 20), Mervyn stressed heavily that she was a *professional* matron, betraying some emotion I find hard to identify; if it's a joke then I have have completely missed the point.) She let him use her room in the institution, work at her table and type on her typewriter. As she was well out of the way most of the time, going about her business in the institution, he was left in peace and quiet – perfect for working.[1]

In addition to typing up his poems for Chatto and Windus, revising old ones and adding new ones, he was making drawings for the book of poems and advancing steadily with *Titus Groan*. In the ten months from the end of July 1940 to the end May 1941 he wrote about 130,000 words, nearly two-thirds of the book. The final third was to take another thirty months.

Such advantageous working conditions were too good to last; on 3 June Mervyn learned that he was to be transferred to work in camouflage, which would have made good sense, but then the Army changed its mind, for when his posting came on 6 June it was to the Royal Engineers, No. 1 Bomb Disposal Company at the Duke of York's Barracks, Chelsea. According to Dr John Rhodes, curator of the Royal Engineers Museum, Mervyn 'had skills relevant to that Corps' (letter to GPW dated 5 October 1998), and, since he passed a 'Trade Test as [a] Draughtsman' on 14 June 1941 (according to his record of service at the Ministry of Defence), I guess that the Royal Engineers were planning to use him in this capacity. At any rate there were many good things about the new posting: he was back in

familiar territory and, what is more, in the borough favoured of artists, Chelsea. Mervyn soon found a cheap room in Store Street which he could use as a studio, and Maeve began to travel up from the School House at Warningcamp to stay with him there. There was little furniture and no cot for Sebastian, so they made a bed for him in the bottom drawer of a large chest (Watney, p. 108).

July brought the contract from Chatto and Windus for the volume of verse, listing the poems accepted. Mervyn responded with a provisional title, *Stones and Stars*, and decided on the order in which the poems should be printed. Only six of them had previously been published; they include 'The Cocky Walkers', 'Rhondda Valley' and 'Coloured Money'. The latter was substantially revised to include the lines I have placed as an epigraph to this book. For me they encapsulate Mervyn's attitude towards his writing and sum up the process of transmuting his inspiration into words and pictures. Among the new poems were the dedicatory 'To Maeve', which Walter de la Mare had liked so much, and two others which he singled out for praise when Mervyn submitted half a dozen poems to him earlier that summer: 'What Is It Muffles the Ascending Moment?' and 'London 1941'. Two more, 'The Shapes' and 'The Sounds', also evoke London's bombed houses, only less powerfully.

Among the new poems, a few, such as 'Had Each a Voice What Would His Fingers Cry?', overtly express Mervyn's reaction to the war, how his fingers clasp a barrel, not of cedar but of steel, and the lead it contains is not for drawing but for killing. Most, however, are less explicit and reveal a divisiveness that was not present in the earlier poems. 'I am / Split tree-wise inly,' he writes in 'They Move With Me My War-Ghosts', and 'My brain is webbed like water with slow weeds / These days I cannot trust it.' In 'I Am For Ever With Me' he rejects the boyish 'pirate Peake' he used to take himself for: the 'pilferer / Of hollow goods'. He finds in himself 'the boy of shoddy glamour / . . . / The penny pirate and his cheap adventure.' His rejection of the pirate suggests how deep his self-questioning had gone.

The poem closes with unexpected allusions: 'For everyone his Gabriel and the Mocker, / The stillness, and the fountain, and the Master.' This is the first explicitly Christian reference in his poetry,

and it reflects something of the depth of the conflict he was experiencing in the Army. About this time, mockery and mocking laughter began to appear in his writing; later it became a motif in his painting, centred on the crucifixion.

Being in London again, Mervyn was able to place work with periodicals, and several of the poems retained for *Shapes and Sounds* appeared elsewhere while the book was in preparation. Two went directly into an anthology called *Poems from the Forces*, edited by Keidrych Rhys, which was published later that same year.

What with work on his poetry, access to a studio for painting and the recovery of his social life in London, he got little writing done for several weeks. But he did sketch out more plans for the development of his novel. (My comments are in square brackets.)

> – Lord Groan is going mad and takes drugs to deaden the pain of losing his books. He concentrates on fulfilling the castle ritual and in the end has to be restrained by a gold chain attached to his ankle. He starts writing and is in a strange state of mind at the Dark Breakfast. [The more extravagant of these ideas were abandoned or at any rate not made explicit in the published novel.]
> – The new Master of Ritual, Barquentine [as yet unnamed], is found and proves to be possessed of immense knowledge, which is another blow to Steerpike's ambitions.
> – The war of nerves between Flay and Swelter heightens in pitch. At night Flay can hear Swelter sharpening his knife.
> – A beautiful chapter to describe Keda's departure and return to the Outer Dwellings, six months months later, pregnant.
> – Steerpike is gathering control into his hands, while
> – Irma, who is still suffering from the shock of the fire, has to be tied down in her bed.
>
> (End of 1: v; transcribed in *PS*, 1996; 5: 1, 32–3)

Beginning on 7 August he completed the chapter of 'The Burning' and its aftermath, 'And Horses Took Them Home' (up to p. 325).

We have no information as to the work Mervyn may have done at the Chelsea Barracks as a draughtsman, but the Army must have

found him to be quite unsuited to disposing of bombs: one day he absent-mindedly set fire to his room by tossing a cigarette end into the wastepaper basket. He was court-martialled but given the benefit of the doubt. It is fortunate that no one knew that he had just described the destruction of a library by arson. They might not have accepted it as coincidence. There is also an indirect allusion to this episode in *Gormenghast*. One of the teachers 'augmented the pall of tobacco smoke already obscuring the ceiling of the [Professors'] Common-room with enough of his own exhaling to argue . . . that the floorboards were alight' (p. 52).

According to Meirion and Susie Harries, Mervyn's commanding officer wrote to the WAAC in October, fervently supporting his desire to be a war artist, but he was turned down yet again with the comment: 'It was felt most important that the Committee should not, in such cases, allow themselves to be influenced by the fact that the artist might wish to get out of the Army' (*The War Artists*, p. 201). It does not appear to have occurred to the WAAC that the Army might be equally desirous to be rid of a most unpromising soldier.

About this time Mervyn swapped the studio in Store Street for a larger one in 'Trafalgar Studios' on Manresa Road (more or less opposite the old Chelsea Library); the rent was only a few shillings a week, and he retained it for more than fifteen years. It comprised two rooms on the first floor: a large studio, one wall of which, facing north, was all window, and a small utility room that served as kitchen and bathroom. Despite an enormous black stove it was dreadfully cold in the winter, but Maeve and Sebastian would come up regularly and join Mervyn there. One evening both parents went out for a short while, leaving Sebastian asleep – but on their return his bed was empty. Anguished search of the first floor proved fruitless; they went downstairs where there were four studios around an inner courtyard and finally found him in one of them, sitting on the knee of Dylan Thomas.[2]

Shapes and Sounds was published on 20 November in the same week as *The Hunting of the Snark*, which came out in Chatto and Windus's new Zodiac series of small hardbacks at just a shilling each. Paper restrictions meant that the print runs were short (a

thousand copies of *Shapes and Sounds*, of which only five hundred
were bound immediately), and Maeve reported to the publisher that
many prospective purchasers of *The Hunting of the Snark* had been
unable to buy the copies they wanted (letter to Chatto and Windus
dated 13 December 1941; *PS*, 1999; 6: 2, 26). To satisfy demand, it
was reprinted early in 1942. On 16 December Chatto also brought
out a clothbound edition at five shillings; more than two centimetres
(one inch) taller than the popular edition, it set off the drawings to
better advantage, but the print run was only 1,400 copies. *The
Hunting of the Snark* is one of Mervyn's best illustrated books, and it
has deservedly been reprinted many times since. The original illus-
trations for both this book and *Ride a Cock-Horse*, as well as five
drawings originally intended to illustrate poems in *Shapes and
Sounds*, were exhibited at the Leicester Galleries in December 1941.
One of them came up for sale recently and is reproduced in
Collected Poems (p. 92).

In a Soho pub at about this time Mervyn was introduced by
Dylan Thomas to Kaye Webb, one of the editors of the popular mag-
azine *Lilliput* (and later of Puffin Books), and she at once commis-
sioned him to illustrate a story that appeared in the issue for January
1942.[3] Over the next two years he provided illustrations to a dozen
stories, including one by Stephen Spender, and to a poem by Ruth
Pitter. Then the contact lapsed, and it was not until the early 1950s
that more of his work appeared. In his book John Watney repro-
duces a cartoon from *Lilliput* depicting an officer giving a piggy-back
to a soldier 'with Mervyn's unmistakable features' (pp. 116–17), not
realizing that this particular copy of the cartoon had been doctored
by Mervyn to look like himself. In the cartoon as actually printed
the soldier bears no resemblance to Mervyn at all. Watney was taken
in by Mervyn's own joke about himself.

During this exciting time Mervyn was unexpectedly transferred
on 13 December 1941 to the School of Surveying at Larkhill, near
Salisbury. No doubt the Army had just arrived at the brilliant con-
clusion that a man who could draw (Draughtsman Class III) should
be good at making maps. However, Mervyn proved to be no more
adept at the principles of triangulation using theodolites than he had

been with anti-aircraft guns or trucks. According to Eric Drake, he stood up at the end of the class one morning and told the instructor, 'For you the figure 7 may be just a number, but for me it's a voluptuous curve', and struck a pose to illustrate his point. Maeve tells a slightly different version of this story, in which Mervyn saw 6, 9 and 0 as feminine and 1 and 7 as masculine (Gilmore, p. 47). Eric Drake, however, was adamant that his memory was correct:

> With due respect to Maeve, I stand on what I have said about the 'voluptuous curve' of the figure 'seven', and would do so on oath if necessary. What someone else reported on some other occasion is irrelevant even if inconsistent – which it isn't, if one stops to think: the figure seven can be written in two ways, with straight lines or with curved. In the first way it is conceivably masculine, in the second way equally conceivably feminine – the hand and curving arm, the concave for the waist, and the convex for the hip. It was the latter that Mervyn sketched so eloquently at full arm's length with a gesture I have never forgotten. Add to this that Mervyn was dramatizing his point in front of an audience to the discomfort of the teacher: say 'eight' and the effect is killed, but say 'seven' . . .? Again, sketch 8 in the air (requiring two hands) and the effect would be pure music hall, while Mervyn's 7 refined the figurative into the abstract as did his words: 'voluptuous' indeed, but not a woman, a 'curve'.
>
> (Letter to GPW dated 29 August 1979)

He was sent to the commanding officer, who was fortunately an understanding man: after Mervyn had told him about his poetry and writing, he decided that Mervyn could carry on with these activities until such time as his transfer to a more suitable unit could be arranged.[4]

In the event, it was not his novel that Mervyn worked on but a new long poem, *A Reverie of Bone*, which was not published until 1967 when it was included in a slim volume of poems, to which it gave its title, in an edition of 320 copies from Bertram Rota. Here Mervyn reflects on how long our bones outlive our flesh, how the hand that props his forehead is no more durable than the frost on

the morning fields. He evokes a Rider in purple, observing how locks of his hair lift in the sunny wind but seeing, too, how his legs are twin femurs astride the scaffolding of the sunlit arches of his horse's ribs. While there are verbal echoes of Keats's 'Ode to Autumn', this kind of X-ray vision recalls some of Blake's engravings: Plate 20 in the *The Book of Urizen*, for example, shows a crouching figure whose flesh is but a pink halo around the skeleton. It also takes us back to John Donne's meditation on death and his thought that when his grave is reopened, 'some second guest to entertain', the gravedigger will see 'a bracelet of bright hair about the bone'. Some, but by no means all, of the obscurities in Mervyn's poem are elucidated when we recall that among his favourite ornaments were vertebrae from a whale that he had found on a beach on Sark.[5] Furthermore there are numerous early burial sites in the neighbourhood of the camp, which was itself only a few miles from Stonehenge; it is possible that he witnessed the uncovering of a tomb or saw remains in one of the local museums.

Passing through London at the end of February he learned that the first five hundred copies of *Shapes and Sounds* had already been sold and took cognizance of the reviews. That month Stephen Spender, writing in *Horizon*, revealed that

> Mervyn Peake is a poet who impresses me by his sincerity. His writing is technically weak, but there is a genuine feeling for life, and also a genuine personality behind it, combined with a sense of words that is sometimes striking. His poems are enjoyable, and he must be a remarkably sincere and intelligent person.[6]

We can wonder whether Mervyn was flattered by this assessment of his verse; Spender's appreciation of his personality and the emphasis on sincerity was, in lieu of criticism, a mere sop. Mervyn returned to writing his novel; the chapter called 'The Dark Breakfast' is dated 1 February 1942. He also took the opportunity to talk to Sir Kenneth Clark and propose – no doubt thinking of his visit to the Rhondda Valley six and a half years before – that, as a war artist, he might depict miners at work.

He was waiting for an answer to this when he was posted at the beginning of March to a camp at Low Moor, near Clitheroe.[7] This was the Royal Engineers' No. 1 Depot Company, where new recruits came for basic training and where others, like Mervyn, were parked awaiting transfer or discharge. They lived in huts and tents in the shade of a huge disused cotton mill that the Army had taken over for stores and training. Now long since demolished, the mill was one of the largest in the area; unlike the box-like shape of so many cotton mills, it comprised two long wings on either side of a central structure. From contemporary photographs, I calculate that on the façade overlooking the river, where sappers learned to assemble the Bailey bridge and pontoons, there were about three hundred windows, and I suspect that this mill helped inspire the dreaded factory whose windows, each filled with an identical face, are reflected in the waters of a lake in *Titus Alone* (pp. 167–8). It certainly inspired Mervyn with powerful feelings.

John Watney paints a lurid picture of this camp; according to him, it was swept every now and then 'with epidemics of gingivitis and scurvy' (Watney, p. 109). The Curator of the Royal Engineers Museum, Dr Rhodes, is understandably more cautious: 'Conditions, I would have thought, would have been dull and uncomfortable rather than unhygienic, for many of [the men] would have remained in the Company for only a very short time' (letter to GPW dated 5 October 1998). Whatever the truth of the matter, Mervyn was clearly determined to get out of the camp as fast as he could. On arrival, he hastened to inform Edward Dickey of his new address, and, having understood that the difficulty of obtaining work as a war artist consisted not only in persuading the WAAC of his ability but also in persuading the Army to relinquish him, he passed on the names of both his immediate commanding officer and the commander of the camp.

A prompt response informed him that the committee had postponed its decision pending the return of Sir Kenneth Clark. Mervyn remained hopeful, as Sir Kenneth had been pleased with his idea of drawing miners when he told him about it in London. Yet he wrote dispirited letters to Maeve and Goatie:

Oh God, I'm sick, sick, sick of it . . . they've done nothing but muck
me about from unit to unit. Granted, I'm hopeless, but I wouldn't
be if they'd put me into something where my talent could be used.
. . . If they put the wrong people in the wrong jobs at the bum end
of the army they probably do the same at the scalp end.

> (Letter dated 7 March 1942; in Smith, p. 82)

He was also worried about his brother, from whom he had had
no news since the fall of Singapore. 'I don't know what I'd do if I
heard that he'd been killed. I just want to cry when I think of the
stupidity of the whole bloody, ghastly, sordid business' (letter dated
7 March 1942; in Smith, p. 85). Lonnie had, in fact, been captured
and he survived the war; his wife Ruth and their two children had
been evacuated in good time to Australia, but Mervyn was not to
learn this for many months.

In the meantime, it was solace to return to writing. By 5 March
he had reached the middle of page 362, where Swelter is looking at
the disobedient kitchen boys and thinking they will save him having
the trouble to invent some reason or another for punishing 'a brace
of their ridiculous little brothers'. This is the first sign of viciousness
in the novel and signals the stress that Mervyn was under; he even
expressed irritation at 'the monotonous conversation of what I sup-
pose are my comrades' (letter dated 7 March 1942; in Smith, p. 82).
A few days later he described Fuchsia's distress at seeing her father go
mad as he sat 'huddled in the middle of the broad carven mantel-
piece' (p. 365); Sepulchrave makes no answer, 'and she becomes
older during these long moments, older than ever a man or a woman
could ever understand' (p. 366). 'Father's become wrong, Dr Prune;
Father's become all wrong,' she cries (pp. 368-9).

Maeve was expecting another baby at the end of March, and she
found a thatched cottage for rent, just at the foot of Dr Peake's
garden, called 94 Wepham. Mervyn helped her move there during
the ten-day leave he had from 16 March. Consequently he was back
at Clitheroe when his second son Fabian was born on 2 April, and,
since he had just been on leave, he was refused permission to go and
see him. He promptly forged a pass and hastened down to the Peter

Pan Nursing Home, Rustington, where Maeve had been aided by a nurse appropriately called Wendy. After his weekend in Never Never Land he returned to the kennel, as it were, at Clitheroe; there he was confined to barracks for going absent without leave.

Again his writing reflected events in his life: straight after his visit to Maeve, with memories of new-born Fabian in his mind, Mervyn began describing Titus lying on the Countess's bed; in preparation for the Dark Breakfast he is trussed up 'in a small velvet cylinder, or mummy . . . His eyes are very wide open . . . his mouth puckers and works, and the heart of the earth contracts with love as he totters [for *teeters*, I expect] at the wellhead of tears' (p. 370). At this point there is also more emotion in his writing.

Unknown to Mervyn, his project had been approved at the meeting of the WAAC on 1 April 1942:

> It was agreed that he be made a special case and be recommended for two months release from his military duties to enable him to carry out a commission to draw [South Wales] coal mining subjects [for 25 guineas]. While it was thought that there might be some artists serving in the army who were more aesthetically gifted than Mr Peake it was nevertheless agreed that he was likely to carry out this particular commission with success. (PS, 1991; 2: 2, 11-12)

The following day Edward Dickey communicated the decision to Colin Coote, the War Office representative on the WAAC, adding: 'I shall not write to Peake about this until I have heard from you that you are writing to his CO.'

So Mervyn was unaware of this decision when he wrote to Edward Dickey, five days later, with the latest news in the saga of his military career. Some time before, the Army had decided that his category was to be lowered, but the decision had not taken effect because the authorities had mislaid his documents. On 15 April he was called into the company office and shown a letter requesting his medical history sheet and category, prior to posting him to yet another destination. This, too, was shelved pending the rediscovery of his papers.[8]

It is quite possible that this posting was, in fact, the proposed release as a war artist, and he was more than ready for it. From the terms of forced enthusiasm in the letter he wrote to Edward Dickey on 15 April, it is clear that he was desperate to get out of Clitheroe and into something useful: the idea of drawing the miners seemed to be 'as thrilling a subject as I can imagine'. He assured the WAAC that he was 'eager to produce, not only something important in the aesthetic field but [also] a constructive contribution to the whole multi-sided war effort by showing what happens beneath the earth' (*PS*, 1991; 2: 2, 13).

Not receiving clearance from the War Office, Edward Dickey noted in an internal memorandum on 20 April: 'I am writing to Mervyn Peake to tell him that we cannot do anything for him. I hope you will have better luck with Carel Weight.'[9] In all probability there was simply an administrative hitch caused by Mervyn's papers being mislaid, for there was no point in the Army holding on to him when it had not found any use for him.

We can imagine Mervyn's bitter disappointment on receiving this news. Yet he was back with another proposal only a week later; this time he tried to interest the WAAC in *The Works of Adolf Hitler*. He had been in correspondence (that I have been unable to trace) with a John Baker of the Publications Department of the Ministry of Information; he may be the person who had originally purchased the Hitler pictures. At any rate, Mervyn had been expressing his desire to redraw the series now that the idea had matured in his mind. He felt he could produce something that would be simpler and at the same time more powerful. Apparently John Baker had concurred with the proposal, and so Mervyn went round to his commanding officer to seek permission for leave to work on the pictures. But the Army did not grant leave as easily as that. Although he was sympathetic, Mervyn's CO told him that he had to take up the matter with the colonel who in turn would probably have to pass on the request to the War Office.

So Mervyn needed fresh letters of recommendation, and he asked Sir Kenneth Clark for one. He kindly responded at once:

7th May 1942

Sapper Mervyn Peake, 1592537 is one of the most skillful artists of his generation and has a particular aptitude for propaganda drawings. Those which he has done already are the most powerful and effective of their kind which I have seen, and I think it would be in the National interest that he should be allowed to do more.

While Mervyn's papers were mislaid, not even this generous note could move a CO. In his letter of thanks, Mervyn added:

By the way, I hate doing propaganda work myself (as such) but sometimes the ghastly things one reads about makes one want to fight back somehow or other against the perpetrators whoever they are – & my only weapon's a pen. Probably most 'impure' art. What the hell does that matter as long as one is saying something that one feels still remains to be said. Whether it has value comes afterwards. Heigh ho . . . ! (Letter dated Friday, probably 8 May 1942)

About this time he sent two of his Hitler series to Augustus John, perhaps with a request for another recommendation. Answering on 28 July John expressed the hope that 'you will find it possible to carry out your project of a series of drawings . . . So far one has seen little but the comic side of warfare treated by alleged draughtsmen. You, like Goya, are interested in the serious side.'

Mervyn also asked Edward Dickey if it would be possible for Brendan Bracken, the Minister of Information, to look at one or two of the pictures and give him a reference that he could make use of (see letter of 27 April 1942, printed in *PS*, 1991; 2: 2, 15). In the Ministry of Information file, however, there is no copy of an answer to this proposal. There is just a note by Edward Dickey at the top of the letter to the effect that he had told Mervyn he would do all he could. It is likely that Mervyn learned by telephone that this suggestion had been turned down as well.

Outwardly he seems to have remained optimistic, but when he wrote to Harold Raymond on 19 May he was using a boxing metaphor that did not bode well. 'I am as usual fighting the authorities,' he said.

There was just a hope that he would soon be down in London again, as 'Round 9362110711 seems to be going in my favour so far' (letter to Chatto and Windus printed in *PS*, 1999; 6: 2, 30). But he lost the round, for as the days passed he became depressed, unable to sleep at night and, of course, tired and irritated all day. The crunch came when he broke a bootlace and started to weep. Wisely he took himself off to see the Medical Officer, and on 27 May 1942 he was admitted to the military wing of Southport Emergency Hospital diagnosed as having had a nervous breakdown.

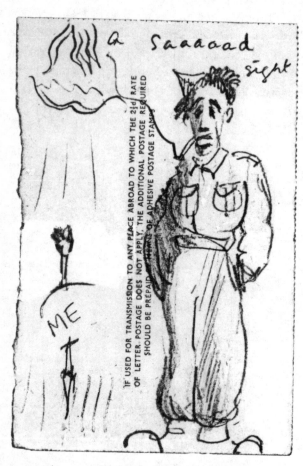

'A saaaaad sight'; a caricature of himself
that Mervyn sent to Kay Fuller

13
Southport, 1942

NOTHING could be more understandable than depression at such a point: Mervyn had been parked in a depot company, useless to the Army, and the one service he ardently desired to render was denied him. Nor does he seem to have been badly depressed, since he could still view himself with humour, albeit a little uncertainly. When he wrote to Chatto and Windus on the day after his arrival at Southport Emergency Hospital he told them:

> I imagine I'm here for a month at least, and I must say it feels as though I'm in an asylum. People go about grinning suddenly at nothing, and make exaggerated gestures – perhaps I do too, but I don't think so. . . .

After life in the camp at Clitheroe there were distinct advantages to being in an institution:

> It is wondrous to sleep between sheets again, and to have hot water to shave in; and baths whenever one wants them, and no parades – Good old neurosis – but perhaps not (he added as his pen shot out of his fingers as of its own volition and he took a bite out of the table).

He was also sufficiently detached to comment on the strange, blue, pyjama-like clothing with which he had been issued:

> There are no trouser pockets. This is the most dreadful thing that
> can happen to any man, to be given trousers which have no
> pockets. It is guaranteed to give the most violent form of neurosis,
> surely, to even the most healthy of men, but to give such torturing
> things to us 'inmates' is the worst psychological blunder I have
> come across so far.
>
> (Letter to Chatto and Windus dated 28 May 1942; *PS* 1999; 6: 2, 32)

We might note that in this letter Mervyn twice uses the word 'neuro-
sis', rather than 'depression' or any other synonym for a breakdown,
and I can only assume that his doctors must have used it to describe
his condition, for it seems an unlikely epithet for him to have
applied to himself.

At Chatto and Windus this letter came as a great surprise and
Harold Raymond responded magnificently by return of post with
the suggestion that Mervyn should illustrate *The Rime of the
Ancient Mariner* – 'about as Peake-ish a subject as we could think
of'. Given the paper shortage, he exclaimed, 'how and when and
on what we could produce the book, God only knows, but if you
fall for the idea, we would start collecting old envelopes, bun bags
and train tickets now' (letter to Mervyn dated 2 June 1942). It was
to be another Zodiac book, with four full-page and six half-page
illustrations.

Mervyn was delighted at the prospect of working on such a master-
piece and responded in a long letter (which unfortunately does not
appear to have survived) in which he also told Harold Raymond
more about *Titus Groan*.[1] Throughout this tense period he had con-
tinued writing, and the stress he had been under is reflected in the
book: at this point all the characters are either behaving strangely,
like Lord Groan who thinks he is an owl, or are acting under great
duress, like his manservant Mr Flay, who has pearls of sweat on his
forehead as he obeys Lord Groan's strange orders, although it is cold
(p. 370). Questioned by the Countess, Nannie Slagg 'clutches her
hands together. Her bleary eyes grow wild. Her lips tremble' (p. 372).

For the first four days in the hospital Mervyn was not allowed out.
That was frustrating because he could see Southport's wide sandy

beach and the sea through the windows. What better therapy than to continue writing *Titus Groan?*[2] And write he did, filling his notebook by the end of the month. The first scene that came to his pen was Chapter 54, 'A bloody cheekbone', in which Flay, having flung a cat at Steerpike (who had mimicked the Earl in his madness), is banished from the castle by the Countess.[3] Then he filled a second one (which he headed 'Occupational Therapy, June 42, Southport'), beginning with 'The Reveries' and continuing with Keda's return to the Mud Dwellings. The end of the notebook is dated 24 July 1942, and there, at p. 411, he stuck. Knowing what was to come, we may sympathize with him: Lord Groan was to drag the dead Swelter into the Tower of Flints as an offering to the death owls, there to meet his own death; this is closely followed by Keda's suicide, witnessed by Flay, in Chapter 63, 'The Roses Were Stones'. Not exactly the best kind of thoughts for a person recovering from depression.

Luckily Mervyn had other projects to occupy his mind, not only *The Rime of the Ancient Mariner* but also a new commission from Batsford, which he had received some weeks earlier: illustrations for a new book on *Witchcraft in England* by Christina Hole.[4] As he was under contract to Chatto and Windus he checked with them whether they would allow him to do illustrations for another publisher; they responded favourably, worried only that the topic of witches might 'undo all the work we have done in steering you away from the horrific' (letter dated 15 June 1942). By August a third publisher, Faber and Faber, had approached him with a request that he illustrate C.E.M. Joad's *Young Soldier in Search of a Better World*, so his professional prospects were looking good. But at Southport he was unable to complete any drawing to his satisfaction because he was so 'jittery', as he put it in a letter to Goatie (Smith, p. 88). This is an interesting comment. If being 'jittery' prevented him from completing drawings it could mean that he had shaking hands, and shaking hands was the first symptom of the condition that Mervyn suffered from in the 1950s and from which ultimately died. If he had it in 1942 it disappeared for over ten years.

During the long hours of occupational therapy Mervyn's hand was steady enough for him to draw 'strange animal shapes' (Watney,

p. 113) and cut them out of cardboard. Having coloured them and added the address and a stamp, he would send them off to Maeve and his two sons. He also developed his musical skills. Although Mervyn had never formally learned an instrument, he was musical enough to play a ukelele on Sark (Watney, p. 55, quoting a letter from Lisel Drake), and in Blackpool he had bought himself a Tipperary whistle, a kind of flute, on which he played simple tunes well enough to recognize them, 'especially if I shut my eyes'. Now he made himself a couple of bamboo pipes, one in A and one in D, and developed his skill. On his return home he continued to play for a few years, while Maeve accompanied him on the piano. It will be recalled that Steerpike plays a similar instrument, somewhat eerily, in *Gormenghast*.

In mid-July Mervyn was given leave to go up to London for an interview at the Ministry of Information. I have found no official record of it, but the result was positive, which must have given him a tremendous uplift. Nevertheless, the doctors kept him in the Southport hospital for four months, much longer than the single month he had anticipated. Releasing him on sick leave until the end of the year, the chief medical officer recommended that he be discharged from the Army if work using his qualifications could be found for him (WAAC minutes, 20 January 1943, p. 133). He hastened down to 94 Wepham, where he was reunited with Maeve, Sebastian and little Fabian, now six months old; Mervyn had not seen him since his birth.

14
London, 1942–1945

WORK was found for Mervyn in the studios of the General Production Division of the Ministry of Information, which was housed in the University of London Senate House. Exactly what he did there is not known. 'General Production' was primarily 'commercial' in character, but it is just possible that he produced some drawings that were used for propaganda. Certainly a postcard lampooning Hitler and Mussolini as a wedding couple surfaced quite recently (it is reproduced in *MPMA*, p. 67); the language of the caption suggests that it was for distribution in South America, but it is undated and could have been issued at any point in the war.

He began work on 5 October 1942, having taken a room at 44 Frith Street, Soho (in which he was photographed by Bill Brandt), and by the end of the month he was given a contract until the end of January. During this period, he worked on the illustrations for the *Ancient Mariner* and called in on Chatto and Windus with his designs. They were pleased to approve them and sent him an advance of £5, asking him to acknowledge receipt of it some time, 'certainly before you go to Russia' (Chatto's copybook letter 343, dated 10 November 1942). So it would appear that Mervyn nourished hopes of travel, presumably as an official war artist. His colleague from the Westminster School of Art, Elmslie Owen, had become secretary of the WAAC on 23 September 1942, and this was to make a considerable difference to his prospects.

In the meantime he was also working on illustrations for *The Adventures of the Young Soldier in Search of the Better World*, whose title echoes George Bernard Shaw's *Adventures of the Black Girl in Her Search for God* (1932); it was a response to Sir Stafford Cripps's promise of a better and happier world after the war. The author, C.E.M. Joad, was head of the Department of Philosophy at Birkbeck College, University of London, and a popular radio personality. In the preface he commented, not without a degree of self-congratulation, on Mervyn's contribution to the book:

> I cannot, I am afraid, resist the temptation of adding a word of apology to readers for the frivolity of some parts of this work. It was conceived in a solemn, albeit a satirical vein, but when I came to the writing of it, cheerfulness would keep breaking in ... Then came Mr Peake's gorgeous pictures and made matters worse. How could one keep a wholly straight pen while writing a letterpress round some of his richer conceits? I see that what began as an apology is developing into a justification, so I will content myself with asking the reader not to allow the levity of the author, the irresponsibility of the characters and the exuberance of the illustrator to distract his attention from the gravity of the issues which they are jointly concerned to present. (p. 5)

As this implies, Mervyn's illustrations were an inspiration to the author, who rewrote parts of the book the better to take advantage of them. The converse was not necessarily the case: some passages were written with a view to inspiring the illustrator, but Mervyn did not always rise to Professor Joad's bait.[1]

Time has confirmed the sly suggestion made by the *Times Literary Supplement* on 4 September 1943 that 'it would serve [Joad] right if his book came to be valued less for the text than the illustrations, as it might be'. Mervyn's illustrations are indeed the best part of the book; even the *Church Times* overlooked its anticlericalism to recognize that 'these pictures ... double the value of the book' (10 September 1943, p. 465). They are at the same time highly satirical

and beautifully executed. The book was reprinted three times within a year and also published in the United States.

It would appear that Mervyn did not actually do the drawings as quickly as promised. Early in 1943 he moved to 43 Store Street, even closer to Senate House, and Goatie Smith recounts in his memoir how he and Mervyn found a whole series of reminders from Professor Joad, in rising tones of exasperation, on the door of the old room when they went round to collect the last of Mervyn's things.

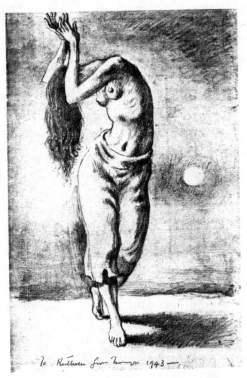

A drawing on the flyleaf of a copy of *Shapes and Sounds*
inscribed to Ruthven Todd

About this time Mervyn confessed to Goatie that he was worried that he should have broken down in the way he had the year before, so Goatie arranged for him to see a Harley Street specialist of his acquaintance, Dr William Brown. Nothing is known of the single

consultation, but I expect that the doctor (whom Mervyn described as being like a great eagle) was sympathetic and reassuring, for Mervyn remained, outwardly at least, as blithely cheerful as ever, as the following anecdote shows.

Early one morning he wanted to get Goatie into the Ministry of Information, where the cafeteria did a good breakfast.

'Wouldn't I need a pass or something,' asked Goatie, glancing down the road at the armed sentries and coils of barbed wire. 'Tight security, I imagine.'

'A mere modicum,' rejoined Mervyn. 'Not a plethora. Don't worry so.' And on the admission slip he drew 'a very small elephant with a very large navel' (Smith, p. 90) and waved it cheerfully under the noses of the guards as they walked in unchallenged. It was a good breakfast.

Now that Mervyn was employed at the Ministry of Information and an ex-colleague of his was the secretary of the WAAC, conditions were right for his appointment as an official war artist. Elmslie Owen pointed out in a report to the committee that Mervyn's 'highly individual style' was not really suited to the General Productions Division and that his contract was due to end on 31 January 1943.[2] On 20 January 1943 the WAAC decided to commission Mervyn to execute 'a painting and some drawings of a Glass Works', for which they offered him the sum of thirty-five guineas. This meant that his return to the Army after sick leave was deferred by two months, that is, until 6 April. They also sent details of the allowance for working away from home and strict instructions concerning secrecy. 'I must caution you', intoned the commissioning letter, 'not to show any of these works, even to your friends, before they have been submitted by us to the censor.' Ownership of 'the original picture and drawings and all rights of reproduction in any form shall be vested solely in the Crown'. Mervyn signed the forms and was directed to the glass factory of Chance Brothers, Spon Lane, Smethwick, where they were blowing cathode-ray tubes for 'radio detection and ranging' equipment – now known simply as radar, of course. Originally developed for television, the tubes were fitted in RAF aeroplanes to display the relative position of enemy

aircraft and formed a key component of Britain's defence system, thus meriting recording by a war artist.[3]

This proved to be an important commission for Mervyn, not merely because he was at last doing the kind of work he had aspired to for fully three years. At the factory he became fascinated by the skill of the glassblowers as they transformed with balletic motion mere sand into glass vessels: another vast alchemy. In their work he saw an analogy with the creation of man, when life was breathed into dry bones, and a parallel with his own inspired act of creation as he turned the material world into art. They would dip their blow-pipes into the molten glass and then, keeping a gobbet of glowing glass spinning at the end of the pipe, blow down it to create the hollow flask shape that we all know as 'the tube' of our televisions. To maintain an even flow of air down the pipe, the glassblowers plumped their cheeks in a characteristic manner that Mervyn captured perfectly in his drawings. He made a great many sketches and several large paintings, not all of which went back to the WAAC. As he sketched, he found that phrases and verbal images, 'tangential or even remote from what was actually taking place before my eyes', came to his mind.[4] These evolved into a poem about the work of the glassblowers, published in the volume to which it gave its name, and also a prose piece that appeared in a magazine called *Convoy* in 1946 (reprinted along with many images in *MPMA*, pp. 70-3).

Mervyn submitted his commissioned drawings and a sketch for the oil painting the end of March 1943, reminding the WAAC at the same time that he was due to go back to the Army on 6 April. The committee responded by commissioning a large oil painting, for which it would pay £162 10s and which was to gain him a further deferment of three months. But that was soon irrelevant: he went before the Medical Board at Queen Alexandra's Hospital, Millbank, on 15 April and was discharged on medical grounds at the end of the month. The commission was confirmed, to take effect from 11 May. Unfortunately Mervyn failed to acknowledge it and difficulties arose later over the payment. Furthermore, despite his interest in the subject matter, he was extremely dilatory over making the painting, submitted several smaller ones and finally, despite

reminders, delivered the large one only in February 1944 (see *PS*, 1991; 2: 2, 32–40). Clearly, other matters had arisen that were of greater interest to him.

First, there were the drawings for *The Rime of the Ancient Mariner*: in mid-February 1943 he carried the finished illustrations to Chatto. A few days later Harold Raymond wrote to him expressing grave doubts about the figure of Life-in-Death, 'the leprous lady', as he put it, whom Mervyn had depicted with large hypnotic eyes, perfect skin barely covering a noseless skull, her torso a mere skeleton, her clasped, fleshless hands occupying the foreground. It was too terrifying. Tactful but firm, Chatto declined to publish it and offered to pay for a replacement drawing. A week later Norah Walford, their art editor, also wrote to him, acknowledging safe arrival of the drawings and wondering if any alternative to the lady was to come. Only shortly before this, on his way home from the glassblowers in Smethwick, Mervyn had met up with Eric Drake again, which will have reminded him – if a reminder was needed – of his principles of artistic integrity and fidelity to his inspiration. So when he visited Chatto on 10 March he declined to change his drawing and refused to replace it with another. The book appeared without an illustration of this scene. Thirty years later, when the drawing no longer shocked in the same way, Chatto and Windus reissued the book in a large format, complete with the leprous lady. In the meantime she had appeared in Tambimuttu's *Poetry London* X (1946); the impact of the illustration was such that it was plagiarized, by an artist unknown, on the dust-jacket of *The Hounds of Tindalos* in 1950 (reproduced in *PS*, 1993; 3: 3, 21).

The Rime of the Ancient Mariner was a great success right from the start: the entire first edition was snapped up within a week, and only the wartime shortage of paper prevented Chatto from reissuing it at once. Over the years, however, it has become the most frequently reprinted of Mervyn's illustrated works. In 1997 it was celebrated as one of the most powerful interpretations of the *Rime* in a bi-centenary exhibition dedicated to 'the poem and its illustrators' (see *PS*, 1998; 5: 4, 45). One of the original drawings is reputed to be in a royal collection, and Mervyn was justly proud of it. The others were acquired

by the Wordsworth Trust at Dove Cottage in 2007. In 1958 C.S. Lewis, having just discovered *Titus Groan* and *Gormenghast*, wrote to Mervyn, who responded by sending him a copy of the *Rime*. Here is part of Lewis's assessment:

> I find the pictures very satisfactorily 'horrid' – using the word in Miss Morland's sense.[5] The Mariner himself (facing page 6) has just the triple chord I have sometimes met in nightmares – that disquieting blend of the venerable, the pitiable and the frightful. But at the same time – thanks, I suppose, mainly to the position of the arms – the horrid representation is a graceful thing. (I give no praise to picture or story which does not fulfil both demands. What the, so to speak, 'plot' requires representationally must coincide with what the 'thing' requires in order to be a delightful object.) And that of course explains (it took me quite a few minutes to see this) why you represent almost exclusively the terror – what corresponds to S.T.C.'s 'nook in the leafy month of June' being done by your line. Thus while few things could be nastier (in what it represents) than the picture facing page 30, the composition of it is a harmonious tranquillity. The very lines which make the Mariner a hideous and rigid man simultaneously make him a shape as charming as a beech tree. Another beautiful example is that facing page 24: to the imagination, all ruin, despair and monstrosity, but to the eye as relaxed and liquid and gentle as a willow hanging over a pool. 'Abstract' and 'photographic' art (with their literary equivalents) are simply two alternative refusals of the real problem.[6]

Another book that Mervyn illustrated at this time was Quentin Crisp's hilarious limerick sequence, *All This And Bevin Too*. (The title derives from the 1940 film *All This and Heaven Too*, starring Bette Davis, based on the 1938 novel of the same title by Rachel Field.) At forty-eight stanzas it is among the longest sequences – as opposed to a series – of limericks in English, and an excellent one at that, without a single indecent line. Ernest Bevin was a trade-union leader who, as Minister of Labour in Churchill's national government, set about persuading non-conscripted citizens to volunteer for

war work. They did so in great numbers, although many complained at the extraordinary bureaucratic complications that this entailed. Hence Crisp's satire of the patriotic Kangaroo, who heeded

> the wireless announcement that pleaded,
> > or read in the press
> > the distressed SOS
> saying 'KANGAROOS URGENTLY NEEDED'.

Filling in the inevitable form, he quite understandably gets stumped by paragraph 472:

> It said, 'Kindly state how and when
> in the future, the past or since then
> > either you or your mother
> > or father or brother has ever?
> And will they again?'

Having none the less been accepted, he is sent, in what might seem like a parody of Mervyn's own experience of the Army, 'to a school with a foal / being trained as a mole / and a finch being trained as a filly'.

In his autobiography, *The Naked Civil Servant*, Quentin Crisp recounts with self-deprecating humour how he persuaded Mervyn that a publisher was dying to print his illustrations and the publisher that Mervyn was dying to illustrate Quentin Crisp's book, with the result that it was illustrated and published in record time. Mervyn's drawings are the perfect complement to the poem, executed in a tongue-in-cheek style that combines the fine cross-hatching he had initiated in the *Rime* with the line-drawings of Londoners and zoo animals from his head-hunting days.

At this point, too, Mervyn decided to have his unfinished novel typed up; he submitted it to Chatto and Windus on 28 May, telling them that it was but the first third of a much larger work. He had thought of it all along as illustrated – 'in fact I have left out descriptions which I would otherwise have inserted had I not decided I could be more graphic with a drawing' – and said that he planned to

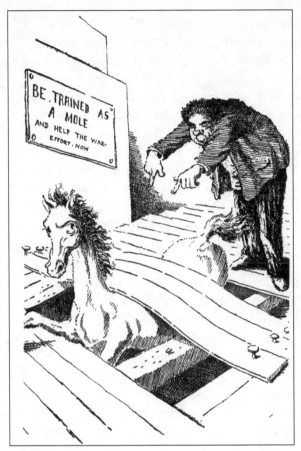

The foal being trained as a mole, from *All This and Bevin Too*, 1943

make about sixty drawings for each of its parts. 'I plan a portrait gallery at the beginning of the book giving front face and profile, so that the reader can refer back.' There were also to be 'maps, diagrams and drawings of the action, etc.' (letter to Harold Raymond dated 28 May 1943; *PS*, 1999; 6: 2, 36). I fear this might have given the impression that these were crime novels, with 'mug shots' from police files as prefatory material.

Mervyn certainly had an attentive publisher, for less than a month later Harold Raymond had already read through the lengthy typescript. He wrote to Mervyn, however, in some perplexity; he

wished to send it out to a reader for a second opinion, as he found it prolix and sometimes ill-structured, and he wondered if Mervyn would be prepared to prune (letter of 22 June 1943). From the notes he made it is clear that he was also bothered by the shifts of tense. Mervyn had written whole chapters in the present tense, almost as though he were giving a running commentary on the action as it unfolded in his imagination, and then he would shift back to the past, without apparent rhyme or reason. When he came to revise the book he put almost everything but the reveries into the past, which caused some local infelicities but otherwise left the text with a tangible fresh-ness, a sense almost of continuous surprise at events, that contributes to the unique flavour of the work. At this point, however, Mervyn could not think of anything he wanted to remove. On the contrary, it was the sort of book that might appear long and rambling but whose true proportions would become apparent when set beside the second and third parts that he planned to write (letter to Harold Raymond dated 23 June 1943; *PS*, 1999; 6: 2, 37). Two days later Harold Raymond returned the manuscript: without cuts he would not consider publication.

Mervyn was not unduly dismayed. That spring he had made the acquaintance of Graham Greene, who in mid-1940 had become one of the directors of the publishing house of Eyre and Spottiswoode. Although he was employed by MI6, Graham Greene 'continued to receive his [annual] £100 tax-free [entertainment] allowance' from the publisher. This enabled him to scout for talent and build up Eyre and Spottiswoode's fiction list, which was weak. It was also a way for the publishers to ensure that Graham Greene went back into the firm after the war – which he did after he resigned from MI6 in June 1944.[7] He and Mervyn had met in the literary circles that gravitated around the pubs and cafés of Chelsea. Mervyn had told him about his novel and shown him the opening chapters, including the prologue. So it was to Graham Greene that Mervyn wrote at once when he heard on 5 May that he had been discharged from the Army. It was a grand feeling, he told him, because this meant he could concentrate on finishing *Titus Groan*. And he went down to 94 Wepham for a fortnight's steady writing. It was also to

Graham Greene that he turned as soon as he received the rejection from Chatto. Greene recommended that he should contact the managing director of Eyre and Spottiswoode, Douglas Jerrold, with a view to discussing not only the novel but a project for an illustrated book. Mervyn telephoned at once, but it was not until 21 July that he had an appointment.

At the interview Douglas Jerrold expressed surprise that Mervyn should want to illustrate his book; he felt that this would be liable to place it apart from 'fiction', making a sort of ivory tower of it. Although no firm decision was made at this point, it was clear that the publisher was not interested in the idea. Mervyn, on the other hand, did not forget it as is shown by the letter he wrote to the Society of Authors when it came to drawing up the contract for the book in April 1944 (see p. 130).

As for the new project, the book to be illustrated was *Household Tales* by the Brothers Grimm. Mervyn took to the idea at once and told Graham Greene that Jerrold had mentioned £150-worth of drawings, which was far more than Chatto and Windus had ever offered him for illustrations, although it hardly compared with the Ministry of Information's payment of the same sum for twenty-four Hitler pictures. The editor he was to work with, Ruby Millar, showed him the format that they had in mind, an unusual squarish shape, and he was delighted with it. In short, he was thoroughly enthusiastic about the whole project and planned to work on it down at Burpham.[8]

Titus Groan was not yet finished, nor had Douglas Jerrold read any of it. Mervyn assured him that he would need only about ten days to a fortnight to write the last chapter and get the last four chapters typed. In this optimistic frame of mind he wrote Chapters 62–9 (pp. 439–506) – rather more than four chapters – in July and August 1943, reaching the end of the book, with the poetic scenes 'By Gormenghast Lake' and 'The Earling', after three years of writing. The closing words are far more upbeat than the 'Nevertheless' he had originally planned to end with.

He hastened to send the completed novel to Graham Greene, whose reaction came as a great shock to Mervyn:

Dear Mervyn Peake,

You must forgive me for not having written before, but you know it's a long book. I'm going to be mercilessly frank – I was very disappointed in a lot of it and frequently wanted to wring your neck because it seems to me you were spoiling a first class book by laziness. The part I had seen before I of course still liked immensely – though I'm not sure it gained by the loss of the prologue. Then it seemed to me one entered a long patch of really bad writing [with] redundant adjectives, a kind of facetiousness, a terrible prolixity in the dialogue of such characters as the Nurse and Prunesquallor, and sentimentality too in the case of Eda [sic] and to some extent in Titus's sister. In fact – frankly again – I began to despair of the book altogether, until suddenly in the last third you pulled yourself together and ended splendidly. But even then you were so damned lazy that you called Barquentine by his predecessor's name for a whole chapter.

I'm hitting hard because I feel it's the only way. There is immensely good stuff here but in my opinion you've thrown it away by not working hard enough at the book. There are trite, unrealized novelettish phrases side by side with really first class writing. As it stands, I consider it unpublishable – about 10,000 words of adjectives and prolix dialogue could come out without any alteration to the story at all. I want to publish it but I shall be quite sympathetic if you say 'To Hell with you: You are no better than Chatto' and prefer to take it elsewhere. But at least I can claim to have read it carefully and I do beseech you to look at the MS again. I began by putting in pencil, which can easily be rubbed out, brackets round words and phrases which seemed to me redundant, but I gave up after a time.

Write and let me know how you feel about all this. If you want to call on Sat[urday], call me out – but I suggest we have our duel over whisky glasses in a bar.

Yours

Graham Greene[9]

They no doubt had their 'duel', and Mervyn realized that he would have to do some pruning if he was to get the book published.

Greene's accusation of laziness probably struck a chord: when it came to his art, Mervyn was ready to labour long and late. Soon after this he read Virginia Woolf's *Common Reader* (probably at Greene's suggestion since it was not exactly Mervyn's usual fare), and it seems to have given him a completely fresh perspective on his book. In fact, from the metaphor he used, he seems to have perceived it as overweight and 'flabby', for he told Goatie that he was going to have to 'spare himself no pains in cutting away all the unhealthy and redundant flesh and get it down to a spare, muscular body' (letter dated 24 October 1943; in Smith, pp. 103–4). This would mean rewriting whole chapters.

It was an important moment in the creation of *Titus Groan*; for the first time Mervyn looked back critically at what he had done and discovered that while writing he had lost sight of what he was after, perhaps because he had not clearly defined to himself what he was after to start with. Certainly he wanted 'to create a world of my own in which those who belong to it and move in it come to life and never step outside into either this world of bus-queues, ration-books, or even the upper Ganges – or into another imaginative world' (Smith, p. 103). More specifically there was the 'mood' of the book. Although it might vary from chapter to chapter, it should remain consistently of the same essence. Writing to Goatie Mervyn developed an extended metaphor around the idea of the Gryphon with a complex temperament that showed different coloured scales under different lights. His book was to be Gryphon and not, for instance, Bulldog (too close to home, the world of ration-books and bus queues) or Gazelle (still of this world, even though exotic) or even Gargoyle (another identifiable realm of the imagination). It was to be uniquely Gryphon, and its smell had to pervade every page, sometimes as odour of Gryphon, sometimes as stench of Gryphon, sometimes as Gryphon-of-roses.[10] And this he did not think he had yet managed to achieve.

So he set about revising the book, helped by suggestions from Goatie. He made numerous cuts, taking out passages of authorial omniscience, for example, and he tightened up the action by reducing the amount of description. It was a lot of work, and it continued

even after the book was in proof, by which time Mervyn had begun to appreciate the creative side of what he called the blue-pencil approach.[11] He discovered that self-editing and rewriting belong to the process of making a book quite as much as the original writing. By pruning he created space for something else to grow. Thus the book began to take on its final shape.

15
Belsen, 1945

THROUGHOUT the autumn of 1943, while Graham Greene was reading the first draft of *Titus Groan*, Mervyn was researching and preparing the drawings for *Household Tales*, which Eyre and Spottiswoode had asked him to complete before Christmas. He took great care over this series, as he wanted to make the clothing and backgrounds look authentically medieval and to move on from the cross-hatching technique that had largely characterized his work until then (see letter dated 24 October 1943; in Smith, p. 102). Even when he took a holiday with Maeve, down near St Ives in Cornwall, he was 'Grimming' hard (postcard to Graham Greene, postmarked 20 October 1943), but in the end the book did not come out until October 1946. I do not know the reasons for the delay; there were no doubt problems in obtaining sufficient quantities of paper, as the book ran to more than three hundred pages, with sixty drawings in black and white and five colour plates, including the double-page spread for the title.

The quality of the illustrations varies: the most successful are the darker ones, and the darkness is achieved by cross-hatching. They are also the ones in which Mervyn's emotions are more clearly engaged. In other words, in trying to move away from cross-hatching he did not at once find a style with which he was comfortable. Numerous outlines are sketched with broken and duplicated lines, as if he were unsure how to achieve the lightness he desired; in later

works such as *Quest for Sita* he was to achieve exquisite effects with a single unbroken line. Here the shading tends to be made with heavy strokes; later he could dispense with shading altogether, so expressive of volume were his outlines. So this may be seen as a transitional work.

During this time, too, Mervyn was slowly completing his Glass-blowers commission for the WAAC. He did most of his painting in the Trafalgar Studio in Chelsea because the cottage at 94 Wepham was terribly small for two adults and two energetic little boys, although they had given themselves more space by knocking a 1.2-metre-wide (4-foot) gap in one of the inner walls (Smith, p. 102). However, he travelled frequently down to Burpham and retreated there when he caught flu[1] or had an accident, as happened in January 1944 when he scalded his foot badly enough to be immobilized for a couple of weeks.[2] He completed the last painting of his commission in January 1944 and brought it up to London in February, apologizing as he did so for a hole in the canvas. In all, the WAAC acquired seventeen items from this commission, including three oil paintings, the last and largest of which was more than 2 metres high and 115 centimetres wide (80 by 45 inches). It was exhibited at the National Gallery and donated in 1947 to Manchester City Art Gallery.[3] A large oil (85 by 110 centimetres; 33½ by 43¼ inches), with eighteen figures depicting the various stages in *The Evolution of the Cathode Ray Tube*, went to the Imperial War Museum along with other works in mixed media – ink, pastel, gouache and watercolour in various combinations.[4] Versions of these works, in various media including at least two oil paintings, are in private hands.

Mervyn's work as an official war artist did not stop at this. In December 1943 – in other words, before he had finished the final Glassblowers picture – he put forward an idea for a further commission: 'that he should do about ten drawings of briefing RAF pilots and interrogation of pilots on return from operational flights'.[5] The WAAC approved the project on 12 January 1944 but required Mervyn to submit some preliminary sketches first. This proved problematic for security reasons, and it was not until 19

April 1944 that the WAAC was able to report that 'arrangements have now been completed for this artist to undertake a picture of bomber crews and he went to an RAF station in No. 4 Group for this purpose last week' (WAAC Minutes, p. 92, quoted in *PS*, 991; 2: 2, 40).

As with the previous commission, Mervyn made many drawings and paintings, for which he was paid £82 10s in September 1944. The Imperial War Museum possesses twenty-six items, of which one is in oil and the remainder mixed media, many of them ink and wash. Other drawings, not all of them related to the commission and in one case the draft of a poem, figure on the back of several of them. From the quality of these works I would judge that the subject did not move Mervyn in any way comparable to the Glassblowers commission. For the most part his drawings are merely workman-like; they do not vibrate with the quality of life that can be found, for instance, in the sketches of soldiers that he made while he was serving in the Army (for examples see Smith, Plates 25-8).

By now it was a long time since Mervyn had had an exhibition; moreover a full year had passed since his discharge from the Army, and he had an excellent studio to work in, so he had built up quite a stock of work. Peter Jones, the department store in Chelsea, had created an area in its shop for exhibitions, and there in June 1944 Mervyn showed drawings, engravings and oil paintings, including a large one called *Mr Brown's Resurrection*. This canvas formed the subject of the entire review by Eric Newton in the *Sunday Times* in which he pointed out how hard it is to live with modern paintings: 'Peake has elaborated the sinuous rhythms of a nightmare, grafted them on to a ballet and woven them, for contrast, into a sordid little bowler-hatted scene from everyday life. The result is impressive . . . Mr Peake evidently had to paint it. But what is the smug world of drawing-rooms and firesides going to do with it? . . . As a picture it must be lived with. But where?' (18 June 1944, p. 2). Indeed. It was never reproduced (as far as I know, although it may be glimpsed in the background of Plate 1 in the first edition of this book), and in the end Mervyn painted over it.[6]

The exhibition was also reviewed by Maurice Collis in *Time and*

Tide (8 July 1944);[7] he was particularly impressed by a line drawing of a huge man holding up on a tray, as if with great effort, a tiny flower. He sought Mervyn's acquaintance and they became friends, Collis serving as a kind of mediator between the world of London's patrons of the arts and Mervyn's world of turpentine and canvas. Thus, when Mervyn was awarded the Heinemann Prize in 1951, he asked Maurice Collis to accompany him to the ceremony. Back in the summer of 1944 Mervyn's line drawing gave Collis an idea: he invited him to illustrate his retelling in modern English of the Sanskrit epic that he called *The Quest for Sita*, the story of how Sita was abducted by the monstrous Ravana and rescued by her husband Rama.

Mervyn made the drawings in the late summer and autumn of 1944, and when the book came out 1946 they proved to be superb. (The book itself is equally fine, quarto in size, bound in buckram and printed on handmade paper. The print run was 500 copies.) The sculpturesque sense of volume that he achieved with pure line is quite outstanding, and the theme of Sita – the original Helen – is celebrated in portraits of eerie beauty in which the features of Maeve are made sublime. The dwarves and monkeys, the symbolic dragon-like creatures of the Orient and the horses are perfectly in keeping with the spirit of the work. Only the male figures disappoint – with the exception of the beautifully proportioned man who holds aloft a flower on a tray; the others suggest that Mervyn found the nude male an embarrassment. (This comes as no surprise: explicit adult sexuality is almost entirely absent from his *œuvre*.) On the other hand, the transformation of Surpanakha into a fiend is utterly masterful: Mervyn could always relate to the grotesque.

In the autumn of 1944 the lease of 94 Wepham was terminated by the Norfolk Estate, and Mervyn found a studio – rather than a flat – for the whole family at 70 Glebe Place, Chelsea. It was spacious, with adjoining rooms they could use as bedrooms and kitchen, for very little rent, so he was happy to retain the Trafalgar Studio in Manresa Road (just across the King's Road from Glebe Place) as well. For the first time in four years the family were together on a daily basis. Sebastian was coming up to five, and Fabian was

two and a half. But life in a high-ceilinged studio is a chilly business in winter, and they were very grateful for the gift of a sack of coal that Christmas (Gilmore, p. 51).

One of the advantages of having two studios was that the Peakes could indulge their generosity towards fellow artists. John Grome was one of those who was lodged for a while in the Trafalgar Studio. They even engineered an exhibition for him, and he was delighted when one of his paintings was sold. It was on the wall at Glebe Place the next time he dropped in after the exhibition closed: Maeve and Mervyn had bought it.

At this time Mervyn made thirty drawings for 'a little book of extraordinary piety' called *Prayers and Graces*, compiled by Allan M. Laing and published just before Christmas 1944 by Victor Gollancz. It was an anthology of comic prayers and graces, ranging from the ludicrously pious to the 'Crisis in the Nursery': 'Dear Satan, please come for Nurse, and please come soon', which Mervyn illustrated with a little girl beside a broken vase, overlooked by a startled nannie. He caught the spirit of the book exactly; text and illustrations complement each other most satisfactorily. The variety of techniques employed, which range from cross-hatching through broken lines to plain line drawings, suggest that it was executed between *Household Tales* and *Quest for Sita*. It was at any rate enormously successful: according to the dust-jacket of a sequel published in 1957, the original title sold close to 40,000 copies.

A completely different book, using flat areas of bold colour, was *Rhymes Without Reason*. It was during the Peter Jones exhibition that Mervyn thought of illustrating his own nonsense poems for children, and Eyre and Spottiswoode approved the idea in July (mentioned in a letter to Maeve dated 26 July 1944, quoted by Watney, p. 124). It was published in November for the Christmas market and little children started learning that 'the nastiest grimace / You make upon the sly, / Is choice beside the Hippo's face / Who doesn't even try.' There were sixteen colour plates but, as *Punch* pointed out, '[Peake] has been wretchedly served, unfortunately, by his colour printers, who have reproduced them in a range of bilious hues, overlapping at the edges, which suggest a sort of flag-seller's night out' (*Punch*,

28 February 1945, signed P.M.F.). Eyre and Spottiswoode were very generous to Mervyn, but their printing of anything but text could leave much to be desired, of which this was just a first taste.

Eyre and Spottiswoode's generosity extended, thanks to Graham Greene who had started working there in the mornings, to setting *Titus Groan* in type before Mervyn had finished revising it and allowing him to make all the changes he wished on the proofs. Understandably, he was very grateful to be allowed to do this, without being constrained by penny-pinching considerations.[8] And he began the 'blue pencil' process over again. So many were the changes that sometimes the final text was less than satisfactory. For example, when he deleted text including 'to the extent of' on p. 308, Mervyn forgot a second 'of' that depended on it in the following line. The unusual proceeding of allowing an author to make substantial changes on the proofs also meant that the final text was not fully checked by a copy editor and contained errors of continuity, such as Steerpike being locked in one room only to escape from another, which Mervyn would surely have preferred to avoid. In the early 1980s Maeve allowed me to resolve a few of the purely verbal cruxes for the King Penguin edition that is now the standard text.[9]

By this time Mervyn had also completed the illustrations for *Witchcraft in England*, which was published in March 1945. For this series he used a wider range of media and techniques: ink-and-wash for sixteen illustrations printed as plates and pen-and-ink for thirty-eight line drawings in the text, which vary from close cross-hatching through broken lines to plain line drawings. The publishers were obviously pleased: the illustrations, they wrote on the dust-jacket, 'are, we believe, a very notable addition to the art of English illustration'. Others admired them, too, for when Batsford came to reissue the book in 1977 the company found that the original illustrations had been purloined from their archives. They are now in various private collections. On the other hand, the author of the book, Christina Hole, is reputed not to have liked Mervyn's contribution to it. Perhaps she shared the fear of the *Times Literary Supplement* that 'the illustrations may give bad dreams to those who study them too long' (24 March 1945, p. 142). The *Birmingham Post* more

sensitively pointed out that they 'convey all the sinister horror, that dreadful lurking fascination that the word "Witchcraft" conjures up'.[10] It is indeed a remarkable series. As with *Household Tales*, the degree of success varies; the good ones are very good, particularly when Mervyn depicts strong emotions such as hatred and terror or scenes of bacchanalia or a witch being searched for signs. The less successful ones are more neutral but none the less serve their purpose well in the book. And the public response was excellent; *Witchcraft* was reprinted in the autumn of 1945 and also published in the United States. In fact, as with Joad's *Young Soldier*, the illustrations have outlived the text.

Strong emotions seem to have been what Mervyn was seeking at this time. In February 1945 he put in another proposal to the WAAC that he 'be considered for a commission, in China if possible, but if not he would like to do paintings of evacuees on the Continent'.[11] The idea of going to China is striking: it is the only instance, in all the correspondence I have seen, of Mervyn showing any desire to return there. That it should come at this particular moment may be explained by the fact that Eric Drake had been posted to China at the end of the previous year to spy on the Japanese (at the request of his brother Burgess, who was in the Intelligence Service out there). The alternative – paintings of evacuees on the Continent – would have been an equally emotional commission for him, for the distress of the thousands of displaced persons was very great. As it was, the WAAC found it 'could make no recommendation' and, returning 'the print' he had submitted, thanked Mervyn for the trouble he had taken (letter from the Secretary of the WAAC dated 2 March 1945).

However, Mervyn did go to the Continent that year, and a highly stressful experience it proved to be, too. It was at Maeve's instigation that he began to seek a commission in Fleet Street, motivated in their innocent idealism by a desire to record what people had suffered during the war (Gilmore, p. 59). He sent some of *The Works of Adolf Hitler* to a current affairs magazine, the *Leader*. The editor, Charles Fenby, commissioned him, along with a young journalist, Tom Pocock, to report on life in newly liberated Europe.[12] Pocock

had spent the weeks immediately following VE Day (8 May) on the Continent, and he was to serve as Mervyn's guide and mentor in that unfamiliar world, as well as providing the text to accompany Mervyn's drawings – for Mervyn was not known to Fleet Street as a writer. 'I was to be his tour-manager,' writes Pocock, 'and here problems arose . . . The press camps of the Allied armies were full and it was made clear to me at the Supreme Headquarters' public relations office that it would be difficult to have a lower priority for places in them than would be accorded to Mervyn Peake.' Once on the Continent, however, travel was easy enough: 'it was just a matter of asking for (and nearly always getting) a movement order from a public relations officer, [and] transport would be provided – a jeep, or a seat in an aircraft' (Pocock, p. 125).

In the first week of June they flew to Paris, where they paid their respects to the Place Pigalle, 'Pig Alley' to the American soldiers. Mervyn sketched a black drummer in a nightclub band, while 'bar girls and waiters gathered about him to watch. His response was so pleasant and polite that . . . we were soon engaged in quiet and enjoyable conversation; for he had the gift of establishing friend-ship' (Pocock, p. 127). Then they flew on to Mannheim and drove to Wiesbaden by jeep. The destruction of the cities far surpassed anything Mervyn had anticipated. Attempting to give Maeve an idea of what Mannheim and Wiesbaden looked like, he invited her to imagine Chelsea with not a single house and only a few misshapen walls left standing (Gilmore, p. 58). What struck him particularly was the intense feeling of hatred that he sensed on the part of the Germans – not realizing, perhaps, that the 'black, horse-hide half-wellington boots' he had chosen to wear, like Tom Pocock, 'struck fear into the hearts of the defeated enemy' (according to Pocock, p. 126). Driving on, they visited Aachen, Cologne and then attended the first of the war trials in Bad Neuenahr, where Mervyn sketched the witnesses and a condemned man in his cell. From Pocock's account it is clear that Mervyn drew little of the desolation he witnessed; he saved his art for the people they saw, like a wardress at Belsen or captured German soldiers crowded in a pinewood (see Smith, Plates 46-8). Thus he sketched nothing at Kiel, where the

pride of the German navy lay scuttled in the harbour, and made many drawings at Belsen.

The concentration camp at Bergen-Belsen had been liberated by British troops on 15 April. They found 30,000 living prisoners: '1,500 Jewish survivors from Auschwitz; a thousand Germans sent there for anti-Nazi activities; several hundred Gypsies; 160 Luxemburg civilians who had been active against the German occupation; 120 Dutch anti-fascists; as well as Yugoslavs, Frenchmen, Belgians, Czechs, Greeks and, most numerous of all, Russians and Poles – a veritable kaleidoscope of Hitler's victims.' In addition, 'about 35,000 corpses were counted by the British at Belsen', of whom 10,000 lay unburied. 'Even after liberation, three hundred inmates died each day during the ensuing week from typhus and starvation. Despite the arrival of considerable quantities of British medical aid, personnel and food, the death rate was still sixty a day after more than two weeks' (Gilbert, *Second World War*, p. 664). Survivors who were fit to travel began the long journey home; as a sanitary measure, their huts were burned with flame-throwers, the last on 21 May, when there was a little ceremony. The SS barracks was turned into a hospital for those who were too sick to be moved, and it was these improvised wards that Mervyn visited a month later.

The actress Dame Sybil Thorndike visited the camp that same week and cried all the way back to Hamburg in the bus. 'If the resistant Sybil could be so affected,' pondered Pocock, 'how much more deeply wounded must the infinitely vulnerable Mervyn Peake have been' (Pocock, p. 145).

Mervyn left the camp with drawings, the beginning of a poem and contradictory feelings: could any art do justice to what he had witnessed? He felt ashamed, guilty even, to have come to see, to view, to sketch and turn into art the suffering of these people who were literally dying before his very eyes. Nor could publishing poems and drawings erase the memory or reconcile him to his feelings, for that would have meant making money out of another person's utter misery, as he put it to Goatie.

'He was away a month,' wrote Maeve, 'and during that month the sights and sounds of Germany must have damaged him more

than he ever said' (Gilmore, p. 59). She did not reveal what impact his visit had on herself, yet it was at her instigation that Mervyn had gone, and she clearly blamed herself for his trauma.[13] Their son Sebastian's compulsive visiting of the German concentration camps, years later, confirms that it affected them all profoundly. When he writes in his memoir of feeling guilt because his father did not turn away at the gate of Belsen, as though he were in some way responsible for his father's behaviour, he may well be voicing some of his mother's regrets. 'I feel very ambivalent about my father's work at Belsen,' he writes, 'because my admiration for his total genius does not excuse the circumstance of his visit' (Peake, p. 48). The confusion of expression and conflicting emotions point to the devastating emotional impact on his family of what his father witnessed.[14]

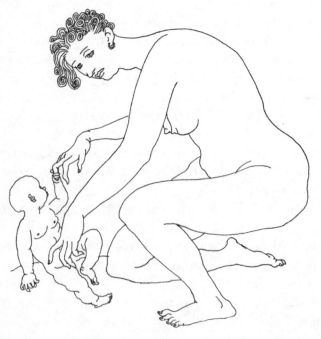

Mother and child; pen and ink on blue writing paper, mid-1940s

16
Titus Groan, 1946

A FTER the end of the war in Europe came the end in the Far East, on 15 August 1945, following the dropping of atomic bombs on Japan at Hiroshima and Nagasaki. It was not until 30 August, however, that British medical officers were parachuted into Changi prisoner-of-war camp, Singapore, where Mervyn's brother Lonnie had been held for four and a half years. Indian troops liberated the camp a week later and the Japanese formally surrendered Singapore in a ceremony on 12 September. The return of Lonnie, who had been reduced to a walking skeleton, was the cause of great rejoicing at 70 Glebe Place; he stayed with Mervyn and Maeve until it was possible for him to cross the Atlantic and be reunited with his wife and children.

And it was also at Glebe Place that the two families lived together for nearly six months when Lonnie, Ruth and their two children returned to England in 1946. It was a squash to fit eight people in, and Lonnie's son Kit remembers how grateful he was to escape to the studio in Manresa Road and watch Mervyn painting there. Then Lonnie and Ruth returned to Malaya, while their children stayed on at school in England.

The end of the war brought a great demand for books, to which publishers responded with paperbacks. A new company called Pan Books approached Mervyn with the request that he draw their logo; he did two drawings, both of which appeared on Pan's first titles. As

the publishers settled into their stride, they adopted just the head of the seated figure, using it in silhouette, and it has remained their logo ever since, now placed within a frame like an open book.[1]

Paperbacks were all the rage on the Continent, too, where companies strove to dominate the market for books in English in the way that Tauchnitz and then Albatross had done before the war. Up in Stockholm, the Continental Book Company (Albert Bonniers Förlag) launched Zephyr Books, and early in 1945, having failed to get permission to use Tenniel's drawings, they invited Mervyn to illustrate number 67 in the series, *Alice's Adventures in Wonderland and Through the Looking Glass*. He rose to the challenge and produced illustrations that rival the classic interpretations.

His *Alice* deserves closer and more detailed study than is possible here. Let me just point to his use of both cross-hatching and line drawings in a new, happier combination that is light enough when required and yet dark enough to satisfy Mervyn's imaginings. For his *Wonderland* is a truly crazy world, entered with a superb drawing of Alice passing through the looking-glass. His model for her was a girl called Caroline Lucas (née Norton), whose parents lived close by in Chelsea, but she does not figure often in his illustrations: he shows us Carroll's world through Alice's eyes – once seen, never to be forgotten.[2]

This was one of Mervyn's largest assignments: the published book contains sixty-six illustrations, of which almost half (thirty-two to be precise) are full page. However, few people in Britain ever got to see the Swedish edition; for copyright reasons it was not for sale in the British Empire or the United States. So Mervyn's reputation as an illustrator of *Alice* lay in abeyance until 1954, when the London publisher Allan Wingate obtained permission to reprint the book. For some reason twenty-nine of the original drawings remained with Bonniers – they were returned when one of their editors read in the *Times Literary Supplement* of the 1972 Mervyn Peake exhibition at the National Book League – so Wingate was obliged to reproduce them from a copy of the Swedish edition. Some of the lines in the drawings were so fine that, in view of the coarse quality of paper they were using, Wingate asked Mervyn to strengthen

TALES OF THE
SUPERNATURAL

LONDON
PAN BOOKS LIMITED

The title page of *Tales of the Supernatural*,
one of the first Pan books

them. While doing this he took the opportunity to rework some of the drawings, particularly the faces of Alice and Tweedledum and Tweedledee, whom he saw as two naughty little boys, always spoiling for a fight. He also produced a superb frame, recalling the major characters, for the dust-jacket; in subsequent editions it has been used for the title page.[3]

About this time Mervyn started working on illustrations for *Bleak House* at the invitation of the publisher John Murray, but after he had done a good deal of research and made many preliminary sketches for the book the project was cancelled. The sketches were published in 1983.[4] Another abandoned project was a comic periodical which Henry Hobhouse and an American colleague planned to bring out; Mervyn provided some delightful illustrated nonsense rhymes, but the promoters failed to convince the paper controller that their publication was sufficiently cultural to warrant an allocation of paper, so it never appeared. Mervyn's contribution was not published until more than fifty years later (in *PS*, 1998; 5: 4, 21–7).

Something of the joyous spirit of the immediate post-war days can be sensed in the punning envelope that Mervyn sent off to a correspondent at the Bear Hotel (complete with bear) in Woodstock (with wooden stocks) and in the light-hearted drawings he produced

The illustrated envelope sent to a correspondent at
the Bear Hotel, Woodstock

at this time. It was appropriate that Eyre and Spottiswoode should have decided to reprint *Captain Slaughterboard Drops Anchor* for the 1945 Christmas market. Colour being a requisite by then in children's books, they overprinted selected areas in pink, blue and yellow. The effect is debatable, but at least the book was back in print and selling. The novelist and short-story writer Elizabeth Bowen no doubt won Mervyn's heart for declaring it 'a perfect pirate picture-book for strong-nerved children . . . This book is on the top plane of imaginative-fantastic art' (*Tatler & Bystander*, 13 February 1946, p. 220).

By this time the revision of *Titus Groan* was complete, and preparations for publication began. Calling at his publishers Eyre and Spottiswoode (known to Mervyn as 'Migraine' – derived from 'eye' and 'spot'), he was appalled to find that he was expected to write the blurb for the dust-jacket. He couldn't, he protested; it would be indecent. At best, he could call it 'the life of Titus Groan. It is, and it is not, a dream' (*PS*, 1992; 2: 4, 23). But 'Migraine' had had so many complaints about their blurbs that now they insisted on their authors doing them themselves. Mervyn turned to Goatie and begged him, since he had already carefully read through the manuscript (and corrected every instance of 'Fuschia' into 'Fuchsia'), to condense the 'oomph' of the book into two hundred words. Which he did, 'in a somewhat Gothic vein that was slightly modified by the publishers'.[5]

Unusually, the book was set in Bodoni bold, which contributed to the Gothic air. The design of the book, with its heavy rules, bullets and cups, has been attributed to Vincent Stuart, although Mervyn is reported to have quipped that it was by the office-boy.[6] Mervyn provided a striking jacket design of an abandoned crown and broken chain, with a crow perched on one of the crown's arrow-shaped ornaments, and a similar title-page vignette; these clearly correspond to 'the iron crown of the Groans that fastens with a strap under the chin. It had four prongs that were shaped like arrow heads. Between these barbs, small chains hung in loops' (p. 52).

Publication on 22 March 1946 – after six years' gestation – was an anxious moment. Mervyn and Maeve scanned the reviews. Maeve

reports that the first they read was 'a cold douche' by Edward Shanks and Mervyn wanted to send him a telegram, 'Shanks a million' (Gilmore, p. 54). But he refrained. According to John Watney, Maeve 'wanted to stab the wretched reviewer to death' (p. 130) – she was always vigorous in her defence of Mervyn's work.

The assessments varied. Kate O'Brien saw only 'bad tautological prose ... a large, haphazard, Gothic mess' (*Spectator*, No. 176, 29 March 1946, pp. 332 and 334); Howard Spring, while recognizing that *Titus Groan* was 'full of the macabre power that makes Mr Peake's drawings notable', regretted that 'he has not yet learned to apply this power effectively to the writing of fiction' (*Country Life*, 6 December 1946, p. 1108). Charles Morgan generously gave it a thousand words in the *Sunday Times* (31 March 1946), recognizing that Mervyn's 'primary purpose has been to describe a timeless and placeless world, to people it with creatures of his imagination, to urge them into dreamlike adventure, and, in doing these things, to achieve a free (and yet, on its own plane, a consecutive) fantasy'. At the same time he pointed out 'the dangers and blunders' in the enterprise, the difficulty of maintaining credibility and Mervyn's tendency to destroy his own effects with excess, 'shocking affectations and sudden pedestrian vulgarisms' from which an editor worth his salt would have saved him. Elizabeth Bowen declared at the outset that '*Titus Groan* defies classification: it certainly is not a novel; it would be found strong meat as a fairy-tale. Let us call it a sport of literature (for literature, I, for one, do find it to be) – one of those works of pure, self-sufficient imagination that are from time to time thrown out.' Perceptively, she concluded, 'I predict for Titus a smallish but fervent public, composed of those whose imaginations are complementary to Mr Peake's. Such a public will probably renew itself, and probably enlarge, with each generation: for which reason I hope the book may always be kept in print' (*Tatler & Bystander*, 3 April 1946, pp. 23 and 28).

The book did indeed sell; by the autumn the first impression of 2,000 copies had gone and Eyre and Spottiswoode reprinted. But when that had sold out the title lapsed; only with the second edition of 1968 in hardback and, more importantly, in paperback was Ms Bowen's wish fulfilled.

There was an American edition in the autumn of 1946, and Mervyn was dismayed to discover, too late to intervene, that the publisher had added 'A Gothic novel' to both the cover and the title page. Many American reviewers dismissed it, having sought in vain for a meaning to the book. As in England, Mervyn's most sympathetic readers proved to be fellow writers: August Derleth informed readers of the *Milwaukee Journal* that 'this novel offers rich reward to anyone who exercises the patience and imagination to stay with it', while Robertson Davies, as yet unknown and writing in the *Peterborough Examiner* (Canada) under the pseudonym Samuel Marchbanks, concluded 'it is an astonishing work of art' that he recommended highly.[7]

This question of the Gothic nature of *Titus Groan* needs to be addressed. Viewed from America, where Gothic stories have quite a prestigious history from Edgar Allen Poe and Nathaniel Hawthorne to William Faulkner and Eudora Welty, not to mention more recent titles like Toni Morrison's *Beloved* (1987), the epithet had nothing derogatory about it. So how Gothic are the Titus books?

Much, of course, is going to depend on what you understand by the term 'Gothic'. Applied to the novel, it qualifies a combination of themes, motifs and settings of numerous works that appeared in the last quarter of the eighteenth century and the beginning of the nineteenth, often characterized by over-writing and a lack of any consistent symbolism, apart from the association of a declining dynasty with the declining fabric of its home. (This is best exemplified by Poe's great story 'The Fall of the House of Usher'.) Under various guises and with varying emphases, it resurfaced in Victorian novels by Dickens and the Brontë sisters and infected other genres such as the ghost story, the horror story and detective novels. Gothic moments crop up in novels by most of the great (and an awful lot of lesser) writers in the twentieth century.

A major aspect of the Gothic lies in its attempt to produce a sense of horror in its readers: they must sympathize with the heroine, or hero, whose hopes, of liberty in particular, are stifled by physical incarceration. In this respect, Peake's novels are highly Gothic, recounting as they do Titus's struggle against the oppression of

Gormenghast's deadening ritual. Only in the third volume does he ultimately escape from it. Meanwhile, the motif of incarceration is omnipresent in the isolation of Gormenghast itself, explicit in Titus's punishment for truancy by being shut up in the Stone Fort and mirrored by numerous other incarcerations, from Steerpike in the Octagonal Room at the beginning of *Titus Groan* to the Twins (whose mad laughter is heard by Flay, just as Bertha's laugh is heard by Jane Eyre – a truly Gothic touch) in *Gormenghast*.

What undermines the Gothic in Mervyn's writing is the sense of distance that he creates, anaesthetizing the horror. This he achieves by comedy – whether it be in the absurdities of the ritual and its failure to maintain the traditions it attempts to perpetuate or the visits paid by Dr Prunesquallor and Barquentine to Titus in his prison – and by careful control of point of view. At no point, once the Twins have been isolated from the rest of the castle community, does Mervyn allow the reader to share the horror of their fate. Instead we follow Steerpike in his visits to them, aware of his need to prevent them from betraying him and grudgingly admiring of his success at foiling their attempts to kill him in the booby-trapped doorway.

Their death is not described directly; instead we have Flay as a mediating non-witness. Hearing their mad laughter, he seeks to map out the labyrinthine corridors and find their rooms but fails. Then the narrator intervenes to inform us that Flay never learns that he was the last to hear their voices or that, as they gave up hope, the Twins lay down side by side and died at the same instant (G, p. 302). When Steerpike makes his final visit to the Twins' cell, even greater distance is created by narrating the scene from the grouped points of view of Titus, Flay and Prunesquallor, who have followed Steerpike. As they peer into the apartment and see the skeletons lying side by side on the floor, 'their pulses beat no faster' (G, p. 380). There is no terror, only the innocent eyes of the young Titus who, having never seen skeletons before, has no idea that he is staring at his aunts. They are just interesting objects. At this point the narrator intervenes again to ensure that our feelings remain detached. His sardonic eye observes that the two skulls are identical but for a spider's web across one of the eye sockets; at the centre of

the web struggles a fly, 'so that in a way a kind of animation had come to either Cora or to Clarice' (G, p. 381).

Appreciation of the Gothic in Mervyn's writing thus depends upon the reader's ability to share in his sombre humour; for the sympathetic reader his novels are darkly comic, mocking our fears just as Steerpike mocks the Twins' with Sourdust's head on a broomstick (and other fears, too, as Barquentine buries the remains of Sourdust with a calf's skull substituting for the missing cranium). On the other hand, if the humour fails, then you have unalleviated gloom and horror.

Like Elizabeth Bowen, I will stick my neck out and predict for the Titus books a growing reputation as forerunners of a specifically late-twentieth-century form of the Gothic that they themselves helped to create. (Articles in *Peake Studies* have suggested some of the ways in which writers such as J.G. Farrell, Iain Banks and Patrick McGrath have been influenced by Mervyn Peake's work.)

Not unrelated to this is the specific style of Mervyn's writing. I have already suggested that his poetry is particularly physical in its expression. Since *Titus Groan* is often called an intensely visual work, let me underline how much the mode of representation is physical rather than visual. Take the justly famous opening sentences:

> Gormenghast, that is, the main massing of the original stone, taken by itself would have displayed a certain ponderous architectural quality were it possible to have ignored the circumfusion of those mean dwellings that swarmed like an epidemic around its outer walls. They sprawled over the sloping earth, each one half way over its neighbour until, held back by the castle ramparts, the innermost of these hovels laid hold on the great walls, clamping themselves thereto like limpets to a rock. (TG, p. 15)

There's not a colour, not a line, nothing to instruct the eye. It's all in the feeling, the physical sensation of the 'massing' of the stone, the 'ponderous quality' of the architecture, the sprawling humble dwellings that 'swarm' around the foot of the castle walls and cling 'like limpets to a rock'. The Tower of Flints is similarly described in

the following paragraph as being 'like a mutilated finger' which 'arose from among the fists of knuckled masonry and pointed blasphemously at heaven'. When other senses enter, it is *sound* rather than *sight* that predominates, again expressed in physical terms and parts of the body: 'At night the owls made of it an echoing throat; by day it stood voiceless and cast its long shadow' (*TG*, p. 15). Most readers will quite unconsciously translate these physical and auditory terms into their favoured mode of internal representation, the visual, with the result that they believe the books to be highly visual. In this way, reading the Titus books affords them an intense multi-sensory experience. Therein lies one of the gifts of Mervyn Peake.[8]

Another of his gifts was to work in the opposite direction, giving us a sense of physicality entirely through the medium of the eye, and this was exemplified in his modest little book that came out in May 1946, *The Craft of the Lead Pencil*.[9] Although – or perhaps because – Mervyn had not taught drawing since the end of 1939, he recorded in this instruction book his current thinking about his art as a craft. A born teacher, he empathizes with the beginner's feeling of clumsiness before emphasizing the need to look, to stare and to decide what the drawing should express: 'It is for you to leave the spectator no option but to see what you liked.' Then he demonstrates various techniques and illustrates them superbly. The printing of the drawings in this 24-page booklet is equally superb, showing that a good blockmaker could render the subtleties of pencil lines. And this no doubt gave Mervyn ideas for future books, such as *Letters from a Lost Uncle* and his book of drawings dated 1949. But those were a few years off yet, and there was the second volume of his Titus story to work on.

The menu for a PEN presentation dinner, 1946

Jim watches Long John Silver clean his knife on a wisp of grass,
from the Eyre and Spottiswoode edition of *Treasure Island*, 1949

17
Sark, 1946–1949

IN the summer of 1946, Mervyn and Maeve took the bold decision to leave London and live on Sark. Their finances had never been so good and there were prospects of more to come: he had just signed the contract for a Danish translation of *Titus Groan* (which never materialized), and he had a retainer with 'Migraine'. Mervyn went out to Sark alone for a couple of weeks in August, staying at Le Clos-de-Bas, the southernmost dwelling on the island, while he sought for a house to rent and write 'Titus 2' (as he called it).[1] The house he found, Le Chalet, was a white elephant with at least a dozen rooms but no running water or electricity. During the occupation it had been used by the German soldiers as their headquarters on the island,[2] and for these two reasons it was very cheap: £80 a year for a 99-year lease. At that price they did not hesitate.

A commission came in at once: the Brewers' Society wanted advertisements for pubs, and it paid well. The drawings were printed very small, only 8 centimetres across (little more than 3 inches), and would have benefited from enlargement as posters. But it was just Mervyn's luck with that 'having regard to the difficulties of paper and printing' the Brewers' Society decided against 'the reproduction in poster form . . . of the Mervyn Peake designs' (from the report of the advertising committee of the Society, *Brewing Trade Journal*, April 1947). Worse, after fifteen drawings, Mervyn refused in the name of art to move a tree (as mentioned earlier), and the contract

There is nothing like a game of darts in an English pub for promoting a steady hand and a ready smile. During the war "a game of darts at the pub" became a favourite call, particularly among the American and Canadian soldiers over here. In the dark nights of the blackout, the hazards of the "double" and the "whitewash" brought relief to spectators as well as players. Darts is essentially a friendly game. That is why it finds its proper setting in the public-house — where every man is as good as his fellow, and where friendliness and sportsmanship abound as nowhere else.

Illustration specially drawn by Mervyn Peake

Much of the characteristic charm of our inns lies in their diversity and differing "personalities". George Borrow, gay gipsy, spoke of the inn as "a place of infinite life and bustle". Samuel Johnson, a townsman, said — "at a tavern there is a general freedom from anxiety". Yet Matthew Arnold echoed the thoughts of all gentle and genial men when he described the Scholar Gipsy "at some lone alehouse in the Cumnor Hills". So deeply remains our affection for the pub— wherever it may be. Often the more remote, the more welcome are its hospitable lights.

Illustration specially drawn by Mervyn Peake

The literary critic, Mr. Oliver P. Otis,
Has written a quite charming and enthusiastic notice
On Jamaica Rum's new booklet ✳ ; its list of novel potions
Are, so he says, exactly in accordance with his notions;
And he adds (we quote):"Jamaica Rum will be a real best cellar."
(Mr. Otis always was a very, very witty fellar).

✳ Send for your copy of the new booklet on Jamaica Rum. Please write to: 'Jamaica Jo.' (Dept. PP.2) 40, Norfolk Street, Strand, W.C.2.

It's wonderful what Jamaica Rum will do!

A bottle goes such a very long way!

Above: Two advertisements from the Brewers' Society commission, 1946–7
Right: The advertisement for Jamaica Rum, 1949

was terminated. He regretted the income; a student remembers him in later years looking wistfully at a large advertisement drawn by Ronald Searle posted up in the London Underground and wondering how much Searle was paid for it – but he stuck to his principles. A couple of years later he did an advertisement for Jamaica Rum, but it was a one-off.

In some ways Sark was idyllic: peace and quiet for working, beautiful views, a whole island for the boys to play in. In other ways it could be hellish: the howling of the wind in the winter and the cold for lack of proper heating; the claustrophobia of being trapped on a tiny island; and the distance from the main source of income, London. In the end, the disadvantages clearly outweighed the advantages. But during the three years when Sark was his home Mervyn wrote *Gormenghast* and a ballad, *The Rhyme of the Flying Bomb* (not published until 1962); illustrated *Dr Jekyll and Mr Hyde, Treasure Island, Thou Shalt Not Suffer a Witch and Other Stories* by Dorothy K. Haynes and *The Swiss Family Robinson* and wrote and illustrated his own *Letters from a Lost Uncle* – not to mention completing numerous other, lesser commissions. It was a most productive time.

It was also an important period for the family: Mervyn was at home nearly all the time and participated as never before in family life, with his customary gusto and imaginativeness. He could do the kind of things that small boys adore: make coins vanish up his sleeve and belch at will (Peake, p. 120). Sebastian recalls a delightful occasion on which he and his father galloped through the house, each with a picture frame on their shoulder, leaping in and out of the frame as they went (Peake, p. 28). They had the inevitable cat as well as ducks and a donkey who participated in family life by wandering into the house and startling visitors. Maeve admired Mervyn for working in these conditions, believing that he did not like to be cut off from the life of the household (Gilmore, p. 72), yet to others he complained of the difficulty and the interruptions (see, for example, MPR, 1979; 9: 25). As the boys grew up, the little school on Sark was deemed inadequate for Sebastian; he was sent to a Catholic boarding-school on Guernsey, where the régime was

strict and the punishments harsh. He was understandably very unhappy there. Fabian joined him at the school for a couple of terms in the winter of 1949, while Mervyn and Maeve were settling in back in Chelsea. In the meantime, a daughter, Clare, was born to them at the end of May 1949.

Right from the start, Mervyn made regular trips back to London from Sark, first of all to attend Eric Drake's wedding to Janna Bruce in October 1946. The following year he went to make recordings for the radio. During the war he had met Kay Fuller at the Café Royal, in the company of Elmslie Owen and other artists – she had studied at the Westminster, leaving shortly before Mervyn started teaching there. On the evening of their meeting 'there was an animated discussion about ends and means'. Kay 'maintained that the effect was all that mattered, however achieved. This went down very well with Mervyn, who moved up the table to sit beside me. We continued the conversation a day or two later and thereafter met at intervals over a good many years' (MPR, 1979; 9: 24). In 1947 Kay became Talks and Features Producer for the BBC external service, whose programmes went out to Australia, New Zealand and the Pacific Islands on what was called the Pacific Service. She devised a series of ten-minute talks under the general title 'As I See It' and invited Mervyn to contribute. Thanks to her advice about what listeners needed, it was a carefully prepared and revealing talk that he brought to London for recording on 29 April 1947, taking up the command to 'stare' from *Craft of the Lead Pencil* and realizing that his looking was very different from that of others: 'We do not see with our eyes, but with our trades.' (He originally wrote 'brains' rather than 'trades' – and 'minds' would have been an equally appropriate word.) And indeed it is so. Recent research has shown that, when we look, what we consciously register is generally 80 per cent preconception, derived from memory, beliefs about the world and so on and only 20 per cent fresh input. The world we each inhabit is largely the reflection of our own minds. The visual artist, on the other hand, strives to communicate much more of what he actually sees.

Kay Fuller was pleased with Mervyn's recording and, even before it was broadcast, invited him to give another, in the same

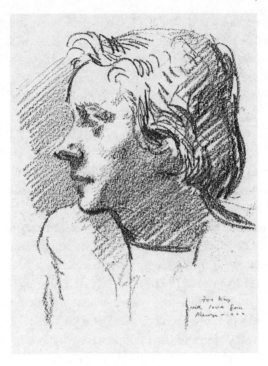

Kay Fuller, a rapid sketch in charcoal, mid-1940s

series, on 'Book Illustration', which they recorded on 20 May 1947. Here Mervyn spoke for the first time about the art he had developed during the war, revealing how he had become fascinated by the whole idea of illustration, which is so different from seeing and yet requires a similar kind of staring: seeing the world though the eyes of the author he was illustrating. He had set out to view the work of the great illustrators: 'Rowlandson, Cruikshank, Bewick, Palmer, Leech, Hogarth, Blake . . .'[3] Echoing Keats on the qualities of the poet, Mervyn concludes that the great illustrator has the ability to slide into the soul of the writer he is illustrating. This is the gift which he himself possessed in abundance. It is the counterpart to the physical quality that I have already highlighted in Mervyn's poetry and prose.

The work he illustrated straight afterwards, *Treasure Island*, superbly exemplifies this. As John Lewis writes in *The 20th Century*

Book: Its Illustration and Design, 'To appreciate these illustrations it is best to rid one's mind of all previous ideas of how the book ought to be illustrated.' Mervyn's is a new reading of the story, in which the pirates are truly evil men: 'The quizzical expression on Silver's face does not hide the fearful potential of the man. As for Blind Pew, God help any poor boy if that old monster grabbed his arm in a lonely lane on a dark night' (*The 20th Century Book*, p. 209). Visually, the pirates swarming the palisade round the log-house are close relatives of the monkeys in *Quest for Sita*. The extraordinary thing about these illustrations is that they seem more true with every year that passes.

In technique, Mervyn combined his fine cross-hatching with broken lines, achieving some superb night pictures and effects of miasmic mist. His control of lighting is masterly, whether it be in the cabin of the *Hispaniola* or the treasure cave or a clearing in the forest where Silver stands with a dead body at his feet, 'cleansing his blood-stained knife upon a wisp of grass'. These particular scenes show that Mervyn was aware of earlier illustrators, including the anonymous first illustrator of the book, Wal Paget and N.C. Wyeth, but he surpasses them time and again. Paget's illustration of Silver 'cleansing his blood-stained knife' is relatively uninvolved; the posture of the dead man could be mistaken for exhaustion, and even the knife cleaning is perfunctory, while Silver's eyes are neither on his victim nor anything else that we can see. Mervyn's picture echoes Paget's but adds a frame of undergrowth that half hides the contorted figure of the dead man; Silver's eyes nervously scan the vicinity for the chance witness while he cleans his knife with the care and respect of the professional killer. And chance witness there is: Jim, in the foliage above him, his gaze following the sunbeams down to the scene on the grass and acquiring in the process both innocence and objectivity. Mervyn's picture replicates the involvement of the reader – and Jim – at the same time as squarely facing the evil and duplicity of Silver.

In marked contrast to this were the illustrations for *Dr Jekyll and Mr Hyde*. The Folio Society required that they be done in yellow and black, an approach that Mervyn was unfamiliar with. Although he did not respond well to instructions as to how he should do his

illustrations, he prepared this series with his customary care – some of his exploratory sketches can be seen in *Mervyn Peake: The Man and His Art* (pp. 138–41). As with *Titus Groan*, the result did not meet with much immediate praise or admiration, but the response has warmed steadily over the years, another instance of growing public appreciation of Mervyn's work.

A third recording for the BBC, made on 20 June 1947, was a round-table discussion of *Titus Groan* in the series called 'The Reader Takes Over', in which a novelist was confronted with a professional critic and several 'lay readers'. It was perhaps the Canadian broadcaster, Rooney Pelletier (then head of the North American Service of the BBC) who suggested bringing Mervyn in; a painter in his spare time, he had been much impressed by *Titus Groan*. If it wasn't he, then it was the 'professional critic,' John Brophy, who had sought Mervyn's acquaintance following the Peter Jones exhibition and bought a hundred pounds' worth of pictures in a single visit to his studio (Watney, p. 135). 'He was so vehemently of the opinion that Mervyn was undervalued and under-publicized that he was constantly taking or indeed making every conceivable opportunity to get Mervyn's name better known' (letter from Brigid Brophy to GPW dated 1 June 1978). Among the 'lay readers' was Kay Fuller, who was brought in, she thought, as moral support for Mervyn but who felt extremely nervous to be, for once, at the live end of the microphone. All in all, however, Mervyn could hardly have had a more supportive group, and it went off very well.[4] So it is a shame that, like his talks, this broadcast was destined for overseas audiences only: he might have found a wider national readership. Unfortunately, all the tapes were wiped long ago; there is no record of Mervyn Peake's voice.

When he was at home on Sark Mervyn would spend plenty of time with his two sons. It became a ritual to draw pictures for them each Sunday; he went down to the bays and swam with them; he told them stories; and in the bitter winter of 1947-8 he built an igloo for them in the garden, complete with a drawn Eskimo in the window. It would be natural to assume that these activities coalesced into his illustrated storybook, *Letters from a Lost Uncle (from Polar*

Regions) had not John Watney assured us that Mervyn had 'originally written and illustrated [it] in 1945' (p. 146). Be that as it may, the finished product, published by Eyre and Spottiswoode late in 1948, was deeply disappointing to him, as the reproduction emphasized the difference of paper between the pencil drawings and the typewritten text, instead of fusing them into a seamless whole. Worse, the publishers then reduced the cover price from seven shillings and sixpence to three shillings and sixpence, which gave the book 'a second-hand look from the very outset', as Mervyn put it in a letter of complaint to them (Watney, p. 146).

The story of the Lost Uncle's search for the polar White Lion, the Emperor of the Snows, is the pretext for many superb pencil drawings, but the storyline is weak and fizzles out when the Uncle encounters the White Lion, although the final picture, with its mandala in the sky, suggests a sense of wholeness that the text belies. On the other hand, the story of the independent youth who runs away, crosses water, encounters man-like animals or animal-like men, meets and either acquires (if yellow) or kills (if white) the animal object of his quest and then returns is an archetypal quest pattern which Mervyn repeats throughout his work in various ways. The Slaughterboard stories feel their way towards it, and *Boy in Darkness* expresses it most purely. In the case of the Lost Uncle, the mode is tragi-comic, the obstacles are overcome by tricks, and the object of the quest (white, with yellow eyes) dies a natural death as soon as discovered, so the story would end with a sense of anticlimax were it not for the Uncle's upbeat response. *Boy in Darkness* presents a true challenge and therefore ends more satisfactorily. *Titus Alone* concludes the Titus books by repeating this pattern in yet another permutation.

As with *Slaughterboard*, the *Lost Uncle* contains some in-jokes. The ship the Uncle sails in is called the S.S. *Em*, which recalls the pre-1912 name of Eltham College, 'School for the Sons of Missionaries'. At school matches, the boys would support their team with the chant, 'Ess-ess-emmm!' The Uncle points to the joke by adding, 'Whether her name was short for Empire or Emu I never found out.'

These Sark years are littered with abandoned projects: publishers would approach Mervyn, he would go to work and then they would lose interest or go bankrupt. One of the first such squibs was an illustrated edition of *Baron Münchausen*, which the Cresset Press went so far as to advertise as 'illustrated by Mervyn Peake' on the back of early volumes of its Cresset Library. It never came out. Another instance: in January 1949 Mervyn completed for the Castle Press a series of drawings to accompany extracts from poems by Oscar Wilde. The publisher wanted them promptly and to buy them outright. Mervyn was unwilling to relinquish the copyright in his work, and the book never appeared in his lifetime.[5] He was also full of projects of his own, particularly for large canvases, so big that no gallery would risk hanging them and no private house could accommodate them (letter to Maurice Collis dated 4 March 1947, in *MPR*, 1985; 19: 15). This ambition to paint exceptionally large canvases makes Mervyn sound like Gulley Jimson, the painter-narrator of *The Horse's Mouth* by Joyce Cary which was published in August 1944. The story is set in Battersea, the very part of London where Mervyn lived in the 1930s, and I feel sure, from the altered tone and terms in his letters, that he read the book around this time and was inspired by it.

Other commissions did reach fruition and publication; one of them was an illustrated edition of *The Swiss Family Robinson* produced (as an 'Heirloom Classic') by Weidenfeld for Marks and Spencer.[6] This came out in time for the Christmas market in 1948, and it was reprinted several times over the next ten years. However, Mervyn got little satisfaction from it, as the publishers thought fit to 'improve' the book with decorations by another hand.

While Mervyn was living on Sark he started to receive fan mail. Admirers of his illustrations would send him books to sign; others, such as Hilda Neal, who typed out *Gormenghast*, would request a drawing. Autographs presented no problems, but drawings were another matter. At a time when he would toss off a drawing with every cheque he sent to his bank,[7] Mervyn found it difficult to produce a drawing on request, and the longer he delayed the more difficult it seemed. When his nephew Kit pleaded for Mervyn to draw him something,

he rarely did anything on the spot, but on his next visit he would produce what I had asked for – and it was always different from what I had imagined it would be. I was mad on sport and asked for a picture of a scrum-half. I received a wonderful pen and ink picture of 'Buccaneer Whizz-BrownWhizz Brown – the oldest and fastest scrum-half in the world'. He had only one stocking and a large beard! (Letter to GPW dated 15 November 1998)

In 2005 Kit auctioned off some of his uncle's drawings, including the scrum-half mentioned above, 'Caught and Bowled Copperknob', and 'BOWLED!!' – the captions being Mervyn's. He had understood what Kit wanted.

Hilda Neal had to wait a couple of years for the drawing she asked for, whereas when Michael Meyer asked Mervyn to sign his copy of *Titus Groan* 'he filled the flyleaf with a detailed illustration incorporating two of the book's characters in less than a minute' (*Not Prince Hamlet*, p. 62). An admirer named Miss Dinah Day, who had asked for 'a squiggle' and obligingly enclosed a stamped addressed envelope for the reply, irritated Mervyn by repeating her request after several months had elapsed, since the first had not been answered. Feeling guilty for having mislaid the original letter, he responded with an uncharacteristic (and ungentlemanly) burst of animosity, assuring her that her second assault on him had battered him into a jelly and asking after the other scalps which, he felt sure, must hang at her belt. He laid the blame for this partly on her name and partly on her nerve, ending his letter with the squiggle she had asked for – about five millimetres long! He did relent, though, and enclosed a charming drawing for her, but the letter suggests some of the tension that Mervyn was living under. He never made enough money to live on from his work, and it was only thanks to income from investments that Maeve had inherited and a modest bursary from the Royal Literary Fund obtained in 1948 (Batchelor, p. 37) that they made ends meet. So by 1949 it was clear that they had to return closer to the source of income.

PART 5

Losing the Struggle, 1950–1968

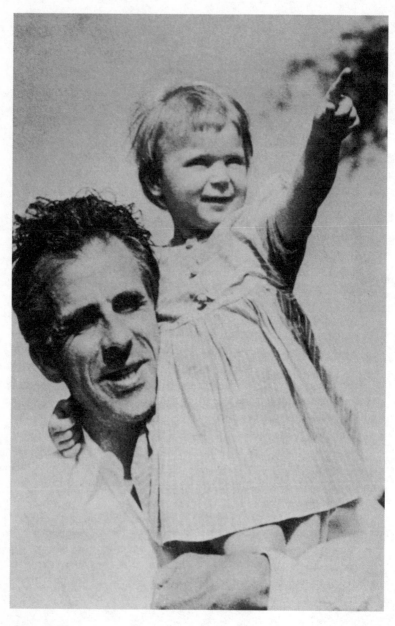

Mervyn and Clare, 1951

18
Smarden, 1950–1952

THE Peakes had not been on Sark twelve months before they
started talking of returning to the mainland – not London,
though: they aspired to a house, or part of a house, in the country.
Towards the end of 1948 Richard Stewart-Jones allowed Mervyn the
use of the stables of Stone Hall, Oxted, which he had recently pur-
chased. For a while Mervyn nourished the hope of occupying a
mouse-nibbled wing of the great hall and went down there fre-
quently enough in 1949,[1] but when the Peakes finally moved in
September that year it was back to London, where they occupied
Maeve's sister's flat at 13 Addison Road in Kensington for a month
before moving to 12 Embankment Gardens, in Chelsea again.
There they rented the two top floors of a house for a mere £3 a
week. But after their spacious house on Sark it seemed awfully
small, especially when the two boys came home for the Christmas
holidays. Then neighbours in the flat below took a dislike to them,
complaining at the least creak of a floorboard, which made the place
feel even less like home. This fuelled their search for something in
the country.

Already Mervyn's prospects seemed more promising. He had
taken a post, teaching life drawing two days a week, at the Central
School of Art in Holborn. He had a book of *Drawings* due out at
any moment from the Grey Walls Press; his volume of poems called
The Glassblowers had been accepted for publication by Eyre and

Spottiswoode, who had recently brought out his *Treasure Island* and accepted *Gormenghast*.

The novel had progressed steadily ever since the publication of *Titus Groan* – often more slowly than Mervyn anticipated – but he had worked on it very carefully, having learned from his 'blue pencil' experience with *Titus*. He finished it before leaving Sark and told his publisher that it could go straight into page proof. He was rewarded with a letter of acceptance that positively glowed with praise and enthusiasm: 'I don't wait to tell you how delighted we are. . . . You have brought the whole thing off triumphantly . . . superbly done. . . . Of the energy and excitement with which we shall publish you need have no doubt whatever.'[2] Few authors can have had their second novel accepted in such terms – and on such terms: 'a straight 15% royalty from the beginning'.

In the end it was mid-September 1950 when *Gormenghast* came out, delayed by a bookbinders' strike, and on the whole the reviewers were more generous to it than to *Titus Groan*, perceiving that 'it has the same power, the same effortless command of the sinister and the queer, and a greater measure of control' (L.A.G. Strong in the *Spectator*, 6 October 1950, p. 375). It is also more comic. It is less funny to notice that the climax of the Titus story, with the killing of Steerpike and Titus's decision to leave his home, coincided with the climax of Mervyn's career and his departure from Sark.

For *Gormenghast* and for *The Glassblowers* he was awarded the 1950 Heinemann Prize. He received no other public recognition of his achievement. The letter from the Royal Society, announcing the award, made a red-letter day for Mervyn and Maeve. Receiving the prize, and the cheque for £100, was a pleasantly brief ordeal. They spent the proceeds on a trip to France, partly in Paris and partly in a country village, while friends took care of their children.

The *Glassblowers* had been long in preparation: Mervyn was already putting poems together for it in the spring of 1947. It finally appeared in May 1950. Only nine of the thirty-five poems had previously appeared in periodicals, and only one of them, 'Sing I the Fickle Fit-for-Nothing Fellows', dates from the 1930s. Another, 'An April Radiance of White Light Dances', would appear to date from

the spring of 1942, since it mentions Pendle Hill, which overlooks
Low Moor and Clitheroe; it was probably written as (or with) a letter
to Maeve. Most of them date from Mervyn's time on Sark, and a
pretty dispirited collection they make as a whole, for they speak of the
loss of love, of failure and of loneliness. The first poem, 'His Head
and Hands Were Built for Sin', sets the tone: 'an earthish doom /
Has dogged him from his fortieth gloom / Back to where glooms
begin'.[3] Moreover, they mark the end of his poetry writing: no new
poems appeared until his last years, published by others from much
earlier manuscripts; *The Rhyme of the Flying Bomb*, for instance, pub-
lished in 1962, was written on Sark in the 1940s. When Maeve put
together a volume of his nonsense verse in the early 1970s, only a few
of the poems were from after 1950.

The book of drawings, originally planned for mid-1949, finally
came out in the autumn of 1950. In the introduction, Mervyn
expresses his ideals with regard to drawing and concludes with
words that apply equally to his novels, for they echo his letter to
Goatie of October 1943 (see p. 197):

> It is one's ambition to create one's own world in a style germane to
> its substance, and to people it with its native forms and denizens
> that never were before, yet have their roots in one's experience. As
> the earth was thrown from the sun, so from the earth the artist must
> fling out into space, complete from pole to pole, his own world
> which, whatsoever form it takes, is the colour of the globe it flew
> from, as the world itself is coloured by the sun. (p. 11)

For Mervyn, this volume should have heralded a new decade of
commissions for illustrated books. Instead, it marked the end of his
career as an illustrator. True, he had yet to illustrate *Tom Thumb*, but
that was for sale in Sweden alone. For ten years no English publisher
offered him major work in illustration; compared with what he did
in the 1940s he was given mere jobbing decoration, a jacket here, a
Radio Times drawing there.

Among the brilliant work in his book of drawings, immediately
following five of his sketches from Belsen, Mervyn included two

studies for paintings of *Christ with the Mockers* (Plates 27 and 28), in which he places Christ on the Cross, whereas the Bible situates the event at the time of his trial (Matthew 26:67, Mark 14:65 and Luke 22:63). No other biblical scene is so explicitly evoked in Mervyn's work; as I have already mentioned, he alluded to it in his poetry in the mid-1940s, and there are echoes of it in his illustrations for two articles that appeared in *Leader Magazine*, 'Where Is Christ in the World Today?' by J.L. Hodson and 'Did Jesus Have a Fair Trial' by Robert Graves.[4] Around 1950 he developed the second study into a powerful oil painting of the crucifixion, which emphasized the weeping angel and omitted the mockers. (This painting has been exhibited but not, as far as I know, reproduced.) Clearly Mervyn felt drawn to this scene: as a solitary artist, who felt mocked by those who did not understand his aims and ambitions, it meant a good deal to him. If this is the counterpart to the feelings of loss of love and loneliness in his poetry, then the themes of *Mr Pye*, with its dramatization of the struggle between good and evil in a single character, are clearly germane to it, too.

There were no doubt equally complex motives behind the ambitious purchase that the Peakes made in 1950: The Grange, a large and elegant house in Smarden, Kent, that they had seen advertised in the *Sunday Times*. They moved in the autumn, having taken out a mortgage that was massive for people of such modest means. Even though their sons went to the local school, rather than an expensive boarding-school, it was soon clear that they could not afford to live there; a legacy for Maeve, whose father died in April 1950, made little difference. It was the death of Dr Peake, at Christmas the same year, that was ultimately to save their financial situation, for he left Mervyn the family house at Wallington; Reed Thatch went to Lonnie. In the meantime they were installed in The Grange, with all its advantages of peace and quiet and drawbacks of maintenance and mortgage payments.

The house had a 'studio' tacked on to the back, and faithful to their habits of generosity to fellow artists the Peakes allowed John Grome, with his young Italian wife and new-born baby, to live there for a whole year. At the same time they let him use the Trafalgar

Studio as an exhibition room where he could show potential pur-
chasers and gallery owners the paintings he had brought back from
Italy – 'a plan that turned out to be very successful', he recalled with
much gratitude.

Grome saw how

> Mervyn's art and his life were all of a piece. He was never one of
> those types who only painted or wrote at certain hours. His creativ-
> ity was in constant action. You might be talking about potatoes or
> apples but there was that glint in his eye, that pre-movement of his
> lips . . . that presaged his sudden conception of a new idea for a play,
> a book, a painting, or perhaps merely the re-organization of some
> piece of work he had been working on or had in mind . . .
>
> Mervyn also had an almost mystical feeling for any creation: a
> baby, a caterpillar, a word, or an idea. It was never mixed up in his
> mind. He never got his essentials wrong or even muddled. For him
> it was quite natural to come out into the garden, do an about turn,
> and return instants later with pencil and pad to draw us all as we sat
> having lunch with the family under a tree.[5]

It was on one such occasion that, dropping in on the Gromes in
the studio one evening, Mervyn noticed how 'the light floating from
the cottage onto the plum tree in the garden was beautiful at that
hour of the night', so out came his easel and canvas and he was at
work. Five of his felt-pen sketches of nightscapes were reproduced in
MPR, 7 (1978). About the same time bonfire night inspired him
with a rare abstract in the same medium, combining the number 5
(for 5 November), a bird-head mask and fireworks.

At Smarden Mervyn participated in the social life of the country
village, the cricket club in the summer and the amateur dramatic
society in the winter. The latter put on a one-act play, *The
Connoisseurs*, which Mervyn adapted from a short story – inspired
by a conversation overheard at a party – that he had contributed to
Lilliput. Two men debate the relative beauty of a Chinese vase,
depending on whether it is considered genuine or not. To find out
for sure, they break the vase open – another shattered vessel – and

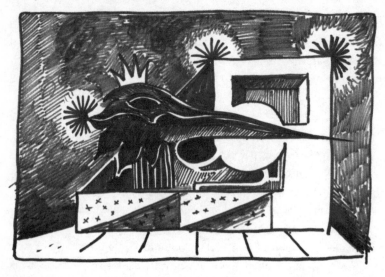

Bonfire night, drawn with a felt pen, *c.* 1951

find deep inside the sign that it was genuine after all. The story echoes the ends-versus-means debate of the 1930s and Mervyn's introduction to his book of drawings. An attack on criticism, which destroys when it seeks to identify and label, it is also a defence of Mervyn's own work, judged genuinely beautiful by some and dismissed as 'naïve' by others. Coming as it does at this turning point in Mervyn's life, the story has tragic symbolism.

The play for the amateur dramatic society was not Mervyn's only contact with the theatre that year. In January and February 1950 he went to Edinburgh several times with Rodney Ackland, who was adapting *Dr Jekyll and Mr Hyde* for the stage;[6] Mervyn was to design the sets, but the project fell through.[7] These ventures rekindled his enthusiasm for the theatre, and he started writing a play called *Sally Devius*. After the first couple of scenes his idea developed into *The Wit to Woo*, the tragi-comedy on which he was to focus much of his energies – and hopes – over the next five years. Meanwhile, at the cricket club he encountered Michael Meyer, whom he had already met at John Brophy's in the 1940s.[8] Meyer does not recall discussing the theatre with Mervyn. 'He was such a quiet and unassuming fellow that he always did the least of the talking compared with Maeve

and me' (from a letter to GPW dated 23 September 1998). He was rather struck by Mervyn's cricketing – 'still a swift runner and a beautiful fielder in the deep' – and by the decorations in his house: 'Almost every white surface except the ceilings bore one or more of his drawings, executed directly on to the paint. One found them on the wainscoting by the floor and in unexpected places in the lavatory' (*Not Prince Hamlet*, p. 62). Esmond Knight was another visitor from the world of the theatre. According to John Watney, he gave Mervyn advice on *The Wit to Woo*, which he thought 'extremely good in its original form', implying that he found it rather less so by the time it reached the London stage in 1957. 'It was very funny and full of marvellous language' (Watney, p. 165). An example of Mervyn's word-play at this time can be found in the title of a projected play, *Isle Escape* – 'a debate as to where to go to escape from 1951' comprising (it would appear) 'six little satires on connoisseurs' and 'notes on private language'.[9] No doubt he was thinking of Sark.

Like many authors who describe real places, Mervyn wrote best about Sark when he was not there. At Smarden he wrote *Mr Pye*, whose eponymous hero is a small, portly man who goes out to Sark to convert the islanders to his own naïve brand of Christianity. Coming from the pen of the son and grandson of Christian missionaries to such places as China and Madagascar, it reads as a clear rejection of their claim to a spiritual truth to which they sought to convert the natives. In a brief piece for the *Radio Times* about how he came to write the novel, Mervyn said: 'Awestruck by zealots I have always been; awestruck, but hate-struck too, in the compound [at Tientsin] where God was at large and the great missionaries loomed like mammoths' (*PS*, 2007; 10: 3, 3). It is also a personal reflection on the nature of good and evil, which echoes the first poem in the *Glassblowers* collection about a man whose 'head and hands were built for sin'. In the poem we never get to know who 'he' is, but it ends with the affirmation that 'in the shrewd eye of heaven' he is as innocent as the waves of the sea. In the novel Mervyn contrasts the asexually pure Mr Pye with the sexpot Tintagieu and concludes that this earth is no place for the former.

Residents of Sark can identify every character in the novel for

you – but not Mr Pye himself (luckily enough); for him they each offer different suggestions. As with all Mervyn's creations there is surely no single source. One of them may lie in an Agatha Christie novel, *The Moving Finger*, which was very popular in the post-war years. It features a Mr Pye who was 'an extremely ladylike plump little man, devoted to his *petit point* chairs, his Dresden shepherdesses and his collection of bric-à-brac. He lived at Prior's Lodge in the grounds of which were the ruins of the old Priory.' This Mr Pye, whose 'small plump hands quivered with sensibility' and whose 'voice rose to a falsetto squeak', 'did not despair of leading you to better things' than 'a radio or a cocktail bar'.[10] Given the proselytizing aims of Mervyn's Mr Pye, who bears a physical resemblance to Agatha Christie's, the nexus of words like 'devoted', 'leading you to better things' and 'The Priory' echo significantly. As for the radio, on Sark the Peakes had listened to their favourite BBC programmes on a Pye radio, whose large battery had to be lugged to a shop at the top of the harbour hill every week to be recharged (Peake, p. 70). There may be another autobiographical element in Mr Pye's odd characteristic of sucking his thumb, which recalls Pip Waldron – but then numerous other characters in Mervyn's novels also suck their thumbs or their knuckles or the pommel of a walking stick at various moments.

Mervyn himself gave a memorable account of how the character of Mr Pye came to him:

> On a day of golden doodling, I saw him with my eyes shut. And he, being seen, made for the horizon, so that I lost him. But the game had started, and devoured me for an autumn. There was no escape from it, from the mad-making, nib-scratching hell of an author's life that cannot be put aside. But there he was, the little man, vivid as a lollipop, Mr Pye himself, poised on a high rock, his soul naked to the 'Great Pal', his God.
>
> At first I could not reach him, but lagged in the shadow of his feathers; wondered at his paunch and the wicked glint of his horns. But when I came to write, I gave it up. Each word strangled the next. My sentences became too tenuous.

In *Titus Groan* and in *Gormenghast* I wrote out of words. Words took me into a land of shadows and of passion where I felt at home. But with *Mr Pye* it was otherwise, and I groped for the kind of clarity that floats like sunlight on dark water.

And so, at last, Mr Pye – the sleuth of glory – found himself between cardboard covers, in a setting as real as I could make it.

(PS, 2007; 10: 3, 4)

The Peakes needed money, but, much to Mervyn's disappointment, *Mr Pye* did not sell well, and in the end it, too, was remaindered. Apparently only light entertainment, it was weighted with serious reflections on good and evil, imagination and invention and the treatment of art and artists by contemporary society that tend to leave the reader more thoughtfully puzzled than amused. It is 'an oddity', as the *Times Literary Supplement* reviewer put it (6 November 1953). Yet it is a thoroughly crafted novel, more carefully structured than the Titus books, with language that is less rich but equally apposite. Indeed, it 'floats like sunlight on dark water'.

During the year at Smarden, moved no doubt by the death of his father, Mervyn made the 'notes for an autobiography' from which I have already quoted. It was a natural moment for reflecting on his life: in the summer of 1951, he turned forty. Family photographs show him with a rapidly receding hairline and a surprisingly lined face. He brings to mind the Bright Carvers of Gormenghast, whose fate it was to age prematurely and decline rapidly. He had but seventeen years to live – and even that was longer than either of his maternal grandparents had survived.

After Dr Peake's death Mervyn wanted to sell Woodcroft, the Wallington house he had inherited. It was far too big for his own family, and he hoped to realize enough money to pay off the mortgage on The Grange. But Woodcroft was let, and the tenant fought to retain the lease. At the same time the bank decided to foreclose the Smarden mortgage, and Mervyn was obliged to sell at a loss, house prices having declined since he purchased the property. He and Maeve returned to London and settled in their single-roomed studio in Manresa Road. It was minute for a family of five, so the

two boys were sent off to boarding-school again. Mervyn took the Woodcroft tenant to court and won the case. But the house proved unsaleable. So in the end, late in 1952, he and Maeve moved to 55 Woodcote Road; he was back in the family house, still owing the bank a thousand pounds for The Grange but without any other liabilities – except the Trafalgar Studio, which he continued to rent at thirty shillings a week (Watney, pp. 169–73). His income was so low that he could barely afford to pay the interest on his debt, never mind reimburse the capital, which stood unchanged for five years. Then Lonnie, remembering Mervyn and Maeve's generosity in accommodating him and his family at the end of the war, sent them a cheque for a thousand pounds, and it was finally paid off.

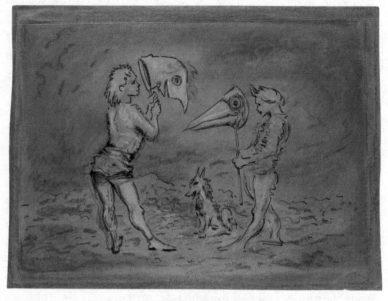

Boys with masks; mixed media, early to mid-1950s

19
Wallington, 1953–1960

THE house at 55 Woodcote Road was large indeed, with six bed-rooms, high-ceilinged reception rooms and an equally spacious garden where there was a wartime air-raid shelter in which Sebastian held his teenage parties. All three children went to day school, and the house resounded with their activities – especially when Sebastian took up drumming. Maeve and Mervyn had their own workrooms, and Maeve loved the house – but hated the suburban setting. They lived for seven years in what she called an Outer Siberia, and she could remember only two people that they talked to there (Gilmore, p. 98).

Here Mervyn corrected the proofs of Mr Pye and wrote numer-ous versions of *The Wit to Woo*. He also worked on several other plays and short stories, for his creativity knew no decline. But in the way of illustrations the only important commission came from Paul Britten Austin, who was employed by the Swedish Broadcasting Corporation. His story of *Tom Thumb* was to be read aloud in English lessons on the radio and, to help listeners with their learning, the text of it was published in miniature books with an English–Swedish glossary. Austin had known of Mervyn as an illustrator since the mid-1940s when he invited Quentin Crisp to write an article for *Facet*, 'a magazine I was rather temerariously launching in Bristol', and Crisp wrote about Mervyn.[1] The success of the first volume of *Tom Thumb*, in the

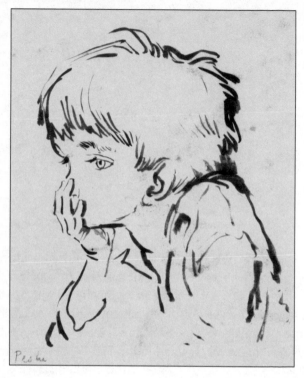

Fabian; brush and ink on brown paper, undated

summer of 1954, inspired a sequel the following summer, which Mervyn also illustrated.

For this commission Mervyn produced forty-eight line drawings, of which twenty-eight were reproduced as full-page illustrations, plus numerous decorated capital letters. He eschewed cross-hatching and used line with occasional shading to great effect. In some illustrations he abandoned outline altogether, using background lines to silhouette objects, with exquisite results. He used this same technique with equal success in some of the illustrations he made for *Lilliput* in 1953, particularly 'The Wendigo' by Algernon Blackwood and 'Love Among the Ruins' by Evelyn Waugh.[2]

Of course he was still drawing his family as regularly as ever, as attested by the beautiful portraits of Fabian and Sebastian reproduced above and on page 18.

About this time, when television was just entering British social life (stimulated in particular by the broadcasting of the coronation of the Queen in 1953), Mervyn developed an idea for a cartoon about a line and all it could express, but it was not adopted. However, after the sketches for it had been published in *Writings and Drawings*, another artist brought out a book, called *I Am a Line*, using the same idea. Mervyn was never short of projects, writing to publisher after publisher with his suggestions – for example, in 1953 he tried to interest Faber and Faber in his illustrations for extracts from poems by Oscar Wilde and also illustrations to poems and stories by Poe. Faber and Faber, in the person of Sir Walter de la Mare's son, was not to be tempted, but Everyman's Library asked him to do a jacket for Poe's *Tales of Mystery and Imagination* and for a couple of other titles, too. Oxford University Press commissioned a few covers for its World's Classics.

The only book project that Mervyn did manage to put over was *Figures of Speech*, which was published by Victor Gollancz in 1954: twenty-nine drawings illustrating catch-phrases and sayings (along the lines of 'Put that in your pipe and smoke it' and 'Severing relations'), presented as a guessing game, with the solutions listed at the end. (The idea was brilliantly echoed by Shirley Hughes in her 'book of sayings', *Over the Moon*, published by Faber and Faber in 1980. Peake's own depiction of 'severing relations' seems to echo a cartoon by Fix in *Lilliput* for August 1942.) *Figures of Speech* is fun – but it was not a commercial success, and in the end it followed what was becoming an all too familiar pattern: it was remaindered.[3]

Small commissions came his way from time to time, particularly portraits. Among those reproduced in this book, I might mention how Mervyn's book of *Drawings* so delighted a printer who worked for the Grey Walls Press that he asked for a portrait of his fiancée. On the appointed day she was late and Mervyn in a hurry, but Jenifer Pink was immortalized in an unforgettable drawing. Friends and acquaintances would also come with their requests. Soon after the move to Wallington, for instance, Mervyn was contacted by Lawrence Graburn, who had been the tenant of Wepham Farm until shortly before the war and knew the Peakes from their days in

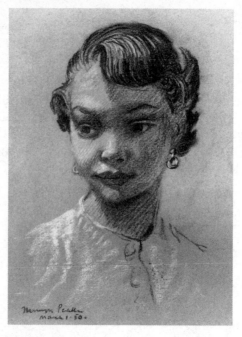

Jenifer Pink; crayon on coloured paper, 1950

Burpham. He had become a regular contributor of articles about local country people to the *West Sussex Gazette* and asked Mervyn to provide some illustrations. He supplied several - exactly how many is not yet known.

Some time later, Eric Drake's brother Burgess wrote *The English Course for Secondary Schools* which was published in 1957 by Oxford University Press, and he asked Mervyn to make some illustrations for it. He depicted scenes from the animal stories in a light vein. As the book is now extremely rare - although it was used in many schools around the world at the end of the 1950s - this series of illustrations is virtually unknown, even to the most ardent admirers of Mervyn's work, so I have included several reproductions here.

During the Easter holiday of 1955 Mervyn was invited to join a group of friends - an archaeologist, a historian, a geologist, a naturalist, a writer and so on - who had persuaded the BBC to finance a visit

Three illustrations from Burgess Drake's *English Course for Secondary Schools*, 1957

to Yugoslavia with a view to producing a television programme that would reflect their individual impressions of the country. It is not clear in what capacity Mervyn went: Maeve says he was the artist and not the writer (Gilmore, p. 112); John Watney says he was the writer and not the artist (Watney, pp. 181–2). I suspect that Mervyn's friends simply wished to give him a holiday! At any event he produced a good many sketches and no writing that I know of, but the programme was never made. Mervyn was interviewed afterwards for children's television, and a few of his drawings were shown, and that was all. He did buy a television at this point, however, and for a while he watched a great deal, but in the end he decided that it was a waste of time (see *MPR*, 1981; 12: 23).

In the seven years at Wallington Mervyn wrote *Boy in Darkness* and all of *Titus Alone* as well as short stories.⁴ Was it the house or Mervyn's changing state of mind, or a combination of the two, that produced the ghoulishness in his stories of this period? According to Maeve (*PP*, p. 119), the Peakes were in the habit of telling ghost stories on Boxing Night, and one of them, 'Danse Macabre', composed for Christmas 1954, was published in 1963. Unlike the Titus books it is told in the first person; the unnamed narrator recounts how he witnesses his own clothes leaving his bedroom at three in the morning and dancing with a lady's dress in the nearby wood. A few days later friends reunite him with his estranged wife, who is wearing the very dress he saw in the wood. When finally he returns to his room he finds both himself and his wife dead in his bed. A classic horror story in its play with the borderline between life and death, and romantic in its notion of a couple that can truly be united only in death, the tale is unique in Mervyn's *œuvre*. Yet it is cognate with the Gothicism of the Titus stories, particularly in the splitting of the self.

Its companion piece, 'Same Time, Same Place', also told in the first person, sees an ineffectual young man, typical of the tepid antihero of the 1950s, ensnared (is it by hypnotism or simply by the strength of his own projections?) into promising to marry a beautiful girl without realizing that she is a dwarf. He discovers the truth at the last moment when he happens to catch a glimpse of his bride-to-be and her outlandish companions preparing for the ceremony.

He hastens home to his parents and embraces the soul-destroying routine from which he had previously wished to escape. The story ironically celebrates ordinariness as a flight from the rich potential of difference – in contrast to the Titus books, which celebrate difference and the adolescent rejection of home – at the same time as undercutting its own irony and justifying the narrator's flight home by making him the victim of the freaks' deceit. (The combination of marriage and circus freaks in this story recalls the long-banned film by Tod Browning, *Freaks* (1932), which Mervyn may have known by repute.) 'Danse Macabre' and 'Same Time, Same Place' are more polished than Mervyn's other writings and eloquently convey the terror of being carried away by irresistible forces. Consequently they have frequently been anthologized.

Situated between the Gothicism of the Titus books and the horror of the short stories comes *Boy in Darkness*, which Mervyn contributed in 1956 to a volume of three novellas, the other authors being John Wyndham (best known for *The Day of the Triffids* and *The Midwich Cuckoos*) and William Golding (author of *The Lord of the Flies* and future Nobel laureate). In common with Mervyn's short stories (including the 'Weird Journey'), *Boy in Darkness* borders on dream, but, like the Titus books, it is told in the third person. The most clearly archetypal of Mervyn's works, it shares the chimeras of 'Same Time, Same Place', but instead of retreating back into the womb of home, like the narrator of that story, the teenage Titus (called just 'the Boy' in a corrupt version inadvertently released at the end of the 1960s, happily now replaced by the original text) confronts the evil Lamb and 'kills' it. I put the verb in inverted commas, since the Lamb, once split open, proves to be empty, 'devoid of bones and organs', just as those things in ourselves which we most fear prove to be literally empty fears when we ultimately confront them. In terms of psychic health, *Boy in Darkness* is the most mature of Mervyn's writings, depicting a rite of passage (in Van Gennep's sense) while remaining somewhat obscure to the reader's rational mind: the private symbolism and inconclusive biblical allusions are distracting rather than enlightening.

From the Smarden days onwards, Mervyn was troubled by shak-

ing hands and a restless nervous energy that made it difficult for him to sleep at night. At first he ignored these symptoms, thinking they would go away – and they did when he rested and got enough sleep – but they always came back. He consulted doctors, who (with the limited means and knowledge of the time) could identify no specific illness. When he was particularly run down at Easter 1956, a generous friend, who insisted on remaining anonymous but is now known to have been Lady Moray, paid the entire cost of a three-week holiday in Spain for him and Maeve, and his condition improved; the shaking, which had spread to his legs as well as his hands, diminished, and he felt younger and more cheerful. He saw the work of the great painters he admired – Goya, El Greco – and brought back some memorable drawings of Spanish people encountered in the street: a policeman, priests, beggars and the man in a beret shown here. But the improvement was short-lived. The restlessness returned and the shaking with it, making drawing and writing very difficult, sometimes impossible. On several occasions Mervyn spent time away from home, hoping that the peace and quiet of a Dedham pub, for instance, would soothe and relax him. Such breaks did alleviate his condition but, as with the Spanish trip, they were just palliatives and could not halt the remorseless progression of his illness.

The man in a beret, from Mervyn's trip to Spain

At home he remained the playful, loving person that his children remember fondly. He was full of pranks, hiding in the airing cupboard to burst out with a 'Boo!' as a child went past. He invariably vaulted over a chair in preference to settling in it in the conventional manner. Compared with Lonnie, he was 'mischievous', 'a grown-up of a type I had never known before', as his nephew Kit put it. 'I enjoyed being a conspirator with him, and felt grown up', too (letter to GPW dated 15 November 1998).

Throughout this time Mervyn was still teaching two days a week at the Central School of Art, which generously kept his job open as long as he could make the journey to the school. As a teacher of life drawing, Mervyn would wait until the students had started to make drawings of the model and then walk among them, observing their progress and suggesting how they might improve their work. Saying little more than 'I think I see what you're trying to do', he would make quick sketches in the margins of the students' papers to illustrate how they might proceed (MPR, 1981; 12: 15). Some of them carefully preserved these sketches. He gave few verbal instructions and no theory.

His illness seems to have stimulated his libido, though. He had his favourites among the girl students and would invite them round to his studio. One girl who admired him greatly caught his eye and he sketched her painting at the school. Then he asked her if he might do a portrait. She writes: 'The more finished drawing was done in his studio, to which I was invited (without a chaperone). This will have been summer 1954.' At the time she was recently engaged, 'and this was the reason I gave him that things would *go no further*, but actually, I was embarrassed by the fact that I was wearing knee-length stockings, and it didn't seem very glamorous!' (personal communication dated 5 August 2007).

At one point he was suspended for kissing a model. The school, and particularly Morris Kestelman, the head of the drawing department, took him back, thanks to the intervention of friends. Even when his condition worsened he continued to teach when he could, for 'though Mervyn's movements were slow, and he had this strange trembling, he taught just as well as before. He had all his humour

with him too.'[5] But he was paid only for the hours he actually taught; there was no pension or sickness benefit.

A student from the Morley College of Music has recently told how he wooed her relentlessly on the evening train from Victoria. Having spotted her especial beauty, he addressed her with:

> Excuse me, oh, you marvel. You long-boned dark chromatic creature. Eyebrows like ravens' wings. You're straight out of Picasso's Blue Period. I must paint you. Come home with me at once. Will you come? My God, why haven't I found you before?
>
> (PS, 2008; 11: 1, 36)

She refused to speak to him and resisted his advances. Week after week he would work his way down the train until he found her; half flattered, half terrified, as fascinated as the wedding guest faced with the Ancient Mariner, she listened while he told her the story of the Titus books. 'But in those days – with so much regret now – I was afraid of fantasy.' A sadder and a wiser woman, she tells how it ended:

> Finally, one Monday night it happened that our carriage was empty. As soon as the train drew out, Mervyn decided in his humour to play out a bit of Irma Prunesquallorish romance and I was embarrassed out of my mind! He was, I realized in later years, simply trying out some romantic comedy dialogue, but at my station I reclaimed my knees from under his head and leapt out. He leaned from the window crying, 'Adieu! Adieu! Beautiful creature! Divine being! Return to me, Priscilla!' – his name for me – 'Farewell!' as I strode the length of the platform, violin case banging my knees, and heads came out of every other window. I never caught that train again.
>
> (PS, 2008; 11: 1, 37)

Mervyn also enjoyed a desultory relationship with an amateur poet and painter, who signed her work 'Francyn'.[6] How they met is not known but their affair started in 1953 and continued for at least three years. They remained friends (as was generally the case

A student at work at the Central School, *c.* 1954

with Mervyn's affairs), and he encouraged her work, providing an introduction to the catalogue of her exhibition at the Woodstock Gallery in spring 1962 and recommending her poems to an American publisher in June 1963. She was seventeen years older than Mervyn, which must have been a shock to Maeve when she found out about it. Reading the extracts from Francyn's diary that Yorke published (in Chapter 13 of his book), we may wonder if some of her encounters with Mervyn did not inspire the scene in *Titus Alone* where Titus makes love with Juno. Maeve became sufficiently reconciled to this relationship to allow Francyn to attend Mervyn's funeral.

July 1956 saw an unexpected inflow of money: the Waddington Gallery in Dublin organized an exhibition of Mervyn's work, and he was proud to return home to Maeve and inundate her with fistfuls of five-pound notes. But it was a rare occurrence. Mervyn was not concentrating on drawing and painting as he used to. From 1950

Watercolour portrait of a boy, 1956

onwards he spent an increasing amount of time on plays, both new ones and adaptations of his own published works. In addition to *The Wit to Woo* and *The Connoisseurs*, five of his plays reached fruition in the mid-1950s: first an original radio play called *A Christmas Commission*, which was recorded in London on 29 October 1954 with Paul Scofield in the role of the artist and broadcast on NBC radio (North America) at Christmas that year. It was revised and broadcast on 18 December 1956 as *The Eye of the Beholder* by the BBC Home Service.[7] The story is simple enough. In a country church a vicar decides to invite an artist called Jarvis to paint a mural on a blank wall. When the work is unveiled, the parishioners turn against it. Yet many years later they no longer hate it; they find it soothing; the shock effect has gone. It makes for good radio because there is no requirement for action that is not verbal, and it gave Mervyn the chance to debate the role of art and the artist in society. For me, this is the work that shows most clearly that he remembered *The Horse's Mouth* by Joyce Cary: Gulley Jimson was forever painting large murals of just this type of subject – with similar

254

reactions from the public. Mervyn added a temporal dimension not available to Cary's first-person narration.

In the way of adaptations, Mervyn made one for television, *Letters from a Lost Uncle*, and two for radio: *Titus Groan* and *For Mr Pye – an Island*. He might have made a name for himself in writing for the radio, as he clearly had a gift for it; but he preferred to pursue the stage, for he believed – erroneously as it turned out – that he could make more money there. Thus one of his major enter-prises was an operatic adaptation of *Titus Groan* and *Gormenghast*, for which he hoped that Benjamin Britten could be persuaded to write the music. There is no evidence of his having actually con-tacted Britten, for although Britten was an inveterate hoarder of let-ters there is no Peake correspondence in his papers (according to Dr Philip Reed, musicologist at the Britten-Pears Library, Aldeburgh). In the event, Mervyn seems to have worked quite as much on designs for the set as on the libretto.[8]

Among Mervyn's unperformed dramatic works from the 1950s there is *Mr Loftus, or A House of Air*,[9] on a theme suggested by Aaron Judah, who lodged with the Peakes for a while. It centres 'around an Oblomov character, a man who, though having great gifts, had decided against using them, and would devote his life to doing nothing on a grand scale' (Watney, p. 186). When completed, the typescript was sub-mitted to producers and directors, but none was prepared to take it up. Mervyn also provided line illustrations for a book of Judah's stories for children, *The Pot of Gold*, which was published in 1959.

Mervyn completed three other plays that were not performed in his lifetime: *Those Wicked Doctors*, *Noah's Ark* and *The Cave*. The first is a farce involving three young doctors who have just set up a practice in Waddington-on-the-Quandle. As they do not have many patients they cannot pay their bills, so they resort to all kinds of nefarious acts to steal custom from the town's other doctors. Naturally, they fall foul of their rivals but are saved by a neat reversal in the final scene. It has not yet been performed. In *Noah's Ark* a modern boy dreams that he goes back to help Noah and saves him from an animal revolution. Although it is written for children to act it relates most closely to *Boy in Darkness*, with a sinister scene in which the Hyena, the Vulture and

the Wolf plot to kill Noah and his family and have the world to them-selves. Their slogan is 'DEATH to the human race!' First printed in *Peake's Progress*, it was broadcast as a radio play in three parts by the BBC in 1981. It has never been staged.

The Cave has not, to the best of my knowledge, been performed either; a dramatic reading in 2009 was billed as a 'world première'. Circulated in typescript by Mervyn's agent in the early 1960s in the hope of interesting a director, it met with no success. It is Mervyn's most philosophical work, aiming 'to show how man has always needed the supernatural in the form of one kind of God or another'.[10] These terms show how far he had come from the religious beliefs of his parents and how lost he felt (like so many others) under the shadow of nuclear war in the 1950s. In each of the three acts the same characters, in the same cave, reveal their metaphysical beliefs: as stone-age cave-dwellers first of all, worshipping the moon and fearing the wolves; then as medieval Christians, believing in the God of the Old Testament and fearing hell and witchcraft; finally, as lonely godless moderns, fearing the Bomb. In one sense it is very much a period piece of the mid-1950s; in another it is very close to Mervyn's preoccupations as an artist and with living genuinely. Each scene ends with the artist character, taunted or provoked by his rational brother, caught on the brink of committing murder. 'All things are on the other side of an unending window-pane,' says one of them, taking up a metaphor that Mervyn used several times, both in prose and verse, when thinking about his art. In *The Glassblowers* he affirms: 'Each day we live is a glass room / Until we break it with the thrusting / Of the spirit and pass through.' The smashing of another window-pane links with the smashing of vases: for Mervyn, to live genuinely as an artist involves breaking out of the invisible cage that most people inhabit, and in so doing he is liable to alien-ate himself from the rest of society.

Then there were uncompleted plays such as *Manifold Basket*, set in a school that has been cut off by a landslide. With but a handful of professors (several with names borrowed from Gormenghast) and no pupils, the headmaster has managed to convince the Ministry of Education that the school is still functioning, and they

are paid for doing nothing, until it is announced that an inspector will arrive – by parachute. As with *Mr Slaughterboard*, Mervyn stopped writing at this point, not knowing how to carry on. In *The Widowers*, or 'Four Old Men', an aged caretaker invites his old schoolmates to come and live with him as squatters in the large unoccupied house that he is entrusted to look after. *The Widowers* was probably intended for television, as was *The Teddy Boys*, which exists only as a fragmentary opening scene.

It will be noticed how the motif of the almost empty house, cut off from the world, recurs in these plays, just as it is central to the Titus books. And Mervyn's characters are often old men, reminding us of Fuchsia's complaint, 'Who is there anyway who isn't old?' (TG, p. 304). The one person who isn't is Gormenghast's bad boy, Steerpike.

The Greenhorn is equally incomplete. It opens with a war-weary mercenary taking it easy in a forest glade:

> Here, a man can rest
> And chew a watery stalk and ruminate
> Or fill his mind with dreams until the battle
> Sags into supper-time, and dusk comes down
> Upon the warriors returning home
> With bloody swords, and it is safe to join
> The gallant asses – one side or the other,
> According to the fortunes of the day.
>
> (PS, 2008; 10: 4, 29–30)

He is joined by a rookie or greenhorn, to whom he passes on his philosophy of life. It would seem that the rookie, a kind of Candide figure, was to rise to social success. 'The Greenhorn is taken in everywhere, so that he sees the inside of everything. With trumpets and torches he is shown the innermost secrets and is fêted as he goes. But the cynic is cast out by life' (PS, 2008; 10: 4, 26). Fragmentary though they be, these plays tell us much about Mervyn's preoccupations and interests. Unlike Gormenghast, however, they failed to grip his imagination sufficiently for him to finish them.[11]

The play that occupied Mervyn's mind and much of his time for

two-thirds of the 1950s was *The Wit to Woo*. The story begins simply enough. Old Man Devius is bankrupt and wants to marry off his daughter Sally to a man of fortune; to hasten her decision he pretends to be dying. Percy Trellis has long courted Sally but nothing in her 'quicken[s] to his obscure advances' (*PP*, p. 293) so he fakes his own death and comes to woo her in the guise of his imaginary cousin October, a painter. This makes Sally realize that she preferred Percy, who therefore returns as his own ghost and they are united at last. Because Mervyn was more concerned with trying to make his audience laugh than with honing the structure of the play, there is too much secondary action between Old Man Devius and his life-long friend and personal physician, Dr Willy, and on the part of the chorus (four men who act first as coffin-bearers and then as bailiffs who carry off Old Man Devius's furniture). The motivation of Percy's valet Kite, a kind of Elizabethan malcontent figure, is not very clear; Mrs Lurch, the housekeeper-cook, and an unidentified figure who twice appears at a window could easily be dispensed with. Although there are parallels with *Volpone*, the play lacks Jonson's strong moral message. It exists rather for the sheer pleasure of its language, as though the characters were more concerned with punning than in genuinely relating to each other.

It must be said, though, that the play has been badly served until now. When Maeve decided to print it in *Peake's Progress* she could find no copy of the text as ultimately performed at the Arts Theatre on 12 March 1957, so she did her best to reconstitute it from the manuscripts. The result was incoherent, to say the least. Luckily, Methuen plan to publish an edition based on a duplicated script which, from the annotations by hand, would appear to have been used by the understudy for Sally Devius. Thus the genuine *Wit to Woo* will become available for the first time.[12]

Mervyn placed great hopes in this play, which did the rounds of numerous directors, producers and actors before Michael Codron accepted it in January 1957. In great excitement Mervyn attended the rehearsals, confident that it would be a great success. But the critics did not share his enthusiasm. Since the departure of Peter Hall in July 1956, the Arts Theatre had put on a series of odd and

undistinguished plays directed by the young Peter Wood. *The Wit to Woo* merely fitted the pattern and was dismissed by the press as 'too conscious of its own cleverness and craziness to be funny all the time' (Cecil Wilson in the *Daily Mail*, 13 March 1957). 'The play has an exhilarating oddness, but breaks a salient comic rule: where everybody is eccentric, nobody is funny, because there is no norm against which to measure them' (*Observer*, 17 March 1957). For W.A. Darlington, 'after the middle of the play, Mr Peake was so busy piling on farcical business that the story went underground' (*Daily Telegraph*, 13 March 1957). The May issue of *Plays and Players* came up with something more positive:

> Mr Peake prevents all this from degenerating into exasperating trivi-ality by not merely suspending disbelief but stringing it up and throt-tling it. Before one can sigh and run away he has brought a bed down from the ceiling containing the girl's spluttering top-hatted father, turned the undertakers into bailiffs cluttering the stage with the impedimenta of removal, introduced a wine-bibbing, dancing, dod-dering doctor, and let imagination run riot in a surrealistic cumulus. And lest the chuckles at satirical wit and happy turns of phrase should make us feel he is merely having a verbal game with us, he melts them with passages of honest poetry and human sentiment.

However, by the time this appeared the play had already come off. And Mervyn had suffered a second nervous breakdown. Maeve recalled that he retired to bed when they got home from the première and became delirious. He lay there for the next few days, as though he had given up hope. Although the doctor gave him tranquillizers, the tremors in his hands and legs increased. To Maeve's horror, there came a day when his memory went completely and he had halluci-nations.

It would appear, however, that he recovered sufficiently to return to teaching in the summer term, although Maeve, in her memoir, telescopes the year between March 1957 when he broke down fol-lowing the failure of the play and March 1958, when he was sent for treatment at Holloway Hospital, Virginia Water. He certainly picked

up enough to go by himself to Sark in July 1957, hoping to make progress on writing *Titus Alone*; there he learned that the BBC was broadcasting his adaptation of *Mr Pye* on the radio, but it could not be heard in the Channel Islands. He wrote to Maeve that he would telephone various film producers in the hope that they would listen to it and consider making a film of his novel (Watney, p. 197). In the event, *Mr Pye* was indeed the first of Mervyn's works to be televised, but that was thirty years later.[13]

That summer the family holiday at Weymouth was marred by Mervyn's irrepressible restlessness. He was able to work, though, and produced thirty line drawings for *More Prayers and Graces*, with which the publishers hoped to reiterate the perennial success of the first volume – but they made an outright payment for the illustrations. Had Mervyn been well he would no doubt have held out for a royalty arrangement. In this book his drawings are more caricatural, a tendency that came to the fore in his later work before it became geometric and then almost abstract. In fact, there is a coarseness of feeling, a lack of sympathy for the persons he portrays, that was not present in the previous volume. As his relationship with his own body became problematic, he began to lose that precious ability to slide into another person's skin. His technique varies from the single sinuous line through broken line sketches to numerous short parallel strokes and dotted shading; from them one could hardly guess the difficulties he was having with steadying his hand. From later work it is clear, though, that short parallel strokes were his solution to the problem; in this way he was able to build up a drawing gradually, particularly with the Flomaster felt pens for which he had developed a liking.

Throughout the years at 55 Woodcote Road Mervyn was working on *Titus Alone*, which was intended to be but the first of several volumes of Titus's adventures outside Gormenghast,[14] and in the autumn of 1957 he strove to finish it. Over Christmas and New Year he sought peace and quiet at Aylesford Priory in Kent and made good progress. He felt optimistic about the future and joked about the Spartan conditions at the monastery. Yet women were allowed to visit, he told Maeve – luckily, 'I have a tame radiator,' he reassured

her. In the event, he was asked to leave before he had finished the book: his physical agitation was such that, unable to sleep, there were nights when he would walk up and down until exhaustion overcame him, which was disturbing for other visitors. Early in 1958 he finally managed to finish the book, and Maeve typed up the closing chapters for him. It was very difficult for her; the manuscript is full of emendations, deletions and alternative scenes, and the handwriting progressively deteriorates. But it was done at last, and *Titus Alone* went off to Eyre and Spottiswoode.

These efforts were made at the expense of Mervyn's health, and in the new year he consulted yet another doctor (whom Watney calls 'Dr Robbins', hiding his real name for professional reasons) who was to become a family friend. He rapidly diagnosed Parkinson's disease, which confirmed Maeve's long-held suspicions. But that did not explain everything, so they also consulted a neurologist, who recommended treatment with electro-convulsive therapy, which was the 1950s panacea for mental illness. The therapy may be compared with an artificially induced epileptic fit, administered while the patient is partially anaesthetized. No one has satisfactorily explained the beneficial effects of ECT, which is no longer used except in extreme cases. One of its side-effects is temporary loss of memory. Most patients found it a terrifying experience and, like many others, Mervyn begged to be spared it. But like many depressed patients who were treated with ECT, he did begin to feel more confident in himself as time passed. The therapy seems to stimulate the body's self-healing processes.

For this treatment Mervyn was in the Holloway Hospital at Virginia Water from the beginning of March until 22 August 1958, and Maeve travelled all the way across from Wallington to see him two or three times a week. His income fell almost to zero. For the next ten years his family depended largely on help from dedicated friends and relatives and from charitable sources such as the Artists' Benevolent Fund and the Royal Literary Fund. Shame at his failure to provide adequately for his family did nothing to improve Mervyn's condition, and he longed for a lucky break that would turn the tide.

Eyre and Spottiswoode were enthusiastic about *Titus Alone*, but the

editorial director, Maurice Temple Smith, suggested that a number of changes should be made before they published it. In particular, he and Ruby Millar, who had seen *Gormenghast* through the press, felt that the 'science fiction' aspects of the story should be played down, and they proposed that Mervyn should rewrite 'the climax of the book – the pseudo Gormenghast' from Titus's point of view alone. Taking the reader behind the scenes, they thought, reduced the impact: 'one sees too early what is being done, and one never, therefore, has that nightmare illusion that this is the real Gormenghast in some horrible form'.[15] Maurice Temple Smith was concerned that Mervyn should polish the book, knowing that 'there are few more panic-stricken creatures than the literary critic who thinks he is about to be caught praising an unfashionable author . . . In the literary circles of the time, [Mervyn] was yesterday's man. Any inadequacies in the book would provide an excuse to ignore it.'[16] However, Mervyn was beyond rewriting at this point; the final scenes had to remain as they were; with a heavy heart Maeve accepted the suggestions for cuts. Without the author to oversee it, the result was patchy and sometimes incoherent, which did no good for Mervyn's reputation. Ten years later Langdon Jones revised the text, including fresh scenes from Mervyn's manuscripts, and this is the version sold today. (The second edition of *Titus Alone* was not issued in the United States until the early 1990s, which explains some of the discrepancies between American and British appreciations of the novel.) It is not perfect, but there can never be a 'definitive text' of *Titus Alone*, since Mervyn did not, and could not, produce one.

Coming out of hospital, Mervyn took another holiday on Sark, where he felt better and nourished hopes of returning to teaching. That autumn, with Maeve's help, he was able to mount an exhibition at the Waddington Gallery, which had now moved to London, but at the time of the private view his condition had deteriorated again and he was in the National Hospital, Queen's Square, London, for tests. The diagnosis was bluntly communicated to Maeve in a hospital corridor by an overworked doctor: 'Your husband has premature senility' (Gilmore, p. 132). He was aged forty-seven years and five months. It was as though his inner time clock was accelerating;

Late figure studies; pen and ink and (right) ball pen, dates not known

indeed, by the time he died, he looked nearly twice his age. He remained in the National Hospital for about six weeks, returning home in time for Christmas 1958.

Tactless though he may have been, that doctor was using the standard medical term of the time to describe Mervyn's condition. In the first half of the twentieth century cognitive decline in the elderly was considered to be normal; it was called 'senile dementia' (senile being the adjective denoting 'old age', quite simply). A person as young as Mervyn who showed these symptoms was therefore suffering from the early onset of the condition, 'premature senility'. Today we have a clearer understanding of what had happened in Mervyn's brain. A Canadian neurologist, Demetrios J. Sahlas, has studied the available evidence and found that, alongside Parkinson's disease, Mervyn was in all probability suffering from Dementia with Lewy Bodies (DLB). This might be compared to having little balls of styrofoam in the brain that intermittently get in the way of cerebral connections; they compound the problems caused by Parkinson's and commonly cause sudden loss of balance, reduced ability to concentrate, difficulty with sleeping and delusions or hallucinations. In the case of an artist such as Mervyn it also accounts for the progressive loss of depth in his drawings; the lines that once gave such a powerful impression

Head; pen and ink, 1954

of volume became mere outline, flattening the form. This process began as early as 1954, as may be seen in some of the images reproduced here, giving them an eerie Picassoesque quality. In later figure studies, the body is not merely flat, it becomes an assembly of shapes. As the little balls proliferate in the brain, the missed connections increase to the point where the familiar personality of the sufferer seems to be present only for brief moments. Unfortunately, tranquillizers of the kind used in the 1950s and prescribed for Mervyn merely aggravate these symptoms.[17]

Early in the following year there was a welcome cheque from the Waddington Gallery: sales had been good, and Mervyn felt more confident. *Titus Alone* was progressing towards proof stage, but when he visited Eyre and Spottiswoode with Maeve he was unable to say what he had come to tell them without prompting from her. Not only was his memory unreliable; his speech had become slurred and was sometimes hard to understand, as though he were drunk. So when the BBC approached him with a view to making a televised interview to promote *Titus Alone*, the project had to be abandoned. Yet he had returned to teaching. He could not manage public transport, but one of his students, Sue French, kindly drove him in by car (Watney, p. 196). It was for this reason that he and Maeve began looking to sell the house in Woodcote Road and move closer to the Central School.

When *Titus Alone* was published at the end of October 1959 the reviewers' praise was qualified with terms that simultaneously damned it. 'The remarkable thing is that so subjective an experience can be communicated at all,' observed John Davenport. 'Even when one is confused by the private symbols, one accepts their reality for the author, and re-reading may give one deeper understanding' (*Observer*, 1 November 1959). 'This book is as fine a piece of fine writing – if you can take it – as we are likely to see for a long time' (*Times Literary Supplement*, 13 November 1959). Sales were poor. Mervyn's reputation had reached its nadir, for the following year was to see the first serious article on his work, 'The Walls of Gormenghast: An Introduction to the Novels of Mervyn Peake' by the Scottish poet, translator and university lecturer (later professor) Edwin Morgan, and interest began to pick up. At this time, too, he was visited by a young admirer, Michael Moorcock, who became a champion of Mervyn's work, mentioning it whenever he could in the science-fiction and fantasy magazines that he edited and thereby bringing him to the notice of a generation of readers who had bypassed mainstream fiction.

Mervyn in 1957

20

Chelsea, 1960–1968

THE year 1960 also saw a turn in the Peakes' fortunes, if not in Mervyn's health. Property developers had become interested in Wallington, demolishing the overlarge Victorian houses and replacing them with blocks of flats. One of Maeve's brothers made an offer for 55 Woodcote Road, and on the proceeds of the sale Mervyn and Maeve were able to buy a house in Drayton Gardens, Chelsea. They moved in May 1960. At the same time Mervyn was approached by the Folio Society, which had commissioned *Dr Jekyll and Mr Hyde* at the end of the 1940s: they wanted him to illustrate Balzac's collection of short stories, the *Contes Drolatiques*. By this point Mervyn's attention span had become so short that he could no longer read a story and retain the idea for an illustration long enough to draw it, so Maeve had to read the stories to him while he worked, repeating them and reminding him of what he was doing. Sometimes the brush would fall from his hand, and she would pick it up for him. Given the circumstances, it is amazing what he did produce; drawing was the last skill he was to lose.

The strain on Maeve and her children was enormous. Even before they left Woodcote Road Mervyn's restlessness would drive him up and down stairs, all over the house, into bed and out again; he would want a pencil to draw with, then brushes for painting and then neither at all; he would get undressed as though for bed and then demand that Maeve help him put his clothes back on again, at any hour of the day or night.

Soon after the move to Drayton Gardens Mervyn and Maeve heard of an operation on the brain that was being successfully performed on people with Parkinson's disease. They were clutching at straws: any chance of improving Mervyn's condition gave them hope. The income from the Folio Society commission provided the means. Mervyn was operated on privately at the turn of the year. It left him with a dent in his forehead the size of a golfball (Peake, p. 135). When he returned home soon after Sebastian's twenty-first birthday, in January 1961, his hand was steadier and he felt more calm, but his mind was, if anything, more confused, his thoughts slow and laborious. He did not return to teaching, although a couple of years later he did apply in person for work at Brighton Art School. As Raymond Briggs recalls, it was clearly beyond him, but that did not remove his desire to teach (*PS*, 2008; 11: 1, 35).

Incredibly, it was in this condition that he made the illustrations for *The Rhyme of the Flying Bomb*, which he had written on Sark. The manuscript had lain buried among Mervyn's papers for more than ten years and surfaced during the move to Drayton Gardens. Dent offered to publish it on condition that Mervyn made drawings for it. It was a long, laborious business. He could manage a stroke at a time, and gradually he built up the pictures which make such a striking accompaniment to one of his best poems.

The shaking may have gone, but the restlessness soon returned. He was forever on the go, sleeping little at night. Although he had to be dressed and fed, he was active and mobile, and Maeve could not be with him every moment of the day; nor could they afford a resident nurse. Because he had had a brain operation, he was eligible to enter a psychiatric hospital, but after a few weeks in one at Banstead he was sent back home. The hospital was simply not equipped to look after a patient with such energy. It was almost impossible to find a suitable institution for him, and over the next few years he was variously accommodated in a nursing home in Brighton,[1] in a care home in Cowden, in Northampton Hospital, with nuns in Lambeth, under the National Health Service in Westminster Hospital, where he remained for several weeks, and in a dreaded mental asylum at Friern Barnet. Between these stays he would be back in Drayton

Gardens trying new medication, while friends or a Red Cross nurse would come in to help Maeve. Despite the Parkinsonian shuffle, he was up and about, going down the street and round the corner to the tobacconist, the hairdresser or the local café. Many a time strangers brought him home, guided by the bracelet with his name and address on it that he wore round his wrist.

Just before they left Wallington, Edwin Mullins, who was editing a small literary periodical, had approached Mervyn in the hope of printing some new writing. He lived not far away in Chelsea and became a friend of theirs.

For several years, we were regular visitors to Drayton Gardens; and just as regularly Maeve would bring Mervyn round to our flat in Redcliffe Square for a drink or dinner . . . There was one special evening at our flat, a couple of years later, which demonstrated to me how Mervyn's gift as an imaginative draughtsman was capable of overriding the handicaps which illness had inflicted on him. Mervyn by this time was unable to work at all. Physically he was very unsteady. He had undergone an operation which was not producing the improvement everyone had hoped. This particular evening he was no different. He seemed limp, and mentally unfocused. He was with us only in flashes, and those flashes were often over before we had grasped what he had said, or could reply. Most of the time he sat in silence, head bowed. It was deeply saddening to watch him, knowing that neither he nor we had any means of communicating. Yet he was a friend, and we loved him.

After dinner he was sitting humped on the sofa when suddenly he made a motion towards Maeve, and as she leaned over him he indicated that he wanted some paper and something to draw with. My wife produced a sheaf of quarto typing paper and placed a ballpoint pen in his swollen hand. We went on talking while he sat with the sheaf of white paper on his knee.

Then I noticed that his hand had ceased its normal shaking, and that he was sitting upright with the paper held firmly, concentrating. For more than an hour, he seemed to lose touch with his illness altogether. He covered page after page with wonderful and

preposterous beasts, leaping, snarling, laughing, cavorting. As soon as one was finished he turned to a fresh page and drew another. We self-consciously kept up our conversation, although all three of us were watching him in amazement. He appeared unaware of our presence. And then the spell was broken. He dropped the pen, and his hand began to shake again. None the less Mervyn looked highly pleased and very weary. Maeve rose and put out an arm to lead him home. But first Mervyn pressed the sheaf of drawings into my wife's hands and gave her a kiss. They were the last drawings I ever saw him do.

(MPR, 1985; 19: 37–8)

Finally, in 1965, at Dr Robbins's suggestion, Mervyn was placed in a private psychiatric hospital called The Priory, at Roehampton, where he was well looked after. On his departure the family breathed a sigh of mixed sadness and relief. Mervyn remained at The Priory for three years, ageing so rapidly that one day when Goatie was visiting him the attendant commented, 'Your father's a little better today, isn't he?' Goatie was the elder by nearly four years. Maeve came to see him as often as she could, bringing pencils, a sketchpad, sweets, her love and her humour. Sometimes Mervyn drew, but with increasing frequency the pencil would fall from his hand. Sometimes he did not recognize her.

The Priory was appallingly expensive, but the following year, 1966, Penguin, thanks to a recommendation by Michael Moorcock, decided to bring out the Titus books as 'Modern Classics', incorporating some of Mervyn's sketches from the manuscripts. Eyre and Spottiswoode took the opportunity to bring out a new uniform edition in hardback, and money started to come in, enabling Maeve to pay off the considerable debts that had accumulated. An American publisher jumped on the bandwagon; after the runaway success of Tolkien's *Lord of the Rings* trilogy in paperback the company was looking to repeat the coup with another 'fantasy', and 'the Gormenghast trilogy' (as the marketing men insisted on calling it) fitted the bill.

Captain Slaughterboard Drops Anchor was also reissued in 1967, and we can hope that Mervyn was not aware of the massacre. His hand-written text in the book was replaced with letterpress, his wording

revised and an extra 'explanatory' sentence added. The text having moved on the page, his drawings were 'adjusted' to match the new layout: large areas were simply chopped off; elsewhere the publisher's resident artist added lines, flowers, shells and so on. It was enough to give a healthy man a heart attack.

In March 1968 the governors of The Priory decided to close down the wing in which Mervyn was accommodated, and Maeve moved him to a home for the terminally ill that her eldest brother James had opened near Abingdon in Oxfordshire. Physically Mervyn seemed to benefit from the country air, but mentally he was further away. In mid-November 1968 his condition declined very rapidly, and he died in his sleep during the night of 16–17 November. He was buried in the churchyard at Burpham; carved on his gravestone is the opening line from one of his poems:

To live at all is miracle enough.

A memorial service was held in the chapel of the Royal Academy on 6 December. Tony Bridge addressed the mourners, who included most of the people mentioned in this book, plus many others, some four hundred in all.

*

With the publication of uniform editions of Mervyn's novels, his reputation began to grow. This was greatly assisted four years later by a major exhibition in London at the National Book League. Previous exhibitions had shown his paintings and drawings; this one included his prose, poetry and plays, both as published books and in manuscript. Also in 1972 came the publication of *A World Away*, the brief memoir that Maeve had written as a cathartic act during Mervyn's long decline. Revealing his private life for the first time, it sent readers back to the Titus books, those 'gutters of Gormenghast' through which Mervyn had performed his verbal alchemies, to his poetry, of which two volumes (*A Book of Nonsense* and *Selected Poems*) were also published in 1972, and to his illustrations, drawings and paintings, in which he had revealed his idiosyncratic view of the world. For the next

thirty years each decade added a zero to their value. At the beginning of 1999 a copy of the first edition of *Captain Slaughterboard Drops Anchor* went at auction for £2,750.

Interest in Mervyn's work was further fed by the publication of posthumous collections, *Writings and Drawings* and a handsome volume of the *Drawings of Mervyn Peake* (both in 1974), and *Peake's Progress* (in 1979). Various troupes adapted the Titus books for the theatre, and film companies vied to be the first to bring the life of Titus Groan to the screen. In the event, it was the small screen that won the day: after *Mr Pye* on commercial television in 1986, *Titus Groan* and *Gormenghast* were adapted by BBC television and broadcast in four parts early in 2000. Since then, the DVD of the mini-series has brought Mervyn's work to the notice of thousands of people around the world who would never otherwise have discovered the Titus books. Thousands more have discovered them through the various 'book memes' – lists of 'the hundred best novels', for example – that circulate on the internet. In 2006 two more books (actually published on the same day) came to fuel their interest: *Mervyn Peake: The Man and His Art*, compiled by Sebastian Peake and Alison Eldred, and edited by myself; and my own study, *The Voice of the Heart: The Working of Mervyn Peake's Imagination*.

With Gormenghast Mervyn built a new edifice in the landscape of the literary imagination, a landmark by which other writers now situate themselves and are situated by others. As a familiar landmark, it is often mentioned only indirectly; the very notion of the 'Gormenghastly' has entered the English language. Its influence on other writers is often subliminal, rather than explicitly acknowledged. *Walking on Glass* by Iain Banks, however, features an uncannily Gormenghastly castle whose inner walls are made of books instead of bricks and mortar. In this edifice, even a table leg proves to be made of compressed books, comprising *Titus Groan*, *The Castle*, *Labyrinth* and so on. In short, Mervyn Peake's work has become part of the fabric of world literature. He is now acknowledged (by the *Encyclopedia of Fantasy*) as 'the most potent visionary the field has yet witnessed'. For all the tragedy of his last years, Mervyn triumphed in the end.

Notes

Chapter 1 (pp. 25–36)

1. Almost all the information about Mervyn's parents' years in China was obtained from letters and documents preserved in the archives of the London Missionary Society at the School of African and Oriental Studies, London.

2. Philip George Peake, father of Ernest Cromwell and grandfather of Mervyn, was born 22 February 1843 at Barton-under-Needwood, Staffordshire, the tenth son of John Peake (who had twenty-one children by two wives). He was ordained on 13 February 1870 and appointed to Madagascar. The following day he married a Swiss missionary, Emilie Caroline Scheiterberg. They had nine children; Ernest Cromwell was their third son and fourth child. P.G. Peake retired, on account of impaired health, in 1909 and settled at Parkstone, Dorset. He died 8 August 1928, just six weeks after his wife.

3. George Henry Peake, the eldest child of P.G. Peake, was born 13 December 1870. He studied medicine at Edinburgh and was appointed as a medical missionary to Madagascar, not far from where his parents were stationed. In June 1896 he married Agnes Martha Fredoux, granddaughter of the celebrated Dr Robert Moffat, one of the great pioneers of missionary work in Africa whose daughter married David Livingstone. In 1910 Dr Peake resigned from the LMS on account of ill health and settled in the south of England. He died on 21 September 1955.

4. Grace Caroline Peake was born 31 December 1877 and trained to help her mother in her work. Appointed to the permanent staff of missionaries in 1903, she became headmistress of the Girls' High School in Ambatonakanga,

Madagascar. In July 1904 she married a Swiss, Charles Henri Matthey, who taught French at the LMS School for Boys in Tananarive. He resigned from the society in 1916, and Grace volunteered for war work in Europe. Subsequently they joined the French Protestant Missionary Society and were stationed at Morija, Basutoland, South Africa.

5. Most of the information in this paragraph comes from Dr Peake's application form to the LMS, dated 19 October 1898.

6. In a letter dated 15 August 1899 Dr Peake told Mr Cousins, his LMS director in London, how pleased he had been to visit Kuling for the first time and expressed his admiration for Kuling as an institution.

7. Kuling was run as a trust, with twelve council members elected from among the landrenters, who were nearly all institutions and not individuals. John Watney (pp. 13–14) says that Dr Peake built a house there, but he is confusing it with the house Peake built in Hengchow beside his hospital. Full information about Kuling at this time can be found in *Historic Lushan: The Kuling Mountains*, edited by Albert H. Stone and J. Hammond Reed for the Kuling Council, Hankow, 1921. For recent photographs and further information see 'Kuling, Peake's Birthplace' in *PS*, 2006; 9: 4, 8–22.

8. Kuling is also famous for very different reasons: Chiang Kai-shek made Kuling his headquarters during his anti-communist campaigns in Kiangsi, 1930–4; later he made it the summer capital of the Kuomintang government. The house he occupied from 1934 to 1948 became one of Chairman Mao's holiday homes, and it was from nearby Lushan that Mao launched the Great Leap Forward which led to the Cultural Revolution. Here too the Central Committee of the Communist Party held the fateful meeting in 1959 which dismissed Peng Dehuai, sent Mao into the wilderness and sowed the seeds for the rise and fall of Liu Shaoqi and Deng Xiaoping. In 1970 it was host to another meeting, this time of the Politburo, when Lin Biao clashed with Mao over foreign policy – and was dead within a year. So Mervyn's birthplace, which was created as a purely Western community, has been adopted by the greatest figures of both republican and communist China.

9. In a letter dated 10 August 1912 to the LMS director, Mr Hawkins, Beth Peake wrote: 'I am Welsh and this explains a great deal.'

10. John Watney (p. 14) states that Bessie attended Putney High School, but the school has no record of her having been there. My information is from Bessie's application to the LMS, written in her own hand.

11. Solitude and loneliness are major motifs of the Titus books.

12. From a letter dated 18 December 1902 to Dr Peake from the Reverend C.G. Sparham of the Hankow Local Committee.

13. Walter Morgan was born in 1876. He married Florence on 16 November 1901 and was ordained the following day. Appointed to Hankey, he retired from the LMS in September 1904 to become a minister in the Congregational Union of South Africa.

14. From a letter dated 17 November 1903 to his director, Mr Cousins, who was much relieved. 'I am glad to learn that Dr Peake has behaved in a becoming manner,' he noted.

15. Dr Peake's photographs of the Spirit Way to the Eastern Imperial Tombs, taken at a later date, are reproduced in MPMA, p. 29.

16. John Watney (p. 14) erroneously places this birth in December 1904, which is odd when we remember that Lonnie himself was a major source of information for Watney's book. He spent his professional life in the Far East, retiring as an International Partner of Price Waterhouse; he had been chairman of Raffles Hotel, Singapore, the Malayan Breweries and *The Straits Times*. He died in 1978, having survived his wife Ruth by two years.

17. Further information about the Peakes' life in China, with photographs and relevant artwork, can be found in the first chapter of MPMA. It also reproduces (p. 64) photographs of Hankow burning taken in 1911 by Dr Peake.

Chapter 2 (pp. 37–49)

1. Information from Watney, p. 22. In MPR, 1986; 20: 6 Lonnie calls it 'Claremont' Road; as it is, both house and road have long since disappeared.

2. For a discussion of this theory, with specific reference to Mervyn, see Demetrios J. Sahlas, 'Diagnosing Mervyn Peake's Neurological Condition' (PS, 2003; 8: 3, 4–20), pp. 15–16.

3. Andrew Murray's father spent his whole missionary career in China, teaching for ten years in Tientsin's Anglo-Chinese College. A photograph of little Mervyn looking at an even smaller Andrew Murray on his mother's knee may be seen in MPR, 1980; 11: 5. Murray went to Eltham College and, before leaving to work as a journalist in South Africa, made contact with Mervyn in London. Mervyn took him to the Tate Gallery and started him on a lifelong hobby of collecting postcard reproductions of famous paintings. Murray

returned to London in 1969 as a professional painter; a book of his pictures, *Andrew Murray's London,* was published by Blackie in 1980.

4. Elsie Laura Beckingsale was born 1 September 1886; having trained at the Women's Missionary College in Edinburgh, she went out to Wuchang in 1911 for the LMS. After a period of sick leave she joined the Baptist Missionary Society and returned to work in China from 1916 onwards, in Tientsin, where she met the Peakes and was a regular visitor to the family, with whom she maintained contact until her death on 6 March 1983.

5. In a letter from Beth Peake, in Shanghai, to her director Mr Cousins, in London, dated 10 September 1903.

Chapter 3 (pp. 53–9)

1. Information from the notes that Mervyn made twenty-five years later for a projected autobiography (*PP,* p. 476).

2. *The Times* of 29 August 1998 placed Eltham tenth in the national A-level league table of mixed schools.

3. Born 1894, Burgess Drake served in the First World War like his younger brother and before returning to Eltham got a first-class honours degree in English. He was at Eltham for six years, moving on in 1927 to be Professor of English at the Japanese Imperial University at Keijo in Korea. From 1930 to 1943 he taught at Bromley County Grammar School, then he was sent out to China for a couple of years as a major in the Intelligence Corps. He returned to teach at Bromley until his retirement. He wrote about a dozen books, two of which Mervyn illustrated, and Maeve provided the jacket drawing for another. He was godfather to their daughter Clare.

4. At Yale Drake conceived the ambition of 'doing for the fine arts what Community Theatre had done for drama in the USA (Provincetown, Pasadena, Dallas, New Orleans, etc., and the "Vieux Colombier" in Paris) with Drama and Dance – open air theatre' (from a letter dated 31 May 1978 to GPW). Married to an American called Lisel (née Eloise Crowell Smith), he set up an artists' colony on Sark, which lasted about five years. He and Mervyn remained in contact during the war, during which Drake served at the Directorate of Camouflage at Leamington Spa, making factories look like fields and fields like factories. There he met and married his second wife, Janna Bruce, with Mervyn as his best man. When the centre at Leamington closed in 1944, Drake was called out to China to join his brother Burgess in

the Intelligence Service, spying on the Japanese. After the war he remained in China with the British Council, charged with setting up the teaching of English in Chinese universities. He was apparently very successful at this, but he was forced to leave in a hurry on the fall of Chiang Kai-shek. At this point he and Janna decided to settle in Australia, where he became a much-loved English teacher at the King's School, Parramatta (New South Wales). He retired in 1971 and died in June 1988.

5. In his last years at school Goatie showed considerable talent for writing poetry, contributing to the school magazine ('especially after I became Editor', he comments), and on leaving school he studied English at University College, London; later he wrote a doctoral dissertation at Oriel College, Oxford, on the psychology of the creative imagination. After teaching in Kirby Lonsdale, Tettenhall and, during the war years, Truro, he moved to Taunton School, Somerset, where he headed the English department for twenty-one years, retiring in 1968. He continued to write poetry throughout his life and, with his fellow Tauntonian John Wilkins, edited a four-volume anthology of English poetry much used in schools: *The Sheldon Book of Verse* (Oxford: Oxford University Press, 1959).

Chapter 4 (pp. 61–73)

1. There are unfortunately no records from this time at Croydon School of Art.
2. These verses are known to us from a letter to Goatie, quoted in *PS*, 1992; 2: 4, 20, and from the copy of *Titus Groan* sold in 1992 by the Ulysses book-shop in London.
3. After reading Goatie's reminiscence in MPR Eric Drake instructed me to pass on the following message: 'Shelley-belly bids Goatie come out of the Eltham bushes and do his stuff!' I did so, and eight years later, to the day, I heard from Goatie that he had finished his memoir.
4. The portrait was mislaid during the war and sought for sixty years by Monica Macdonald's descendants. Happily, they were able to recover it in March 2003 after it came up for sale at Christie's South Kensington. It is reproduced in colour on page 47 of *MPMA*.
5. The origin of the word 'grotesque' lies in the fanciful murals of Roman chambers or *grottoes* that were excavated in about 1500, the principal site being the Palace of Titus.
6. The quotation is from 'London Fantasy', the sole realization of his

'head-hunting' project. It was first published in the *World Review* (1949) and reprinted in *PS*, 2006; 9, 4: 3–7 (p. 3).

7. From 'What Is Drawing?', first published in *Athene* (1957) and reprinted in *MPR*, 1982; 15: 3.

8. Information from John Batchelor. William Evans was born London in 1911. He studied at Hammersmith School of Art before going to the Royal Academy Schools.

9. For more information about the Black Cat (which was what the clientele called Au Chat Noir), see *London Nights* (1925) by Stephen Graham.

10. The portrait did not sell, and after 'kicking it around the studio' for some time Mervyn gave it to Goatie. It was reproduced in PS 2007; 10: 3, 46.

Chapter 5 (pp. 75–89)

1. William Toplis went to Sark for a holiday in 1883 and remained there until his death in 1942. Ethel Cheesewright spent most her life on Sark, painting watercolour views of Sark's coast for the tourist trade.

2. Eric Drake was rather upset by John Watney's comment that 'in its unfinished state, [the spiral staircase was] rather more elegant than it was later to become' (p. 56).

3. George Elmslie Owen, 1889–1964, studied at Edinburgh College of Art and at the Académie Moderne in Paris and was elected RBA in 1933. He was an art teacher, later a colleague of Mervyn's, at the Westminster School of Art. They also corresponded during the war when Owen became secretary of the War Artists' Advisory Committee,

4. Janice Thompson (whose name was unfortunately spelled 'Thomson' by John Watney, with the result that I sought the wrong Janice for thirty years) was born in Brookline, Mass., in 1908. She died by her own hand at the age of eighty-six.

5. Information about this engagement is from Watney (p. 61), who quotes Eric Drake as his source. Tony Bridge did not remember this episode. Soon after her return to the United States, Janice eloped with Grenville Goodwin, the American anthropologist whom she had known since 1929. During the 1930s he lived and worked among the last truly autarkic Apache Indians in the northern Sierra Madre. He died in 1940 of a brain tumor at the age of thirty-three, leaving Janice with a three-month-old son. The book of verse that she sent Mervyn, *Butterfly Mountain*, was privately published in Tucson around 1943. A selection of her poems, including one about Sark, appeared in 1981.

6. Stanley Royle (1888- 1961) was a landscape painter who had already won bronze and silver medals for lithography at the Sheffield School of Art. In 1931 he went to Nova Scotia and in 1937 he became Director of the Art Gallery and College of Arts associated with Mount Alison University at New Brunswick, so Sark was a very brief parenthesis in his career. He returned to England shortly before the Second World War and spent the rest of his life in the Midlands.

7. Pip must indeed have been traumatized as a child: 'he used to climb on to Brenda's lap (he was very small) and suck his thumb' (letter from Tony Bridge to GPW dated 18 October 1998). During the war he, too, worked at the Directorate of Camouflage at Leamington Spa.

8. When the Gallery closed in 1938, Frank Coombs went on to manage the Storran Gallery in the Brompton Road, opposite Harrods. During the war Frank served in the Navy and was killed in Belfast by enemy action (information from his brother Peter).

9. This story is confirmed by Tony Bridge, who none the less underlines that the pirate ring, the scarlet cape and 'the ensuing hoo-ha wasn't half as dramatic as it has since been blown up to be' (letter to GPW dated 18 October 1998).

10. When I visited Sark in the mid-1970s, Tony Bridge's name was often mentioned by those who remembered the 1930s; they did not know what had become of him, but they had clearly been moved by some intangible quality behind the melodious voice and flowing beard. He writes: 'After many years as a successful, atheistic artist, and war service as an Intelligence Officer, [I] reluctantly became a Christian and offered [my]self for ordination' (from the cover of his book about *The Crusades*, London: Granada, 1980). He was made Dean of Guildford in 1968 and is the author of several books. He died on 23 April 2007.

11. Many details of Mervyn's life will be clarified when his letters to Goatie (of which about 150 are extant) are made available for publication.

Chapter 6 (pp. 93–101)

1. Information from Olwyn Hughes in a letter to GPW dated 14 August 1976.

Chapter 7 (pp. 103–15)

1. In February 1937 Dylan Thomas told David Higham that he wished to write a book about Wales, based on a journey he would make 'from the top of the agricultural north to the Rhondda Valley' (*The Letters of Dylan Thomas*

[ed. Ferris], p. 246). He planned to illustrate it with a frontispiece portrait of himself by Augustus John, drawings and photographs. My understanding is that he invited Mervyn to contribute some of the illustrations.

2. Robert Kirkland Jamieson (1881–1950) was a landscape painter, born at Lanark. Elected RBA in 1923, he was Headmaster of the Westminster School of Art, 1933–9; after the war he was Principal of St Martin's School of Art, London. Watney spells his name 'Jameson'.

3. In 1939 *Cavalcade* reported: 'Recently the Queen, seeing a sketch by artist Peake hanging in the Countess of Moray's home, bought it on the spot, took it away under her arm' (11 March 1939, p. 22).

4. Esmond Knight (1906–87) made a distinguished career in the theatre, in films and on television, notably in adaptations of Dickens and Ibsen.

5. The quotation is from Thomas's sole surviving letter to Mervyn (apart from notes begging the loan of clothes) printed in *The Letters of Dylan Thomas*, p. 286. Ferris tentatively dates it to March 1938. The letter continues: 'Nothing we planned seems to have gone right, that visit to Wales for instance . . .' Thomas will have failed to join Mervyn in Wales at Whitsun 1937 because he went down to Cornwall to marry Caitlin.

6. His mother was born at 184 Cardiff Road, Aberdare; in the 1881 census she was registered at No. 194. Other inhabitants of the street were labourers, mainly miners, and a railway signalman.

7. All Mervyn's poems (except for 'The Touch 'o the Ash' and his nonsense verse) are now available in *Collected Poems*, edited by Rob Maslen (Carcanet, 2008).

8. Information from Maeve Gilmore's preface to the second edition of *Shapes and Sounds* (London: Village Press, 1974).

9. This poem was substantially revised for publication in *Shapes and Sounds* in 1941. The title of this book comes from the revised version.

10. This observation about Mervyn's language underpins my study, *The Voice of the Heart: The Working of Mervyn Peake's Imagination* (published by Liverpool University Press/Chicago University Press, 2006).

Chapter 8 (pp. 117–24)

1. This poem was not published until 1967 in *A Reverie of Bone*.

2. John Watney (p. 80) calls it Battersea Old Church Road, possibly confusing it with Chelsea Old Church Street.

Chapter 9 (pp. 125–36)

1. Eddie Marsh was arguably the greatest patron of the arts in twentieth-century Britain. Beginning in 1911, he bought the work of promising young artists and on his death bequeathed the bulk of his collection to the Contemporary Art Society, which allocated the pictures to galleries throughout Britain and the Commonwealth.

2. Christopher Hassall, *Edward Marsh: Patron of the Arts. A Biography,* p. 611. I have not been able to find out what poems these were.

3. The portrait can be seen in *MPMA*, p. 51.

4. Leslie Hurry (1909–78) studied at St John's Wood Art School before going on to the Royal Academy Schools. He made a career in set design after a very successful *Hamlet* in 1941 for Robert Helpmann.

5. The portrait is reproduced as a colour plate in *Writings and Drawings,* p. 53. See also Maeve Gilmore's notes to the DLI Museum and Arts Centre exhibition, 'The Voice of a Pencil' (1980).

6. Both *Writings and Drawings* and Watney erroneously date this poem to 1938; *Writings and Drawings* prints a draft of the poem, with alternative readings, and not the final version printed in the *Picture Post* (and reprinted in *CP*, p. 45).

7. The publisher, Country Life, was still advertising the book in *The Bookseller* in July 1940 (at two shillings and sixpence, too, half price), so the fire was probably caused by bombing between August and December 1940. The most likely date is the night of 29–30 December 1940, when a raid on Paternoster Row almost completely wiped out the offices and warehouses of a dozen publishers.

Chapter 10 (pp. 139–50)

1. Author, journalist and film-maker, Edwin Mullins was a regular broadcaster on radio and television, with a special interest in art.

2. From the papers for 1939 to 4 January 1940 in the Imperial War Museum, file GP/72/A/Part 1.

3. Mervyn Peake's correspondence with the WAAC was printed complete in *PS*, 1991; 2: 2, 3–42 (Summer 1991).

4. 'Stitchwater' may sound like a place, but it is the name of a character in *Mr Pye*.

5. Undated letter from Graham Greene to Mervyn Peake preserved in the D.M.S. Watson Library, University College London. It is quoted in full on page 169.

Chapter 11 (pp. 151–62)

1. Maeve Gilmore (p. 38) situates his departure for the Army just two weeks after the birth of Sebastian. No doubt in retrospect it seemed like only two weeks to her, although it was in fact seven and a half months.

2. P.J. Best's article, 'Gunner Peake', first appeared in the *London Magazine*, Vol. 25, Nos 1 and 2, April/May 1985, pp. 129-32. I have quoted from the reprint in *London Magazine 1961–85*, pp. 279-81 (p. 280), hereafter abbreviated *LM*.

3. Until the end of 2008 the manuscripts of the Titus books were deposited in the D.M.S. Watson Library, University College London. The references are to box number and notebook. Thus '1: iii' refers to the third notebook in Box 1. For further details see *MPR*, 1981; 12: 29-30.

4. See Maeve's description of her journey to Blackpool with Sebastian: he cried all the way (Gilmore, pp. 41-2).

5. The date of this transfer, according to records at the Ministry of Defence, is 11 October 1940.

6. In an unpublished letter from Sir Kenneth Clark to Mervyn, dated 18 October 1940.

7. Maeve calls it Coronation *Drive*; Watney calls it Coronation *Road* – but the manuscript of *Titus Groan* and Mervyn's letters have *Street*, which I accept to be the correct name.

Chapter 12 (pp. 163–79)

1. John Watney (p. 113) erroneously places this episode at Southport, a year later.

2. Information from 'Memories of Bohemian Chelsea' by Maeve Gilmore, in *The Chelsea Society Report*, 1983, pp. 40-5.

3. See 'Peake Remembered' by Kaye Webb in *MPR*, 1986; 20: 16-17.

4. On 19 December 1941 Mervyn sent a telegram to Chatto and Windus requesting copies of *The Hunting of the Snark* and *Ride a Cock-Horse* to show to his commanding officer. (See *PS*, 1999; 6: 2, 27.)

5. *Horizon*, Vol. 5, No. 26, February 1942, pp. 99-100, in an article entitled 'Poetry in 1941' (pp. 96-111).

6. *Collected Poems* restores stanzas omitted from *A Reverie of Bone* ever since its first publication. Rob Maslen writes: 'without them the poem does not seem to me to make sense' (*CP*, p. 238).

7. Both Maeve Gilmore and John Watney erroneously place this camp in the Lake District.

8. There is no mention of this reclassification in his letter dated 11 March, written five weeks before, so a letter written during the interval must be missing from the WAAC file. Documents could easily go astray if the soldier's number on the top was not correct. Mervyn's number was 1592577, yet one of the WAAC documents identifies him as 1592537. John Watney, in his biography, gives a very different number: 5917577 (p. 101).

9. Carel Weight, born 1908, studied at Hammersmith College of Art and then (part time) at Goldsmiths College; in 1942 he held a part-time lectureship at Beckenham School of Art. He, too, was in the Royal Engineers. I do not know whether he carried out this particular commission for the WAAC, but other work of his was accepted, in particular a series of four paintings depicting the 'Escape of the Zebra from the Zoo During an Air Raid', a subject that would have much appealed to Mervyn's sense of humour.

Chapter 13 (pp. 181–4)

1. Harold Raymond responded on 9 June: 'Thank you for telling me such a lot about Titus Groan. I desire his better acquaintance.'

2. On 2 June he requested a copy of *Shapes and Sounds* from Chatto and Windus by telegram, no doubt to support a request that he be allowed to write as therapy.

3. In one of Mervyn's favourite novels by Dickens, *Bleak House* – the only one he was to illustrate – Smallweed bursts out with 'I should like to throw a cat at you instead of a cushion' (Chapter 21; p. 347 in the Penguin edition).

4. Since John Watney believed that Clitheroe was in the Lake District, he was clearly fantasizing when he wrote that 'Mervyn would walk for miles drawing inspiration for the illustrations from the feel of the Lake District hills' (p. 112). On the other hand, Clitheroe lies in the shadow of Pendle Hill, around which lived the witches who were sentenced in the notorious Lancashire trials of 1612.

Chapter 14 (pp. 185–98)

1. See Joad's footnote to p. 25: 'I thought [the woman] would make a nice picture for Mr Peake. But he thought not.'

2. Internal WAAC report dated 21 January 1943, quoted in *PS*, 1991; 2: 2, 20.

3. In 'A Poet in the Glasshouse' (published in the *Journal of the Glass Association*, 1990; 3: 41–5) Greville Watts identified the factory and provided fascinating background information, including the fact that, at the outbreak of war, Chance's had only one man who could blow the tubes. 'They had to choose and train fourteen others, a formidable task at a time when many men had been called up to serve in the forces.' By mid-1943 they were producing 7,000 bulbs a week, ranging in size from 9 to 38 centimetres (3½ to 15 inches). Watney thought that the cathode-ray tubes were 'for army wireless sets' (p. 122).

4. This quotation is taken from Mervyn's blurb for the jacket of *The Glassblowers*.

5. The allusion is to the heroine of Jane Austen's parody of the Gothic novel, *Northanger Abbey* (1818).

6. My transcription from the original letter dated 20 June 1959 differs somewhat from the version printed in *Writings and Drawings*, p. 46.

7. The quotations and information are from Norman Sherry, *The Life of Graham Greene*, Vol. II, 1939–1955, pp. 187–8.

8. Letter to Graham Greene dated 22 July 1943, quoted in Watney, pp. 119–20.

9. I have transcribed this letter from the original in the D.M.S. Watson Library. Written on Reform Club notepaper, it is undated but clearly belongs to the autumn of 1943. The most probable date is mid-October, since Mervyn wrote him a card postmarked 20 October 1946 asking for the manuscript to be sent to an address in St Ives, where he was taking a few days' holiday. My transcription differs from Watney's (p. 119).

10. Mervyn's use of 'Gryphon' (which is usually spelled 'griffin') is perhaps significant: Dylan Thomas was working for Gryphon Films at this time. See *The Letters of Dylan Thomas*, pp. 515 and 611.

11. Undated letter to Graham Greene, enclosed with the proofs of *Rhymes Without Reason*, quoted in *PS*, 1996; 5: 1, 43.

Chapter 15 (pp. 199–208)

1. See Mervyn's telegram to the WAAC dated 15 December 1943, reproduced in *PS*, 1991; 2: 2, 39.

2. See his letter to the WAAC dated 1 February 1944, printed in *PS*, 1991; 2: 2, 40.

3. It was first reproduced in *Studio*, Vol. 132, No. 642 (September 1946), p. 90, then on the front of *The Glassblowers* (1950) and most recently on the cover of *Collected Poems* (2008).

4. *The Evolution of the Cathode Ray (Radiolocation) Tube* is reproduced in *War Paint* (2007) by Brian Foss, p. 101.

5. Letter dated 30 December 1943 from the secretary of the WAAC, E.C. Gregory (Elmslie Owen having relinquished his post) to Group Captain Lord Willoughby at the Air Ministry; reproduced in *PS*, 1991; 2: 2, 38.

6. At the end of the 1970s Maeve Gilmore told me that she had had the second picture cleaned off, so *Mr Brown's Resurrection* may be seen once again.

7. Maurice Collis (1889–1973) was with the Indian Civil Service before returning to London in the 1930s to make a career as a writer and, later, art critic.

8. From the letter to Graham Greene enclosed with the proofs of *Rhymes Without Reason,* quoted in *PS*, 1996; 5: 1, 43.

9. See my article, 'Editing Peake', in *MPR*, 1981; 13: 2–7.

10. The date of this review is not known to me; it is quoted on the jacket of the second edition of *Witchcraft in England.*

11. Minutes of the 176th Meeting of the WAAC, on 28 February 1945, under 'Other Business'.

12. Tom Pocock was a Fleet Street journalist all his life, on the staff of the *Daily Mail, The Times,* the *Daily Express* and the London *Evening Standard.*

13. That the initial idea was Maeve's is clear from Mervyn's letters, quoted in Gilmore, pp. 55–9.

14. Sebastian Peake devotes pp. 45–51 of *A Child of Bliss* to this topic. The interested reader should see these pages for further details.

Chapter 16 (pp. 209–18)

1. There are differing accounts of how this commission came about. See Adrian Room's *Dictionary of Trade Name Origins* (Routledge, 1983) for one of them.

2. Caroline Lucas's reminiscences can be found on a sheet loosely inserted into a pocket in the back cover of the Libanus Press edition of *Peake's Alice* (published in 2001).

3. See the articles by Brian Sibley on Peake's *Alice* drawings in *MPR*, 1978; 6: 25–9 and *MPR*, 1978; 7: 26–9. Also, more recently, Gerard Neill's piece on 'Peake's *Alice,* and *Witchcraft*' (*PS*, 2001; 7: 3, 3–17).

4. Two of the drawings accompanied an article on Mervyn Peake by Frances Sarzano in *Alphabet and Image,* Spring 1946, Vol. 1, pp. 31 and 32.

5. See the undated letter from Mervyn to Goatie reproduced, but not transcribed, in Smith, p. 111; the quotation is from Dr Smith's letter to GPW dated 26 January 1987.

6. See John Wood's recollections in *MPR*, 1981; 12: 18. Apropos the Bodoni typeface, Daniel Berkeley Updike observes that 'a volume set in it suggests a Continental reprint of an English book – an impression by which one is perpetually, though perhaps subconsciously, teased' (*Printing Types: Their History, Forms, and Use*. Cambridge, Mass.: Harvard University Press, 1937; reprinted New York: Dover, 1980; Vol. 2, p. 235).

7. Many more extracts from reviews are included in my essay, 'The Critical Reception of Mervyn Peake's Titus Books', which was published at the end of the Overlook Press edition of *Titus Alone* (1992, reprinted in an omnibus volume 1995).

8. This observation about Mervyn's language underpins my study, *The Voice of the Heart: The Working of Mervyn Peake's Imagination* (Liverpool University Press/Chicago University Press, 2006).

9. From internal evidence I would place its composition at least a year, if not eighteen months, earlier. The text of *Craft* was reprinted in *Writings and Drawings*, pp. 52–60, and discussed by Chris Riddell in *MPMA*, pp. 90–1.

Chapter 17 (pp. 221–30)

1. Information from an unpublished letter dated August 1946 to Hilda Neal, the London typist of his manuscripts.

2. Being so close to the coast of France, the Channel Islands could not be defended; they were demilitarized, partially evacuated and abandoned to the Nazis on 30 June 1940. Many residents withdrew to the mainland, but not one Sark-born inhabitant left the island, with the result that, unlike Alderney, it was not despoiled by the occupying forces.

3. This list is from the complete typescript of the talk, printed in *MPR*, 1979; 9: 14–16, rather than the abridged version in the *Listener* of 27 November 1947.

4. This was the occasion when Mervyn questioned the critics' use of the word 'neurotic', as mentioned in Chapter 6.

5. An edition of these drawings was published in 1980, with an introduction by Maeve Gilmore; she places their execution in 1946, adding that Mervyn had used a Chinese brush and ink that his father had brought back for him from Hong Kong. Dr Peake did indeed go out to Hong Kong after the

war; he acted as medical superintendent of the Nethersole Hospital from 21 January 1946 to 30 April 1947. Given that, according to Maeve, it took Mervyn some time to learn to use the brush, I consider that my dating of late 1948, with completion in January 1949, as confirmed by his letter about the Castle Press to the Society of Authors, is correct.

6. John Watney is wrong in asserting that 'the Heirloom Library was, in fact, none other than the chain store Marks and Spencer' (p. 161), as confirmed to me by Lord Weidenfeld himself in the mid-1980s. He printed large numbers of Heirloom Classics to subsidize his firm's other publications. See also 'My First Book' by Antonia Fraser in *The Author,* Autumn 1994, p. 101.

7. His bank manager, having patiently looked after Mervyn's account for many years, during which time the balance was more often negative than positive, made a handsome profit for himself by selling these drawings at auction in London in the early 1980s. See *MPR*, 1983; 16: 39–41.

Chapter 18 (pp. 233–42)

1. See *Richard Stewart-Jones, as Remembered by His Friends* (compiled by Elizabeth Pulford and privately published in 1980), p. 79. Stone Hall is the 'deserted mansion' mentioned by Mervyn in his letter to Maurice Collis dated February 1949 (*MPR*, 1985; 19: 18). Part of the typescript of *Gormenghast* was found among Richard Stewart-Jones's papers after his death in 1957; twenty years later it joined the collection of Peake manuscripts which was then at London University College Library.

2. The letter is quoted in full by Watney, pp. 151–2.

3. Mervyn seems to have had a strange premonition: it was from age forty that his illness, that 'earthish doom', dogged him 'back to where glooms begin'.

4. These illustrations appeared in the issues of *Leader Magazine* for 17 December 1949 and 8 April 1950 respectively.

5. John Grome wrote his memories of Mervyn in a long letter to Maeve Gilmore dated October 1974.

6. A writer of plays and film scripts, Rodney Ackland was born in 1908; known as 'the English Chekhov' for his early plays, he was particularly successful between 1930 and 1950.

7. My source for this is Mervyn's letter to Maurice Collis dated 2 February 1950, printed in *MPR*, 1985; 19: 20. According to Watney (p. 156), who quotes a letter from Mervyn to Maeve as his source, Mervyn and Rodney Ackland

went to Edinburgh in July, when Ackland was planning to write a play about Burke and Hare. So they may have collaborated on two projects several months apart.

8. Michael Meyer, a freelance writer and occasional academic, spent many years in Sweden and has written much on drama, particularly Strindberg and Ibsen, whose plays he has also translated into English.

9. The quotations are from Sotheby's catalogue when the manuscript was up for sale on 12 December 1991.

10. The quotations are all from the first page of Chapter 3 of *The Moving Finger*.

Chapter 19 (pp. 243–65)

1. Quoted from a letter from Paul Britten Austin to GPW dated 15 November 1981; the article by Crisp appeared in *Facet*, Vol. 1, 1946, pp. 8-13, and was reprinted in *MPR*, 1982; 14: 37-42.

2. All Mervyn's black-and-white illustrations for *Lilliput* were reproduced in *PS*, 2005; 9: 3, 3-28. The coloured ones can be seen in *MPMA*, pp. 132-3.

3. It was reissued in 2003 by Walker Books in a smaller format and with added colour – which in my view tends to mask the beauty of Mervyn's line drawings.

4. All Mervyn's short fiction has now been gathered in a single volume, *Boy in Darkness and Other Stories*, London: Peter Owen, 2007.

5. Hans Tisdall, a fellow teacher, quoted by John Watney, p. 202.

6. In his biography of Peake, Malcolm Yorke erroneously spells this 'Francine'.

7. This version was printed in *Writings and Drawings*, pp. 106-18. It is also known as 'A Mural for Christmas' and 'The Voice of One'. A composite version of the two plays was printed in *PS*, 2005; 9: 2, 5-31.

8. An opera of Gormenghast – with rhyming libretto by Duncan Fallowell, score by Irmin Schmidt – was premièred in Wuppertal, Germany, and praised by the *The Times* (24 November 1998).

9. John Watney misread the subtitle (typed though it was) and called it 'A House of Air'. 'A Horse of Air' is a quotation from the old ballad of Tom o' Bedlam.

10. From Mervyn's notes introducing the play, in the facsimile edition (of an inferior typescript, unfortunately) issued by the Mervyn Peake Society in 1996 – see *PS*, 1997; 5: 3, 28-38.

11. All Mervyn's uncompleted plays have now been printed in *Peake Studies*.

12. The final chapter of my study of the working of Peake's imagination, *The Voice of the Heart*, examines this version of the play at some length.

13. *Mr Pye* was adapted by Channel 4 television and shown as a four-part serial in the spring of 1986 with Derek Jacobi as Mr Pye.

14. Notes for a *Titus 4* exist, but they are barely legible. A fragmentary text from them will be found at the end of *Titus Alone* in the Overlook Press edition, reprinted in 1995 as an omnibus volume with *Titus Groan* and *Gormenghast*.

15. From a letter to Mervyn dated 29 July 1958, reproduced in full in *PS*, 1990; 1: 4, 20-3.

16. From a letter to GPW dated December 1989, reproduced in *PS*, 1990; 1: 4, 26-7.

17. While this paragraph owes much to Demetrios J. Sahlas, 'Diagnosing Mervyn Peake's Neurological Condition' (*PS*, 2003; 8: 3, 4-20), the simile is entirely my own.

Chapter 20 (pp. 267–72)

1. It is quite possible that it was from here that he made his visit to Brighton Art School.

Bibliography

I. MERVYN PEAKE'S WORK

NB This not a complete Peake bibliography; it lists only the items I have quoted from or referred to in the foregoing pages (a complete primary and secondary bibliography is available at http://peakestudies.com).

Books (first editions, followed by the edition quoted from where this differs from the first)

A Book of Nonsense, London: Peter Owen, 1972

Captain Slaughterboard Drops Anchor, London: Country Life, 1939

Craft of the Lead Pencil, London: Wingate, 1946

Drawings by Mervyn Peake, London: Grey Walls Press, dated 1949, published 1950

Drawings of Mervyn Peake, London: Davis-Poynter, 1974

Figures of Speech, London: Gollancz, 1954

The Glassblowers, London: Eyre and Spottiswoode, 1950

Gormenghast, London: Eyre and Spottiswoode, 1950; London: Vintage, 1998

Letters from a Lost Uncle (From Polar Regions), London: Eyre and Spottiswoode, 1948

Mr Pye, London: Heinemann, 1953; Harmondsworth: Penguin, 1972

Peake's Progress, London: Allen Lane, 1978; second edition with corrections, Harmondsworth: Penguin, 1981

A Reverie of Bone, London: Bertram Rota, 1967

The Rhyme of the Flying Bomb, London: Dent, 1962

Rhymes Without Reason, London: Eyre and Spottiswoode, 1944

Selected Poems, London: Faber and Faber, 1972

Shapes and Sounds, London: Chatto and Windus, 1941; London: Village Press, 1974

Titus Alone, London: Eyre and Spottiswoode, 1959; London: Vintage, 1998

Titus Groan, London: Eyre and Spottiswoode, 1946; London: Vintage, 1998

Writings and Drawings, London: Academy Editions, 1974

Books illustrated

Anon, *Ride a Cock-Horse and Other Nursery Rhymes*, London: Chatto and Windus, 1941

Austin, Paul Britten, *The Wonderful Life and Adventures of Tom Thumb*, Stockholm: Radio Sweden, 1954 (Part 1) and 1955 (Part 2)

Balzac, Honoré de, *Droll Stories* (trans. Alec Brown), London: Folio Society, 1961

Carroll, Lewis, *Alice's Adventures in Wonderland and Through the Looking-Glass*, Stockholm: Zephyr Books, 1946; London: Allan Wingate, 1954

— *The Hunting of the Snark*, London: Chatto and Windus, 1941

Coleridge, Samuel Taylor, *The Rime of the Ancient Mariner*, London: Chatto and Windus, 1943

Collis, Maurice, *Quest for Sita*, London: Faber and Faber, 1946

Crisp, Quentin, *All This and Bevin Too*, London: Nicholson and Watson, 1943

[Dickens/Peake], *Sketches from Bleak House*, Selected and introduced by Leon Garfield and Edward Blishen. London: Methuen, 1983

Drake, H.B., *Oxford English Course for Secondary Schools. Book 1: Under the Umbrella Tree*, Oxford: Oxford University Press, 1957

Grimm, Brothers, *Household Tales*, London: Eyre and Spottiswoode, 1946

Haynes, Dorothy K., *Thou Shalt Not Suffer a Witch*, London: Methuen, 1949

Hole, Christina, *Witchcraft in England*, London: Batsford, 1945

Joad, C.E.M., *The Adventures of the Young Soldier in Search of the Better World*, London: Faber and Faber, 1943

Judah, Aaron, *The Pot of Gold and Other Stories*, London: Faber and Faber, 1959

Laing, Allan M. (compiler), *Prayers and Graces*, London: Gollancz, 1944

— *More Prayers and Graces*, London: Gollancz, 1957

Stevenson, Robert Louis, *Dr Jekyll and Mr Hyde*, London: Folio Society, 1948

— *Treasure Island*, London: Eyre and Spottiswoode, 1949

Wilde, Oscar, *Mervyn Peake/Oscar Wilde*, London: Gordon, Spilstead, 1980 [limited edition]; London: Sidgwick and Jackson, 1980 [trade edition]

Wyss, Johann R., *The Swiss Family Robinson*, London: Heirloom Library, 1949

Contributions to books

'Boy in Darkness' in *Sometime, Never: Three Tales of Imagination* by William Golding, John Wyndham and Mervyn Peake, London: Eyre and Spottiswoode, 1956, pp. 155–224

'How a Romantic Novel Was Evolved' in *A New Romantic Anthology*, edited by Henry Treece and Stefan Schimanski, London: Grey Walls Press, 1949, pp. 80–9

Two poems in *Poems from the Forces*, edited by Keidrych Rhys, London: Routledge, 1941

Two poems in *Poetry in Wartime*, edited by Tambimuttu, London: Faber and Faber, 1942, pp. 116–18

Jacket drawings

Defoe, Daniel, *Moll Flanders*, Oxford: Oxford University Press [World's Classics], 1961

Fielding, Henry, *Jonathan Wild*, Oxford: Oxford University Press [World's Classics], 1961

Guerard, Albert C., *The Past Must Alter*, London: Longmans, 1937

Poe, Edgar Allen, *Tales of Mystery and Imagination*, London: Dent [Everyman's Library], 1955

Contributions to periodicals in prose *(with illustrations where indicated)*

'Alice and Tenniel and Me' [extracts from a radio talk], *Listener* (23 December 1954), 52: 1347, 1106; complete text in *MPR*, 1978; 6: 20–4

'The Connoisseurs' [short story, illustrated], *Lilliput* (January 1950), 26: 1 (No. 151), 58–9

'Danse Macabre' [short story], *Science Fantasy* (1963), 21: 61, 46–55

'A Letter from China' [illustrated letter], *News from Afar* (November 1922), p. 172

'London Fantasy' [illustrated article], *World Review* (August 1949), NS, 6: 55–9; reprinted in MPR 1983; 16: 11–15

'The Reader Takes Over' [transcription of a radio panel discussion of *Titus Groan*], *MPR*, 1980; 10: 5–16

'Same Time, Same Place' [short story], *Science Fantasy* (1963), 20: 60, 57–65

'Ways of Travelling' [illustrated article], *News from Afar* (January 1924), p. 9

'What Is Drawing?' [article], *Athene* (April 1957), 8: 3, 21; reprinted in *MPR*, 1982; 15: 3

'What Makes a Good Book Illustration?' [extracts from a radio talk], *Listener*
 (27 November 1947), 38: 983, 926; complete text in MPR, 1979; 9: 14–23

Contributions to periodicals in verse

'Au Moulin Joyeux: September Crisis', *Eve's Journal* (July 1939), p. 48

'Autumn', *New English Weekly* (6 January 1938), p. 250

'Autumn', *New English Weekly* (14 July 1938), p. 260

'Coloured Money', *London Mercury* (August 1937), 36: 214, 325

'The Cocky Walkers', *New English Weekly* (27 May 1937), p. 130

'The Crystal', *New English Weekly* (23 September 1937), p. 390

'Epstein's Adam', *Picture Post* (29 July 1939), 4: 4, 67

'He Must Be an Artist' [illustrated], *Satire* (December 1934), p. 17

'Illustrated Nonsense Poems', *PS* (April 1998), 5: 4, 21–7

'The Meeting at Dawn', *New English Weekly* (30 December 1937), p. 230

'The Metal Bird', *London Mercury* (August 1937), 36: 214, 325–6

'Poplar', *New English Weekly* (13 May 1937), p. 90

'Rhondda Valley' [illustrated], *London Mercury* (October 1937), 36, 216,
 507–9

'Sing I the Fickle, Fit-for-Nothing Fellows', *Listener* (1 December
 1937), 18: 464, 1206

'Spring', *New English Weekly* (26 May 1938), p. 130

'Watch Here and Now', *Pinpoints* (May–June 1939), 4, 25

Drawings contributed to periodicals *(not including illustrated items mentioned above)*

Designs for *The Insect Play* by the Brothers Capek: 'I Proclaim Myself
 Conqueror of the World' and 'The Ichneumon Fly', *London Mercury*
 (August 1936), 34: 202, f.p. 342

Four illustrations to the short story 'The Wendigo' by Algernon Blackwood,
 Lilliput (December 1951–January 1953), 29: 6 (No. 175), 80, 87, 97 and
 105

'On Guard' [patriotic treatment of a young soldier], *World Review* (August
 1940), p. 2

Portrait of Edith Evans, *London Mercury* (September 1936), 34: 203, f.p. 402

Portrait of Walter de la Mare, *London Mercury* (December 1936), 35: 206,
 f.p. 165

Portrait of W.H. Auden, *London Mercury* (February 1937), 35: 208, f.p. 385

Portrait of Ruth Pitter, *London Mercury* (July 1937), 36, 213, f.p. 236

Portrait of James Bridie, *London Mercury* (April 1939), 39, 234, f.p. 584

Six illustrations to the article 'Where Is Christ in the World Today?' by James Lansdale Hodson, *Leader Magazine* (17 December 1949), pp. 9 and 10

Six illustrations to the short story 'Love Among the Ruins' by Evelyn Waugh, *Lilliput* (May–June 1953), 32: 6 (No. 192), 72, 78, 85, 88, 93 and 96

Three illustrations to the article 'Did Jesus Have a Fair Trial?' by Robert Graves, *Leader Magazine* (8 April 1950), p. 79

Two illustrations to the short story 'Life Isn't Worth While' by J. Gurevitch, *Lilliput* (January 1942), 10: 1 (No. 55), 7 and 8

Two illustrations to the short story 'The Fireman's Wife' by Stephen Spender, *Lilliput* (April 1942), 10: 4, (No. 58), 295 and 297

Two illustrations to the poem 'Bill Pronkum Purrs' by Ruth Pitter, *Lilliput* (June 1942), 10: 6 (No. 60), 495

II. OTHER REFERENCES

Books

Banks, Iain, *Walking on Glass*, London: Macmillan, 1985

Batchelor, John, *Mervyn Peake: A Biographical and Critical Exploration*, London: Duckworth, 1974

Bondfield, Reverend G.H. (ed.), *The China Mission Year Book, Being 'The Christian Movement in China'*,1912, Shanghai: Christian Literature Society for China, 1912

Christie, Agatha, *The Moving Finger*, London: Collins, 1943

Clute, John and John Grant, *The Encyclopedia of Fantasy*, London: Little, Brown and Co., 1997

Collis, Louise (ed.), *Maurice Collis Diaries, 1949–1969*, London: Heinemann, 1977

Collis, Maurice, *The Journey Up*, London: Faber and Faber, 1970

Crisp, Quentin, *The Naked Civil Servant*, London: Cape, 1968

Dickens, Charles, *Bleak House* (1853), Harmondsworth: Penguin, 1971

Doyle, Brian (ed. and compiler), *Who's Who of Boys' Writers and Illustrators*, self-published mimeograph; copy in the Bodleian Library, 1964

Eyre, Frank, *20th Century Children's Books*, London: Longman, Green and Co. for the British Council, 1952

Ferris, Paul (ed.), *The Collected Letters of Dylan Thomas*, London: Dent, 1985

Foss, Brian, *War Paint: Art, War, State and Identity in Britain 1939–1945*, London and New Haven: Yale University Press, 2007

Frye, Northrop, *Anatomy of Criticism*, Princeton, New Jersey: Princeton University Press, 1957

Gilbert, Martin, *Second World War*, London: Weidenfeld and Nicolson, 1989

Gilmore, Maeve, *A World Away*, London: Gollancz, 1970

Harries, Meirion and Susie Harries, *The War Artists : British Official War Art of the Twentieth Century*, London : Michael Joseph, 1983

Hassall, Christopher, *Edward Marsh: Patron of the Arts. A Biography*, London: Longmans, 1959

Hawkes, Ken, *Sark*, Newton Abbot: David and Charles, 1977

Marshall, Michael, *Hitler Invaded Sark*, St Peter Port, Guernsey: Paramount Lithoprint, 1963

Meyer, Michael, *Not Prince Hamlet: Literary and Theatrical Memoirs*, London: Secker and Warburg, 1989

Peake, Ernest Cromwell, *Memoirs of a Doctor in China* (unpublished)

Peake, Sebastian, *A Child of Bliss*, Oxford: Lennard, 1989

Pocock, Tom, *1945: The Dawn Came Up Like Thunder*, London: Collins, 1983

Pulford, Elizabeth (compiler), *Richard Stewart-Jones: As Remembered by His Friends*, privately published, 1980

Quayle, Eric. *The Collector's Book of Boys' Stories*, London: Studio Vista, 1973

Ross, Alan (ed.), *London Magazine 1961–85*, London: Chatto and Windus, 1986

Sherry, Norman, *The Life of Graham Greene, Vol. II, 1939–1955*, London: Cape, 1994

Smith, A.C.H., *Orghast at Persepolis*, London: Eyre Methuen, 1972

Smith, P.G., *Mervyn Peake: A Personal Memoir*, London: Gollancz, 1984

Stone, Albert H. and J. Hammond Reed (eds), *Historic Lushan: The Kuling Mountains*, Hankow: Religious Tract Society, 1921

Watney, John, *Mervyn Peake*, London: Michael Joseph, 1976

Winnington, G. Peter (ed.), *Mervyn Peake: The Man and His Art*, London: Peter Owen, 2006

Winnington, G. Peter, 'The Critical Reception of Mervyn Peake's Titus Books' in *Mervyn Peake, Titus Alone* (Woodstock, N.Y.: Overlook Press, 1992), pp. 217-26; reprinted 1995 with *Titus Groan* and *Gormenghast*, pp. 1027-36

Winnington, G. Peter, *The Voice of the Heart: The Working of Mervyn Peake's Imagination*, Liverpool: Liverpool University Press (US distributor Chicago University Press), 2006

Witting, Clifford (ed.), *The Glory of the Sons: A History of Eltham College, School for the Sons of Missionaries*, Headley Bros for the Board of Governors, Eltham College, 1952

Yorke, Malcolm, *Mervyn Peake: My Eyes Mint Gold. A Life*, London: John Murray, 2000

Periodicals

Mervyn Peake Review (issues 1–18, ed. GPW; 19–29, varia), discontinued.

Peake Studies (ed. GPW), 1453 Mauborget, Switzerland, 1988– (details available at http://peakestudies.com)

Articles

Best, P.J., 'Gunner Peake', *London Magazine* (April/May 1985), 25: 1 and 2, 129–32

Crisp, Quentin, 'The Genius of Mervyn Peake', *Facet*, 1: 1, 8–13

Gilmore, Maeve, 'Memories of Bohemian Chelsea', *Chelsea Society Report* (1983), pp. 40–5

Morgan, Edwin, 'The Walls of Gormenghast: An Introduction to the Novels of Mervyn Peake', *Chicago Review* (Autumn/Winter 1960), 14: 3, 74–81

Sahlas, Demetrios J., 'Diagnosing Mervyn Peake's Neurological Condition', *Peake Studies* (2003), 8: 3, 4–20

Sarzano, Frances, 'The Book Illustrations of Mervyn Peake', *Alphabet & Image* (Spring 1946), 1: 19–47

Spender, Stephen, 'Poetry in 1941', *Horizon* (February 1942), 5: 26, 99–102

Winnington, G. Peter, with photographs by Max Stauber, 'Kuling, Peake's Birthplace', *Peake Studies* (2006), 9, 4: 8–22

Index

MERVYN PEAKE:
THE MAN AND HIS ART
Compiled by Sebastian Peake and Alison Eldred
Edited by G. Peter Winnington
978-0-7206-1321-6 • paperback • 224pp • £19.95

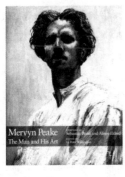

'Ignored for decades, the twisted genius of Mervyn Peake is finally getting the attention it deserves' – Joel Meadows, *Time* magazine

'Peake's unrestrained imagination has influenced a generation of writers. Perhaps, with this book, his influence on artists will become equally profound' – *Locus* Magazine

'As rewarding to the intellect as to the eye, this is a magnificent book' – Ray Olson, *Booklist*

Mervyn Peake (1911–1968), author of the celebrated Gormenghast trilogy, was a multi-talented artist who produced a considerable body of visual art, fiction, poetry and plays. His son Sebastian Peake has collaborated with Alison Eldred and G. Peter Winnington to compile a stunning collection of book illustrations, paintings, photographs, letters, notebook pages and other material – much of which has never been published – to produce a unique memoir of the artist's life and work.

Contributors who discuss aspects of his life and work include the writers Michael Moorcock and Joanne Harris, editor of *Titus Alone* Langdon Jones, artists John Howe and Chris Riddell, as well as David Glass and John Constable, creators of the stage version of the Titus books, and Estelle Daniels, producer of the BBC dramatization. The book covers Peake's upbringing as the son of a missionary in China, his development as an illustrator, artist and writer, marriage and fatherhood, wartime experiences, creation of the Titus trilogy, *Mr Pye* and other literary works, and his tragic decline as illness overcame him, resulting in his early death.

Peter Owen books can be purchased from
Central Books, 99 Wallis Road, London E9 5LN, UK
Tel: +44 (0) 845 458 9911 Fax: + 44 (0) 845 458 9912
e-mail: orders@centralbooks.com

www.peterowen.com

BOY IN DARKNESS AND OTHER STORIES
by Mervyn Peake
with a foreword by Joanne Harris
978-0-7206-1306-3 • paperback • 160pp • £9.95

'A master of the macabre and a traveller through the deeper and darker chasms of the imagination' – *The Times*

'Peake was among the great storytellers of the twentieth century. These stories reflect six very different views of the world among the countless mental landscapes drawn by this most mercurial of visionaries' – Joanne Harris

A treasury of classic literature . . . highly recommended' – *Midwest Book Review*

The novella 'Boy in Darkness' is the centrepiece of this superb collection of Mervyn Peake's short fiction and will be of special interest to Gormenghast fans, as it comprises an episode in the life of Titus Groan that unfolds beyond the pages of Peake's monumental trilogy. Overwhelmed by the pomp and gruelling ritual of life in Gormenghast, Titus braves an escape from his hereditary gaol. Beyond the castle walls, he wanders into a sinister and soulless land, where he is captured by Goat and Hyena, grotesque henchmen of an evil master intent on claiming young Titus's soul. A disturbingly atmospheric tale which bears comparison with Kafka and Poe, it is essential reading for admirers of Peake's fiction.

Written across a range of genres, from a ghost story to wry character studies drawn from the author's life in London and on the Isle of Sark, the other stories in the volume reveal different facets of his unique and sometimes macabre imagination. Ultimately the collection coheres through his ability to make the mundane seem fantastic and to render the fantastic ordinary. This volume features previously unpublished paintings and illustrations by Mervyn Peake.

Peter Owen books can be purchased from
Central Books, 99 Wallis Road, London E9 5LN, UK
Tel: +44 (0) 845 458 9911 Fax: + 44 (0) 845 458 9912
e-mail: orders@centralbooks.com

www.peterowen.com